HDR PHOTOGRAPHY
PHOTO WORKSHOP

Pete Carr and Robert Correll

WILEY

Wiley Publishing, Inc.

HDR Photography Photo Workshop

Published by
Wiley Publishing, Inc.
10475 Crosspoint Boulevard
Indianapolis, IN 46256
www.wiley.com

About the Authors

Pete Carr is a professional photographer living near Liverpool in the UK. He had his first taste of photography at the age of 10 on a day course where they photographed the local town and developed their film in the darkroom. However due to film costs it wasn't possible to pursue it as a hobby. He went to university graduating with a degree in Software Engineering. His interest in Web design lead him to learn Photoshop and from there expanded his creative horizons. He bought a digital camera, and then a dSLR with a bag of lenses. By the time he was a professional Web designer he quit to become a professional photographer.

He documents people, explores urban environments, and relaxes with local landscapes. His work has been exhibited in various galleries including Tate Liverpool, Open Eye Gallery, National Media Museum, and at Albert Dock. His work has also been published in magazines worldwide including *Professional Photographer*, *DSLR User*, and *JPGMag*. He published his first book in 2008, which included many photos from his award winning photoblog, Vanilla Days. Photography will never be just a job.

Robert Correll is an author, photographer, artist, music producer, audio engineer, and musician. He loves taking photos and is a lifelong film and digital photographer. His first assignment in the United States Air Force was as a photo interpreter. Robert now pursues photography and HDR professionally along with his other passions. He is a longtime expert in image editing and graphics software such as Photoshop, Photoshop Elements, and Corel Paint Shop Pro Photo. He also retouches and restores photos.

His latest published works include *Photo Restoration and Retouching Using Corel Paint Shop Pro Photo*, contributing to the *Official Corel Paint Shop Pro Photo Magazine*, and writing *Your Pro Tools Studio*. Robert also authors creative tutorials for the Virtual Training Company. His titles range from *MasterClass! - Adobe Photoshop CS4 HDRI* to subjects covering Corel Paint Shop Pro Photo, Adobe Photoshop Elements, Sony ACID Pro, and Cakewalk SONAR.

Robert makes his music on the electric guitar and bass and graduated with a Bachelor of Science degree in History from the United States Air Force Academy.

Credits

Senior Acquisitions Editor
Stephanie McComb

Copy Editor
Kim Heusel

Editorial Director
Robyn Siesky

Editorial Manager
Cricket Krengel

Vice President and Group Executive Publisher
Richard Swadley

Vice President and Executive Publisher
Barry Pruett

Business Manager
Amy Knies

Senior Marketing Manager
Sandy Smith

Book Designers
LeAndra Hosier
Tina Hovanessian

Project Coordinator
Patrick Redmond

Graphics and Production Specialists
Carrie A. Cesavice
Andrea Hornberger
Jennifer Mayberry
Mark Pinto

Quality Control Technician
Jessica Kramer

Cover Design
Daniela Richardson
Larry Vigon

Proofreading and Indexing
Penny Stuart
Broccoli Information Management

Acknowledgments

We would like to thank the entire team at Wiley for their hard work over the course of this project. Special recognition and thanks go to Stephanie McComb and Cricket Krengel. Thank you both for this opportunity to share our passion for HDR photography in such a wonderful series. We would also like to thank David Fugate for his expert representation and support.

~ Pete and Robert

I would personally like to thank my friends at Talk Photography on Flickr and those who have left comments on my site. Thanks for making me believe that I can take a half-decent photo. Thanks to my friends for doing their best to keep me sane.

~ Pete Carr

My personal thanks go to David and Pete for opening up a whole new creative world to me. Thank you to everyone from around the world who has e-mailed me questions. I enjoy making these connections a great deal. Thank you to my family for your unfailing love, support, and encouragement.

~ Robert Correll

To my parents, thank you for everything and letting me play with a camera. To my sister and nephew, thank you for the walks and hot chocolate.

~ Pete Carr

To my wife Anne, and our children: Benjamin, Jacob, Grace, and Samuel. I treasure you.

~ Robert Correll

Contents

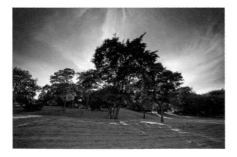

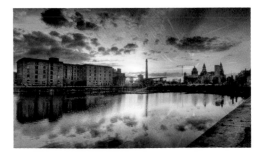

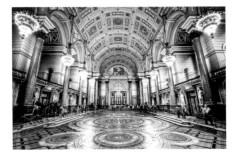

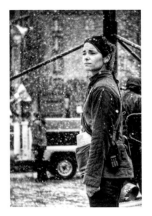

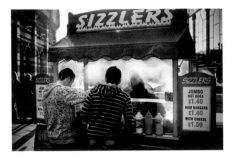

Introduction

Love it or hate it, High Dynamic Range (HDR) photography has generated quite a bit of buzz. Online forums and photo sharing sites such as Flickr have new HDR examples every day and people are talking about it.

So, you are likely wondering what is HDR? Why does it look that way? How can I do it? Will it look realistic? What camera and software do I need? Do I need a tripod? Will it work with people? Can I shoot black and white? What about buildings or interiors? How do I get rid of noise? What file format should I use? What should my workflow be?

If you're asking these types of questions, then this book is for you, whether you are new to photography or a seasoned professional.

Right off the bat you will learn about dynamic range and HDR photography, what HDR is, what you need to start, and how to create it. These are the building blocks for the rest of the book where you will learn how to evaluate scenes for their HDR potential and shoot in many different styles with a wide range of subjects. This is the really fun stuff. You'll learn how to shoot HDR landscapes, architecture and cityscapes, interiors, black and white HDR, people, street photography, and other subjects.

This is not a technical treatise on the physics of HDR or an exhaustive software tutorial/reference. It's about photography and HDR. We focus on Photomatix and Photoshop Elements because we didn't want to overcomplicate matters by trying to cover every possible software combination. At the same time, we choose to try and make the book portable to different software choices. We show you what you can do, tell you how we did it, and leave the rest up to you.

This book will push you. To get the most out of it you should be prepared to put in the effort to learn and practice HDR photography yourself as well as develop your skills with the software you use. This is the creative contract you enter with us by reading this book. Exercise your artistic judgment by using this information as a springboard to achieve your own vision. Be prepared for some frustration. That's okay — we didn't learn this overnight, and neither will you. Photography takes effort.

One final note. You don't need to live in the Swiss Alps to get the best landscape shots. Do what you can with what you have. Embrace it. Find the character of your surroundings through photography — the landscape, your family, the buildings around you, your back yard, a car, the snow — and see where HDR can contribute. The journey of finding out is both fun and rewarding.

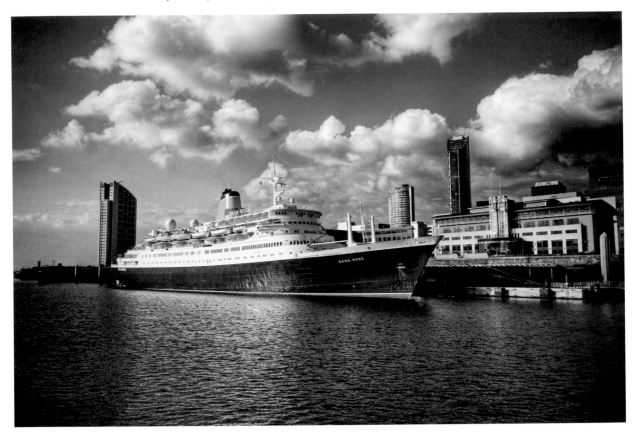

© Pete Carr

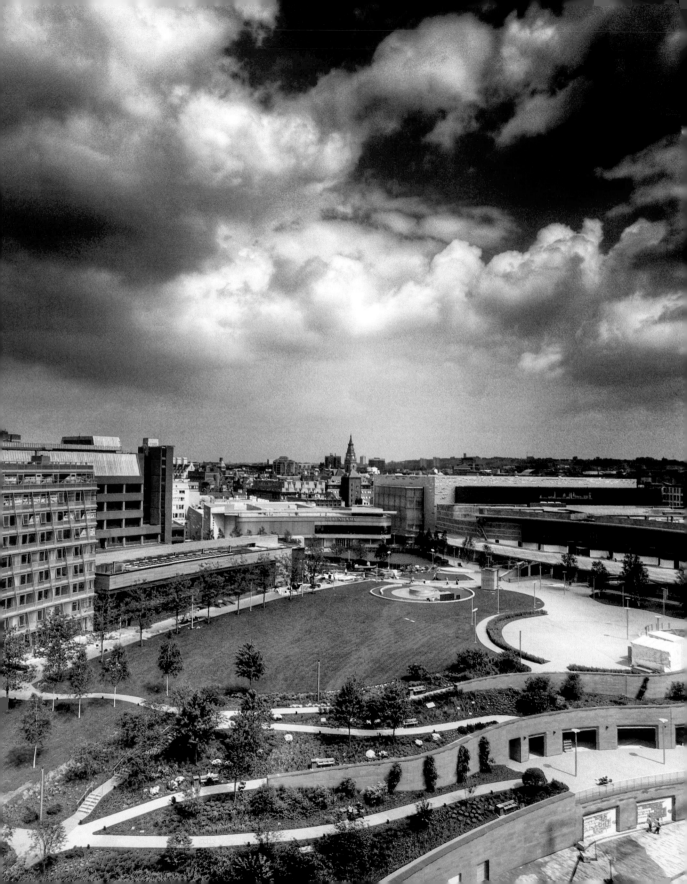

© Pete Carr

Although digital photography is a compelling and satisfying endeavor, there are significant limitations to the technology. You don't often hear of them as such, but they affect you every time you press the Shutter button. The most serious of these limitations, as it relates to High Dynamic Range (HDR) photography, is dynamic range.

The simple truth of the matter is that digital cameras are unable to fully capture what you see with your eyes much of the time. The world is a deeply complex subject whose own dynamic range from dark to light far and away exceeds the digital camera's ability to record it. To make matters worse, you often limit yourself to an averaged or compromised exposure when you rely on a single photograph and normal processing techniques to capture and present everything. This chapter prepares you for the wealth of HDR information and techniques presented later in the book by illustrating the problems inherent in digital photography today. You learn about dynamic range, exposure, metering, and see examples of how photographs are typically compromised by limited dynamic range. You briefly see several traditional solutions to these problems so you can compare their effectiveness to HDR.

DYNAMIC RANGE

Within the context of photography, *dynamic range* is the range of light, from little to much, that can be measured and recorded, normally by a single exposure. It is not how little light can be measured; nor is it how much light can be measured. It is the difference between the two. Dynamic range is often characterized by the terms exposure value (EV) levels, zones, levels, or stops of range.

note Blown-out details, quite often skies, are the result of limited dynamic range. Too much light overexposes parts of the scene and the camera literally cannot measure any more light. The resulting image has no details in the overexposed areas.

Quantifying dynamic range can be a problematic affair. There is no official standard, per se; nor do camera manufacturers list each model's dynamic range as part of their specifications. The specific dynamic range of your camera is something you will have to experience, positively and negatively (see 1-1), firsthand.

If you understand a few technical factors behind the scenes, as explained in the following sections, it will help you understand why dynamic range often seems so limited.

note Throughout the course of this book, the context of the term dynamic range refers to the range of brightness in a scene. It is, in essence, the contrast ratio of the least illuminated area to the most. In a larger sense, dynamic range can refer to any system where you compare two extremes, such as in audio.

SENSOR WALKTHROUGH

To understand how a camera's sensor works, it helps to use an analogy. Begin by imagining a bucket. This bucket holds electrons and represents an effective pixel-sized sensor in your digital camera. The sensor absorbs photons that strike it during the exposure and generates an electron charge that is held in the bucket until the exposure ends. The strength of the charge reflects how much light was measured. This value is passed to an analog-to-digital (A/D) converter with data from the rest of the sensor and turned into an image file.

ABOUT THIS PHOTO
This photo was taken outside on a bright, sunny day of a vintage World War II aircraft. The dynamic range of the scene was too much for the camera to handle. The dark plane looks fine, but the sky and concrete are too light. (ISO 100, f/9, 1/125 second, Sony 18-70mm f/3.5-5.6 at 60mm) © Robert Correll

1-1

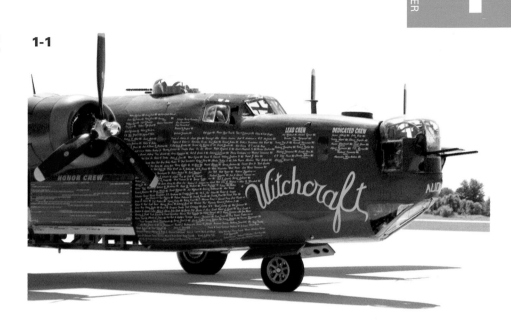

As you might imagine, the size of the bucket (called full-well capacity) dictates how much light the sensor can measure. The difference between a full bucket and an empty bucket is the theoretical maximum dynamic range of the sensor. The larger the bucket, of course, the greater the dynamic range of the system.

There are a number of factors that reduce a sensor's dynamic range. These range from electron noise (see 1-2), which interferes with a sensor's ability to record extremely low levels of light, to pixel size and sensor efficiency. Simply put, no sensor is perfect.

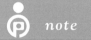 *note*　Another factor indirectly affecting dynamic range, and beyond the scope of this book, is the linear nature of a digital camera's response to light. They do not work as our eyes do. The linear quality of the sensors makes digital cameras incredibly valuable in astrophotography. The direct result is the ability to combine many short exposures, which are more easily attained, into longer ones.

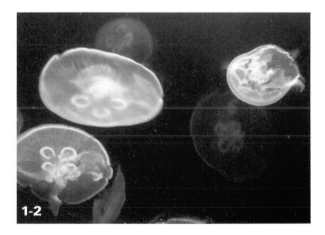

1-2

ABOUT THIS PHOTO *This high-ISO shot of jellyfish amplifies sensor noise along with valuable light. (ISO 3200, f/4, 1/20 second, Sony 18-70mm f/3.5-5.6 at 18mm) © Robert Correll*

BIT DEPTH

The *bit depth* of a camera is analogous to the stop scale. Each stop doubles or halves light, which is exactly how bits work. Adding a bit to a binary number doubles it. Conversely, removing the leading bit of a binary number halves it. Each bit,

therefore, provides a stop's worth of dynamic range. Thus, a 12-bit camera has 12 stops of potential dynamic range, which results in 4096 levels of light-to-dark discrimination in each color channel.

That may seem like a lot, but unfortunately, even a 12-bit camera which can measure 4096 discrete shades of light in each color channel does not have the dynamic range necessary to capture a simple scene at the zoo without blowing out highs and losing details in shadow (see 1-3).

Finally, bit depth can also be used to describe the number of colors a camera can capture and store in a file. In this sense, a camera with a greater bit depth has more color-sensing ability. Each color channel of a 12-bit camera can contain up to 4096 different shades of that color, resulting in a tremendous number of total colors that the three channels can combine to reproduce. However, dynamic range is the story of brightness, not color. As mentioned previously, the shades of color are not evenly distributed across the bit-depth system, which results in a skewed intensity range for each color. Therefore, having 4096 possible shades of each color is not enough to capture the true dynamic range of a scene without compromise. If it were, you would never need worry about a blue sky turning white.

1-3

ABOUT THIS PHOTO
This photo, processed from a 12-bit raw image. (ISO 100, f/5.6, 1/160 second, Sony 18-70mm f/3.5-5.6 at 35mm) © Robert Correll

WRANGLING WITH EXPOSURE

Like wrestling a steer to the ground in a rodeo, exposure can be a difficult beast to control, especially if you don't want to resort to flash photography, EV adjustments, changing ISO, or other techniques. This difficulty is a practical effect of limited dynamic range.

EXPOSURE EXPLAINED

Exposure is how much light reaches the camera's sensor during a single photograph. There are many ways to manage light and its effect on the process, but there are two central ways to control exposure: shutter speed and aperture.

■ **Shutter speed.** Measured in minutes, seconds, or fractions of a second, shutter speed sets how fast the shutter opens and closes. The longer it remains open, the more light makes it into the camera. Faster shutter speeds let in less light. The typical dilemma for a photographer is finding the right shutter speed for scenes with high contrast and movement, as illustrated in 1-4. It is clear that the interior of the tunnel would need a longer exposure to allow the details to be seen. However, slowing the shutter speed to take a longer exposure would increase the amount of light the camera senses and not only lighten the inside of the tunnel, but it would cause the action in the scene outside the tunnel to be reduced to a blur. Additionally, the longer exposure would cause the sky to be blown out.

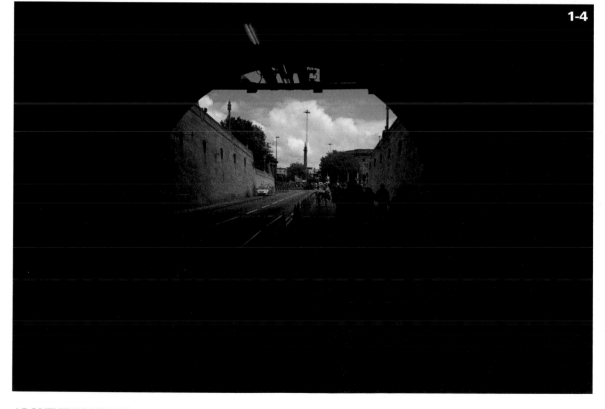

1-4

ABOUT THIS PHOTO *Standing in a tunnel, the outside is perfectly exposed, but the image lacks detail inside the tunnel. (ISO 100, f/4, 1/200 second, Sigma 10-20mm f/4-5.6 at 16mm) © Pete Carr*

■ **Aperture.** This describes the size of the opening in the lens that focuses light past the open shutter and onto the sensor inside the camera. A larger opening lets more light in and a smaller opening permits less light in. Artistically, larger apertures result in a shallower depth of field, blurring deeper area of the foreground and background. Along with the focal length of a lens, the aperture is used to determine f-stop.

note — *Depth of field* refers to the size of the area you perceive as in focus, extending in front of and behind the plane the lens is focused on (most often the subject). Shallow depths of field have a narrow area in focus, with blur elsewhere. This often results in a wonderful artistic effect. Deeper depths of field have more in focus, both in front of and behind the focal distance. Deeper depths of field are important in landscape and architecture photography because a much deeper area of the photo remains clear and sharp.

Manipulating shutter speed and aperture are no less important in HDR than in traditional photography, although you will do so with a different purpose in mind. In HDR, you often use a handful of photographs to capture a wider dynamic range of light than is possible in one exposure.

x-ref — For more information on the gear you need for HDR, please refer to Chapter 2.

EXPOSURE VALUE

As a photographer, you manipulate shutter speed and aperture size (through choosing an f-stop) to control exposure. If exposure is a reflection of how much light enters the camera during a photograph, *exposure value* (EV) illustrates the relationship between exposure, shutter speed, and f-number. EV is not a precise calculation of the

F-STOPS The f-stop is an important subject in photography. F-stops allow the effects of aperture on exposure to be expressed between different lenses and focal lengths, which is a great timesaver when determining exposure values. This is because focal length, which is the distance between the lens and its focal point (which is on the sensor when in focus), is different from one lens to another. As a result, you do not dial in a specific aperture size when setting the exposure; you set the f-number (hence the term f-stop).

For a given focal length, setting a larger f-number (sometimes called stopping down) causes the aperture to shrink and lets less light into the camera. It also deepens the depth of field. Setting a smaller f-number (also called stopping up) causes the aperture to grow and lets in more light. This also results in a shallower depth of field.

Manipulating exposure is very important in HDR photography, but the f-number normally remains the same across exposures. This keeps the depth of field constant. In addition, HDR excels at shooting landscapes and larger shots where a deeper depth of field keeps everything in focus.

quantity of light during the exposure. It is a working number that allows the effects of altering shutter speed and aperture on exposure to be quickly and easily compared.

For example, 1-5 is a high-contrast scene taken from the inside of a log cabin. The calculated EV is between 11 and 12 for this exposure, which has underexposed the interior and overexposed the view through the door. Looking out the right window reveals the best exposure for the landscape beyond. The dynamic range of the camera wasn't large enough to capture the light and dark extremes in this scene at this EV, and moving the EV (by changing shutter speed or aperture on your camera) just results in a different compromise — not more dynamic range. With HDR, you will often take more than one photo, each separated by ideally 1 or 2 EV, to extend your dynamic range. In situations where you cannot take more than a single exposure, there is a technique that uses one raw photo as the source image for HDR, which is a process detailed in Chapter 3.

It is easy to find EV tables on the Internet that list combinations of shutter speed and f-number to give you the EV number. You can also calculate the range of EV for every combination of f-stop and shutter speed yourself using the formula for EV and a spreadsheet.

Study the relationship between EV, f-stop, and shutter speed, and know that this is the playing field for exposure. The settings you normally choose are limited by your camera's dynamic range and the situation at hand. HDR effectively expands the EV you can capture, allowing you to extend the dynamic range of your camera and properly expose different elements of a photograph without having to sacrifice detail or aesthetic quality.

> **note** You can change exposure, and hence EV, directly in software such as Adobe Camera Raw and Photoshop, and indirectly in Photoshop Elements.

ABOUT THIS PHOTO
Shooting from within this log cabin shows how different EV levels make getting the right exposure difficult. (ISO 100, f/8, 1/200 second, Sigma 10-20mm f/4-5.6 at 12mm) © Robert Correll

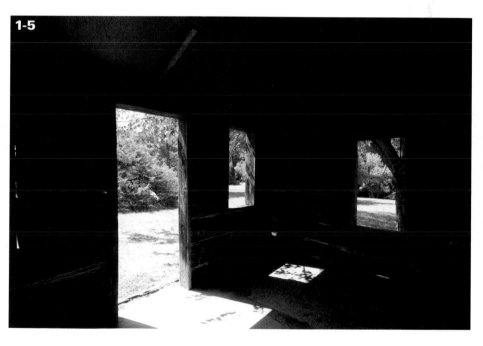

1-5

METERING

Digital cameras have built-in meters that measure light and help set the right exposure. Prior to this feature, photographers had to eyeball it (using tools such as the Sunny 16 Rule) or carry their own light meter. Metering is an important skill in HDR photography because it allows you to evaluate a scene to arrive at the best overall exposure to bracket around or measure the extent of the highs and lows of a scene in order to extend your brackets. If taking a single photograph for HDR, you will meter to take the best photo to start with.

Many professional photographers carry light meters, and you may find having one convenient for HDR photography as well, especially if you work with a tripod. Once you mount your camera on a tripod and compose the shot, you cannot move the camera to do any further spot metering without disturbing your setup.

Virtually every digital camera today, and certainly every dSLR, has three metering modes, sometimes four. Depending on the camera manufacturer they may be called by slightly different names. They are:

- **Average.** This mode evaluates different areas of the scene in order to arrive at an average exposure. Within the bounds of your camera's dynamic range, this is often the best compromise. The problem, however, is that high-contrast scenes (see 1-6) have a way of overpowering the camera. You typically lose details in shadows and highlights.

- **Center-weighted.** This mode gives the center of the scene more weight in determining EV. It is a better choice if the subject is lit differently than the background, but much of the background will be ignored in determining the proper exposure and so you risk losing it in shadow or highlights.

ABOUT THIS PHOTO
The subject turned out reasonably well but was slightly underexposed because the bright sky overwhelmed the Average metering algorithm. Spot mode on his face would have been a better choice. Notice the broad range of dark shadows to bright sky in this casual photo. (ISO 100, f/5, 1/125 second, Sony 18-70mm f/3.5-5.6 at 30mm) © Robert Correll

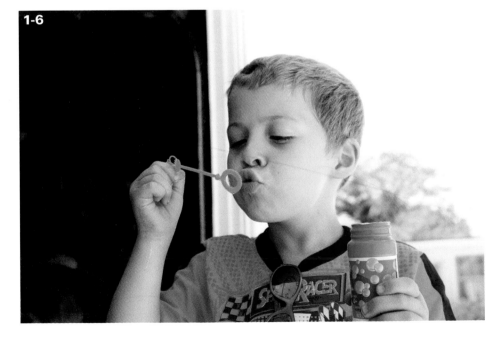

1-6

■ **Spot.** This mode meters the center of the scene only, which ensures what you meter will be exposed correctly, but nothing else will be taken into account. Paradoxically, this works great for scenes with a large dynamic range because you choose the one thing that gets exposed correctly. Unfortunately, everything else often suffers.

> (p) *note* | Many Canon models combine Evaluative and Partial modes (their terms for average and center-weighted) into a fourth mode called Center-weighted Average.

The mere fact that there are several methods to meter light in a scene should tip you off to the fact that a camera's dynamic range is limited, and therefore most photographs are the result of choosing the best exposure compromise. If this were not so, you could simply point the camera and shoot, regardless of the lighting, and everything would look great.

> (p) *tip* | Although often expensive, light meters can be far more accurate than in-camera metering and their spot modes can be more precisely targeted.

SINGLE-EXPOSURE LIMITATIONS

Having taken a look at how it is often impossible to capture the full dynamic range of a scene using traditional methods of manipulating exposure via shutter speed and aperture, this section looks at the limitations of trying to capture and present

that dynamic range in a single exposure with standard processing techniques, which often results in exposure tradeoffs and compromises.

We aren't saying it is impossible to take outstanding photographs in one exposure. However, you should realize the limitations that have shaped photography to see how HDR fits into the evolution of the art.

SKIES

Skies are notoriously hard to get right when the subject of the scene is not the sky. The problem is that a daylight sky is often too bright compared to other scenery, especially anything in shadow. It is so light (don't confuse bright with blue — you can have a very bright sky that is a deep blue), the sky dominates the exposure. Any attempt to lighten foreground subjects invariably overexposes the sky, blowing it out (see 1-7).

1-7

ABOUT THIS PHOTO *This is an example of a blown-out sky. The person is nicely exposed but the background is completely lost, or blown out. (ISO 400, f/8, 1/3200 second, Canon 24-70mm f/8 at 70mm) © Pete Carr*

The same photograph processed as HDR (see 1-8), however, reveals the details that were previously hidden in shadow or lost in highlights.

ABOUT THIS PHOTO *Here you can see how HDR brings the sky back into the image shown in figure 1-7. It is an HDR image created from a single raw exposure converted to three bracketed exposures that bring out the full dynamic range saved in the raw file. © Pete Carr*

The problem doesn't go away when clouds are present, especially if it's partly cloudy and the sky has extreme light-to-dark areas of clouds and sky. Overcast days, paradoxically, can be a joy to shoot in because they even out the dynamic range of the scene.

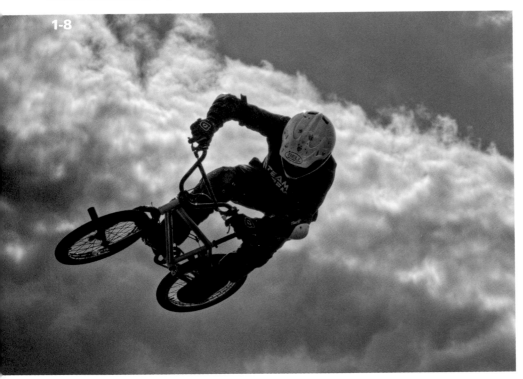

1-8

BUILDINGS

Working with buildings as your subjects is far different than working with portraits in a studio or nearby subjects outside. There are two reasons for this: scale and sky. The scale of a building is normally far larger than other subjects (landscapes as a whole being the exception). You can't use a flash to brighten a building, or use an umbrella to soften the light around it, or turn it in relation to the sun. You're basically at its mercy and must often wait for the perfect lighting and sky conditions to take the photo. Even then, details in the building are often lost because the sky pushes the EV up, which underexposes the buildings, making them darker. Trying to expose the building properly usually blows out the sky, as illustrated in 1-9.

ABOUT THIS PHOTO *This is an example of an overexposed photo with a blown-out sky. (ISO 100, f/5.6, 1/250 second, Sigma 10-20mm f/4-5.6 at 10mm) © Pete Carr*

1-9

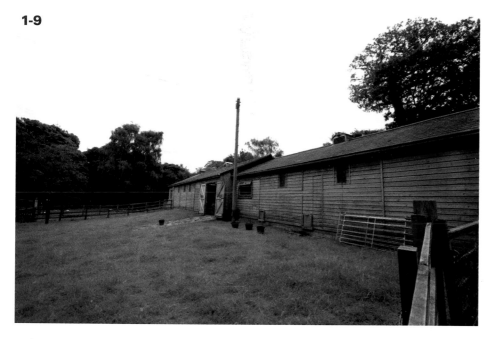

When you know you can't expose both the building and the sky correctly, you have a choice: shoot for the building or shoot for the sky. This is often why photographers choose to shoot during the Golden Hour. The light is most forgiving during this time and produces better photographs. HDR won't make the light at noon better than that of the Golden Hour, but it does enable you to bring out more detail in scenes photographed during off-hours and extends your dynamic range throughout the day.

SILHOUETTES AND SUNSETS

Silhouettes and sunsets are at the opposite end of the spectrum from shooting portraits and buildings. Here, you typically want the items in the foreground, such as a person or landscape features to be in very dark shadows that are silhouetted against a brighter sky or sunset.

In other words, the building or landscape is in near total shadow and the sky is properly exposed. The fact that foreground details are lost when shooting silhouettes and sunsets is expected and aesthetically pleasing.

In both cases, you meter for the brightest object in the scene, either the sky or the sunset. This sets the EV high, which is exactly what you want. It underexposes the foreground and turns it to silhouette or shadow. Buildings turn to black shapes carved out of a red sky, as seen in 1-10.

Difficulties arise, however, when you want detail in these situations (low foreground light at sunset and dusk) and cannot achieve it for lack of the

> *note* The light during the Golden Hour, which is the first and last hour of sunlight each day, is generally softer, more diffused, and the shadows are gentler. Of course, if you are near the Arctic Circle or in Antarctica, your mileage on golden light may vary.

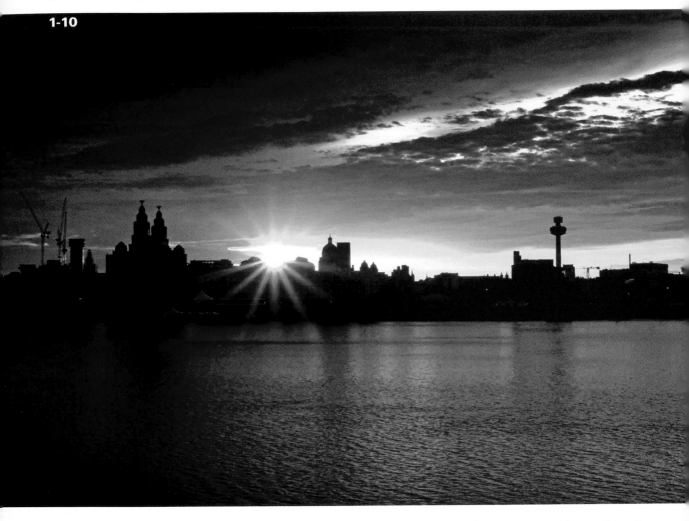

1-10

proper exposure. If you're on the beach with your friends enjoying a summer barbeque, you can't illuminate the entire beach with a flash. HDR photography helps in those situations. You don't have to go overboard, but you can get a beautiful sky, silhouette in the background, and properly exposed subjects without flash using HDR.

TRADITIONAL SOLUTIONS

Over the years, photographers have developed quite a few solutions to getting around the limited dynamic range of their cameras. This section gives you a taste of some more traditional methods so you can see how they compare to the HDR examples shown throughout the book.

LIGHTING

Additional lighting helps you bypass the dynamic range issue by controlling the light differences between subject and background, and hence limiting the contrast. For example, if you are a studio photographer, you have the luxury, and sometimes the burden, of complete control over lighting and environment to achieve whatever artistic

effect you desire, such as in 1-11. It's a perfectionist's dream. If you need less light, you can block out windows. If you want more contrast, you can choose a different background or turn it white and remove shadows for a *high-key* effect (intentionally lowering the overall contrast ratio of a scene). You can put lights above, behind, below, or to the side. You can add reflectors, brollys, softboxes, snoots (if you are in doubt about what these are, check out a lighting or camera sales Web site), or bounce the light off the wall.

It is also easy to get by with less. If you have two lights and a white or black backdrop, you have the ability to create or remove shadows. You can be creative and place a light behind the subject for a nice glow. Many of these options reduce the contrast of the scene, thereby reducing the dynamic range in your photo.

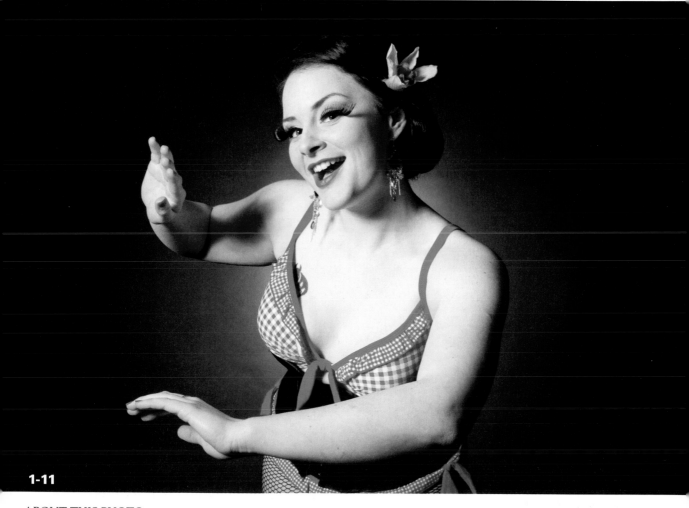

1-11

ABOUT THIS PHOTO *The lighting in this standard studio shot has been carefully manipulated to precisely create this crafted look. (ISO 100, f/13, 1/160 second, Canon 24-70mm f/2.8 at 28mm) © Pete Carr*

Lighting on location is far trickier because you lose total control. You may have no say over the background lighting, which is often up to nature. You do, however, control how bright the model is and can therefore balance that with the background. If you have a few lamps, strobes, or reflectors, you can illuminate the model nicely. Again, this reduces the contrast between your subject and the background, which in turn reduces the dynamic range of the image.

NEUTRAL DENSITY FILTERS

Landscape photographers use Neutral Density (ND) filters to darken portions of their photos. ND filters filter out all wavelengths of light equally, resulting in an evenly reduced exposure.

There are two main types of ND filter: graduated (ND grad) and non-graduated. Both types come in various strengths. Unlike software solutions to

exposure, you can see the effect before you take the photo, and can therefore adjust your settings to get the best exposure value.

ND grad filters are particularly well suited to scenes with simple horizons, as shown in 1-12. They sky was very bright and had to be toned down dramatically compared to the beach and water. An ND grad filter was a perfect solution for this scene. Had it not been used, the sky would have been blown out and devoid of detail.

> **note** A filter is a thin piece of glass (some are made from other materials like plastic) that goes in front of the lens of your camera and is manufactured to filter out certain wavelengths of light. They are often clear, although some are polarized and others colored. Many filters are round and screw onto the front of the lens. Others are rectangular and slide into a mount that attaches to the lens.

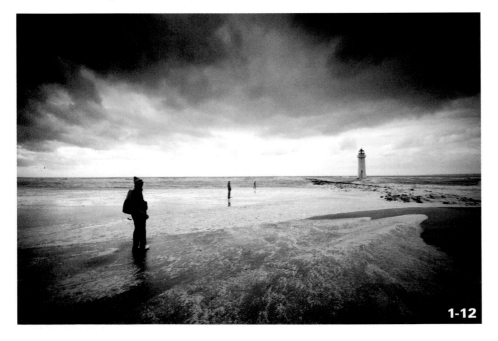

1-12

ABOUT THIS PHOTO
Here you can see an ND filter in action. This is a straight shot with minimal processing applied, and you can see how nicely the sky has turned out. (ISO 250, f/6.3 1/640 second, Sigma 10-20mm f/4-5.6 at 10mm) © Pete Carr

ND filters are not without their problems, however. If the horizon is not perfectly straight (trees, hills, buildings, and mountains get in the way and complicate things) and you use a graduated filter, details on the intervening scenery are likely to be underexposed and mountains or other objects may look like they have halos around their tops.

In short, ND filters are a great tool to use if the landscape is neat and tidy, but not the best solution for chaotic or complex horizons. HDR works in any of these situations because it is not dependant on the horizon line being level.

CONTRAST MASKING

Contrast masking is a software technique that evens the contrast of an image. The idea is to use a new layer to bring out details in the shadows or darker areas and tone down highlights in the sky (see 1-13).

Without getting into too much depth, contrast masking involves duplicating the photo layer, desaturating the new layer, and then inverting it (it will look like a gray negative). Desaturating the duplicate layer focuses the end result on brightness rather than color and inverting the layer pushes the original highs and lows in the opposite direction. The final steps are changing the blend mode of the duplicate layer to Overlay, which lightens or darkens values from the lower layer, and applying a Gaussian Blur to it so that it doesn't completely mask the original brightness of the photo. In the end, selective erasing of the inverted layer helps restrict the effect to the desired areas.

Despite the fact that contrast masking may work in some situations, it can be an inelegant solution. Rather than spend time duplicating layers,

ABOUT THIS PHOTO
This high-contrast scene includes a very dark tunnel and bright white clouds. While contrast masking has helped bring out more detail in the tunnel, the sky is still blown out. (ISO 200, f/5.6, 1/250 second, Sigma 10-20mm f/4-5.6 at 10mm) © Pete Carr

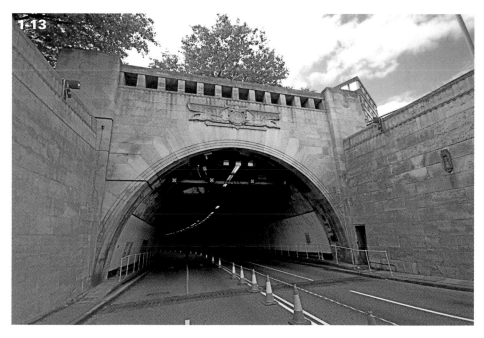

1-13

inverting, blurring, and erasing just to get the right exposure by further compressing the dynamic range of a photo, it's more fun to shoot for HDR and be creative in the processing.

EXPOSURE BLENDING

You could call exposure blending an early form of HDR. In fact, it began (as many software techniques have) in the darkroom. The idea was to take more than one photo and blend them while making the print. Today, exposure blending is predominately a software process, and begins with taking more than one photograph.

For example, to photograph a landscape with a bright sky, take one photo of the land properly exposed, then take another and set the exposure for the lighter sky. You can take as many photos as you want, each differently exposed, as long as you use a tripod and keep the scene composed identically between exposures. Later, blend them in Photoshop as different layers, as shown in 1-14.

There are a number of ways to perform exposure blending in software. You can change blending modes from soft-light to pin-light, or erase parts of the image you don't need and work them until they blend together. Ultimately, this can be a tricky and time-consuming process.

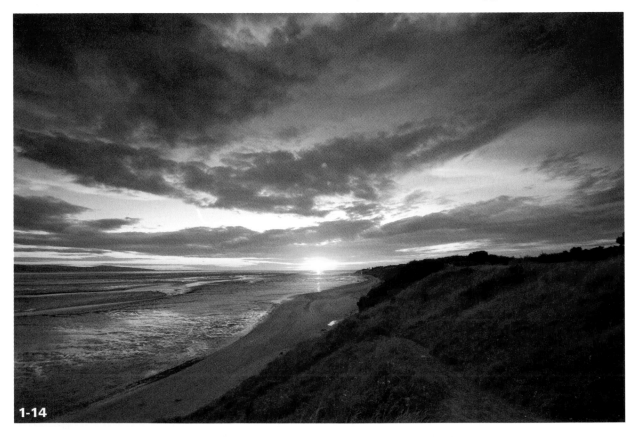

1-14

ABOUT THIS PHOTO *Two exposures are merged together in Photoshop to create a balanced photo. (ISO 100, f/4, 1/50 second, Sigma 10-20mm f/4-5.6 at 10mm) © Pete Carr*

HDR photography is very similar to this on the front end (taking the photos), but in software is vastly different. HDR software such as Photomatix automates blending and other aspects of this task.

TWEAKING SHADOWS AND HIGHLIGHTS

Another reasonably simple solution to overcoming your camera's limited dynamic range is to tweak the shadows and highlights of your photo in your favorite image-processing application. You can recover some detail from a JPEG using this technique in Photoshop Elements. It is easy to ruin the image if you try and push too hard, however. JPEGs have only a stop or so of enhancement in them before they are ruined by noise and color banding. Tweaking shadows and highlights can recover some detail in dark and light areas, such as in 1-15. The tree trunk has been lightened and the bright area of the sky has been toned down a bit with Shadows/Highlights in 1-16. If the result was a bit gray, as was the case here, add a moderate amount of contrast back into the photo to clean it up.

Although you may still want to use this shadow and highlight technique, properly shot HDR reduces the need for most shadow and highlight tweaking for anything but aesthetic reasons.

DODGING AND BURNING

Dodging and burning are two techniques that also have their roots in the darkroom. *Dodging* involves lightening specific areas of a photo. For example, if someone's face is a bit too dark, you can dodge to lighten it and make the person stand out more. *Burning* darkens areas of the photo. If, for example, the sky is too light, a small amount of burning can bring it back in line with the rest of the photo. In these ways, different areas can be exposed with different amounts of light, resulting in customized exposure levels across the photo.

In theory, dodging and burning are simple, but the default exposure strengths in Photoshop and other applications are set so high that it's almost impossible to get good results without a good deal of tweaking. The key is to take it easy and set the strengths correctly. If necessary, apply evenly over more than one application. Using a pen tablet helps tremendously.

The Dodge and Burn tools are located together on the Tools palette of Photoshop. The Dodge tool looks like a small paddle that holds back light and the Burn tool is a small hand. Here are some tips to help you dodge and burn:

- After selecting the Dodge tool, set the Painting Mode range to Shadows to bring details out of darker areas.

- Start with the Exposure between 10% and 20% when dodging and then alter as needed.

- Set the Painting Mode range for the Burn tool to Highlights to darken overly bright areas or Shadows to deepen existing dark areas.

- When burning, set Exposure under 10% to start and alter as needed.

Doing a poor job with the Dodging and Burning tools can create halos around the areas you manipulated, so be prepared to experiment and start over. It is also possible to increase noise levels in areas as you dodge. Additional noise may not be a problem, especially if you are working with black-and-white photos (see 1-17). In those cases, a little extra noise looks like film grain and is aesthetically pleasing.

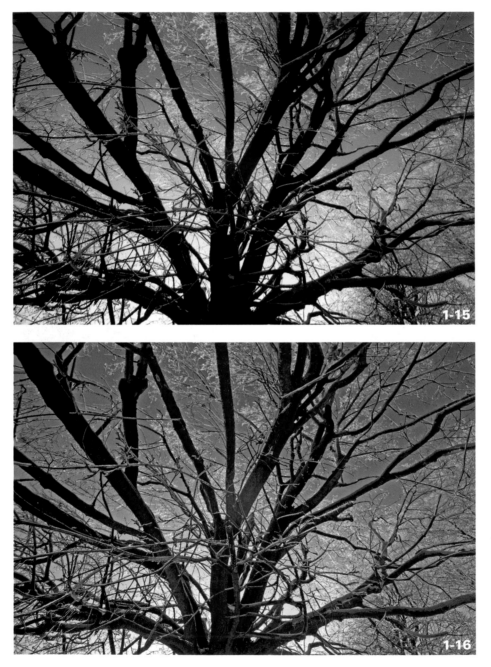

ABOUT THESE PHOTOS *In figure 1-15, the tree is in shadow and the sky is on the verge of blowing out. This called for a Shadows/Highlights adjustment in Photoshop Elements to recover detail. The results are shown in figure 1-16. (ISO 100, f/8, 1/125 second, Sigma 10-20mm f/4-5.6 at 10mm) © Robert Correll*

ABOUT THIS PHOTO *This classic black-and-white photo has been enhanced with dodging and burning. (ISO 250, f/6.3, 1/800 second, Sigma 10-20mm f/4-5.6 at 10mm) © Pete Carr*

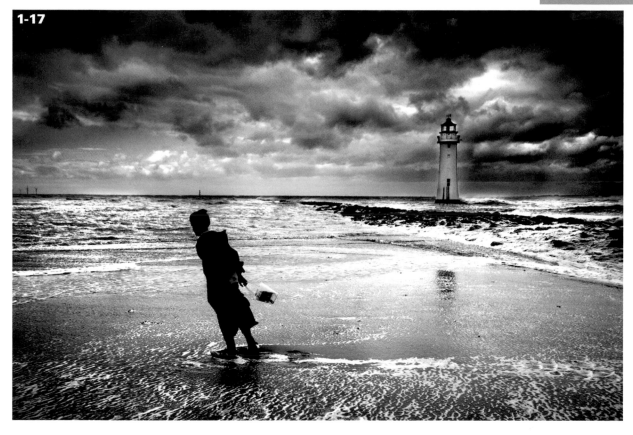

1-17

On the whole, be prepared to continue dodging and burning even when you shoot HDR, but your attention will be much more finely focused on the subtle details rather than trying to rescue the photograph.

FILL LIGHT AND RECOVERY

If you use Adobe Lightroom or Adobe Camera Raw (from within many Adobe products, even Photoshop Elements), there are two very quick and easy ways to rescue hidden details from standard photos: Fill Light and Recovery.

Details get lost in shadow because the limited dynamic range of the camera forces the photo to be underexposed in darker areas to avoid clipping the highlights. Fill Light selectively brightens the dark and midtones of a photo, moving them toward the lighter end of the histogram. If you are using HDR, the multiple exposures capture these details more suitably in the first place, so you don't have to resort to using Fill Light to bring them out.

Overexposed highs normally happen with skies and other bright objects, a problem once more caused by the limited dynamic range of the camera. In this scenario, if the subject is exposed correctly, it leaves the sky white or blown out. To fix this, Recovery works opposite of Fill Light. Recovery takes the highs of a photo and brings them down into a reasonable balance with the rest of the photo.

A gentle application of both techniques is illustrated in 1-18. The bright remains of the setting sun are too bright, resulting in some blown out pixels. In addition, the sky and outer areas of the photo are very dark. Using Fill Light helps lighten those areas up and makes the water clearer from foreground to background. Generally speaking, it is not wise to overdo Fill Light or Recovery or you may lose contrast and tone, or elevate noise.

Both tools attempt to lessen the effects of limited dynamic range by bringing out details that are in the raw file but may be lost in the conversion to JPEG (see the next section for more on raw). They do not actually increase dynamic range, but they can help bring out what is there already.

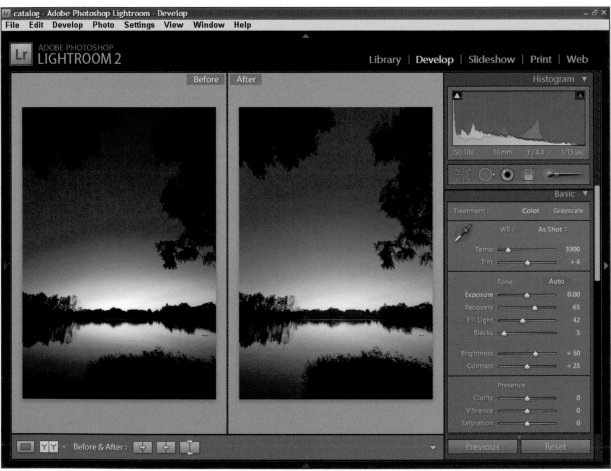

1-18

ABOUT THIS FIGURE *A sunset image has been enhanced with Fill Light and Recovery in Lightroom. (ISO 100, f/4, 1/15 second, Sigma 10-20mm f/4-5.6 at 10mm) © Robert Correll*

POST-PROCESSING WITH RAW

Processing raw images (which includes Fill Light and Recovery) is a very good technique for increasing exposure flexibility because, unlike 8-bit JPEGs, raw images contain the full dynamic range of the original photograph. In other words, when a camera converts sensor data to a JPEG file, it reduces the dynamic range of the photo. Cameras often let you choose an artistic style such as portrait, landscape, or vibrant for it to use as a guideline when it converts from raw to JPEG, but you will directly control the process if you do it yourself.

The tradeoff to control is an altered workflow, increased time spent post-processing, and space. Photographers who have to process thousands of photos often find the convenience of JPEG outweighs the merits of switching to raw. If this is you, you will find HDR more time consuming than pumping out JPEGs, but HDR will pay dividends for important photos.

In the end, working directly with raw photos is a step towards HDR, but still stops short of it. You have more dynamic range with a raw photo compared to a JPEG out of the camera, but are still limited by processing options of the raw editor. Current raw editors reveal a traditional, single-exposure mindset. You cannot blend exposures, tone map a 32-bits/channel HDR image, or use other techniques unique to HDR.

THE HDR ANSWER

The traditional single-exposure technique is the standard way most people take photographs. It is very powerful and you can take wonderful shots with it. It should be clear to you now, however, that you often can't have it all in one exposure. When you meter for bright areas the dark areas are too dark. They are not an accurate reflection of what you see. When you meter for dark areas the highlights get blown out. When you use the average reading your subject may be exposed properly, but other areas suffer. In high-contrast situations, you have to make a choice. What do you want to see well?

In those situations it is normally best to err on the side of not blowing out highlights. This is good practice, of course, but it can skew your perception of the dynamic range of a camera. You think everything is okay when it's not.

HDR is both a photographic discipline and software process that attempts to overcome the exposure problems discussed thus far. HDR bypasses the limitations of dynamic range using two innovative exposure bracketing approaches. The two approaches differ in how you create the bracketed exposures.

HDR PHOTOGRAPHY

One method of HDR photography is to shoot multiple, bracketed exposures (see 1-19 through 1-21). You can take more, but three is the minimum for good bracketing. The first photo is a normal exposure with a good balance of highs and lows (depending on the subject). This is what you should be shooting already. The second is deliberately underexposed to bring down highlights and keep them from being blown out. The third photo is overexposed to bring up the shadows so you can see what is in them.

ABOUT THESE PHOTOS *Shown here are examples of a normally exposed (1-19), underexposed (1-20), and overexposed photo (1-21). They show the range of light in your average photo and why you need HDR to fully capture all this light. 1-19 shows an average exposure, which is probably what you'd get on a normal day. 1-20 has been underexposed by 2 stops to bring out the detail in the sky. 1-21 has been overexposed by 2 stops to bring out the detail in the building, but at the expense of the sky, which is now just white. (ISO 100, f/8, 1/80 second, Sigma f/4-5.6 10-20mm at 10mm) © Pete Carr*

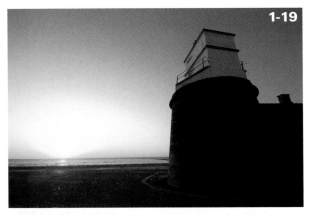

1-19

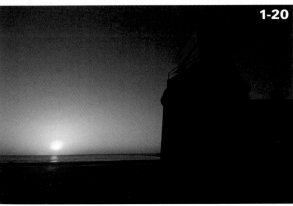

1-20

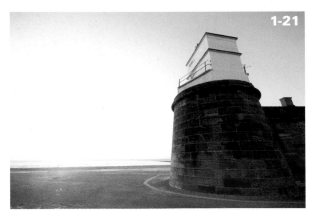

1-21

The other method uses a single raw photo, which is used as the source to create three brackets from. You end up with three bracketed files (one underexposed, one properly exposed, one overexposed), just as you would if you took three photographs. This technique is especially useful for photographs of moving objects and other scenes where you do not have time to bracket, such as in figure 1-22.

HDR PROCESSING

The second aspect of HDR is in software. HDR software such as Photomatix creates high bit-depth images from single (called pseudo-HDR) or multiple lower-depth exposures. After that, you tone map the HDR file to bring out details and create (or avoid) artistic effects. HDR software is specifically optimized for this purpose and automates much of the process. You don't have to create complex masks, use blending modes, or vary the opacity of different image elements to achieve your purpose. After saving the tone-mapped file as a JPEG or TIFF, you can further post-process the photo with your favorite image editor prior to distribution.

A completed HDR file is shown in 1-23. It was taken from three bracketed photos which were merged into HDR, then tone mapped to create the look you see here. Notice that the sun is in view. This should cause the camera to underexpose everything else, resulting in dark shadows or silhouettes. However, details on the facing side of the arch and in fact the rest of the photo are clearly visible. This is the power of HDR. You can retain more detail in your photos, are able to shoot in a wider range of lighting conditions, and craft your final product to suit your artistic tastes.

ABOUT THIS PHOTO This was taken at a street festival a couple of years ago. The flash wouldn't perform so HDR was used to bring back some of the detail in these dancer's dresses and the sky. (ISO 100, f/4, 1/200 second, Sigma 24-70mm f/2.8 at 24mm) © Pete Carr

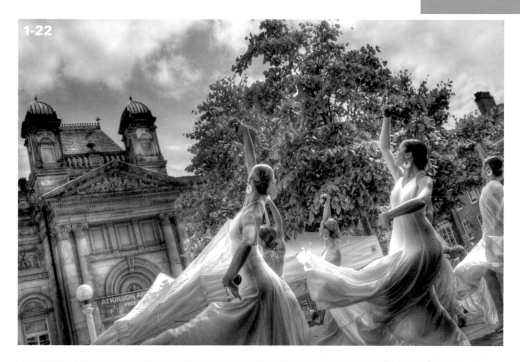

ABOUT THIS PHOTO The largest Chinese Archway in Europe is located in Liverpool, England. With HDR processing and bracketed exposures, shooting directly into the sunset can be done without sacrificing the detail in the arch. Created from three raw photos bracketed at -2/0/+2 EV (ISO 200, f/6.3, 1/125 second, Sigma 10-20mm f/4-5.6 at 18mm) © Pete Carr

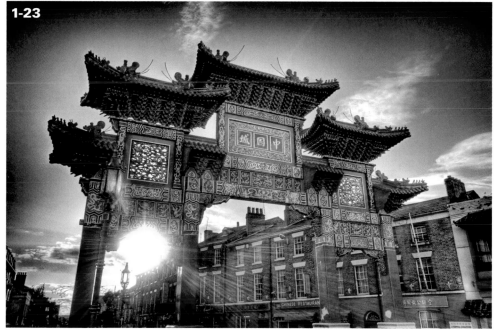

Assignment

Photograph a High-Contrast Scene Traditionally

This chapter has given you a lot of information about dynamic range and digital photography. Now it's time to become personally involved in the process. Grab your camera and complete this assignment to investigate the effects of limited dynamic range for yourself.

Find an interesting high-contrast scene. It should have a good range of shadows and highlights. Make it a challenge. It can be indoors, outdoors, or some creative combination of the two. Although you may want to experiment with filters, flash, or other exposure techniques, shoot at least one photo relying on the camera's inherent dynamic range to capture the scene to share. Try and take the best photograph you can, and note where you are making compromises.

Robert took this photograph on a bright sunny day from within a gathering pavilion at a local park. The challenge in this situation was trying to strike the right balance between interior and exterior exposure. This photo represents an average exposure, which compromises both extremes. Interesting interior details such as the wood grain within the pavilion are lost in shadows, and although the exterior doesn't look too bad, the play equipment, grass, and sky suffer because of the glare. Taken at ISO 100, f/11, 1/15 second, Sigma 10-20mm f/4-5.6 at 10mm.

© Robert Correll

Remember to visit www.pwassignments.com after you complete this assignment and share your favorite photo! It's a community of enthusiastic photographers and a great place to view what other readers have created. You can also post comments, read encouraging suggestions, and get feedback.

© Pete Carr

Photography is about capturing light with your camera. The unique characteristics of the subject, scene, and photographic purpose, however, suggest or may even dictate specific tools for the job. You don't see photographers shooting long-distance shots of wildlife in Africa using macro lenses. Nor do you typically shoot nice wedding portraits with fisheye lenses.

HDR photography is no different. You capture light with your camera using the tools of the trade. The only HDR-specific tool is the software required to convert bracketed photos to high-bit HDR files, which are then tone mapped. Therefore, if you are a landscape photographer with all the gear, you're primed to start shooting HDR. If you are an amateur photographer with a semipro dSLR and kit lens, you can start out, too.

This chapter covers a variety of gear that will enable you to take photographs and transform them into HDR according to your creative vision — from cameras to lenses, tripods, and filters. You also get a brief introduction to the different software packages that make HDR possible.

FOCUSING ON THE PHOTOS

Before getting to the gear, it is wise to start with the big picture. Photography in general — and HDR in particular — are activities that require a specialized set of equipment, the knowledge to use it, and the money to buy it. It is not an endeavor without cost and complexity. Time is also a factor. You need time to learn and time to practice and grow.

HDR expands the working palette of a photographer. As you become more experienced with HDR you will notice your perceptions become tuned to different aspects of a scene. You become consciously aware that the creative possibilities are larger than with traditional photography. You

will be looking for high-contrast scenes and lighting conditions that you may have given up on before. Even if you shoot in the same conditions, your expectations of what the finished product can look like will be dramatically altered.

For example, the scene in 2-1 would have been tremendously hard to shoot and impossible to present this way without HDR. As it was, ISO was set to 200 to increase sensor sensitivity so a faster shutter speed could be used. This ensured the photo would not be blurry. HDR made it possible to see details in several areas: the brightness of the ship without blowing out the highlights, the drama of the clouds without losing details in darkness, and glimpses of the city in amazing detail in the background. All areas of this complex scene are enhanced with HDR to produce a stunning photo.

CAMERA TYPES

Much like regular photography, you have several camera choices when it comes to HDR. The two that have the most HDR potential are the digital SLR (dSLR) and digital compact (excluding the fully automatic models). The dSLR provides you with the best optics through interchangeable lenses, sensor size and quality, internal processing power, and functional control, while the digital compact is generally easier to use and costs less.

> **note** Paradoxically, some camera features tend to diminish as you move up in quality and price. Think of it this way: A high-end dSLR is supposed to do one thing exceptionally well — take pictures. Don't expect to shoot videos and be able to call your friends from it.

If you plan to pursue HDR beyond using single exposures, you must look for a camera that lets you control aperture, ISO, and shutter speed manually.

ABOUT THIS PHOTO *Amazing late-afternoon light in Liverpool hits the Queen Elizabeth 2, the clouds, and the water to create a stunning photo. (ISO 200, f/8, 1/320 second, Sigma 10-20mm f/4-5.6 at 10mm) © Pete Carr*

2-1

THE DSLR

The letters dSLR stand for digital single-lens reflex. The digital SLR is based on the traditional SLR design, which became very widespread and popular as a 35mm film camera. SLR describes how the camera works. Within the body of the camera there is a mirror that bounces the view coming into the lens up into the viewfinder. Therefore, you see exactly what the camera is seeing through the lens when composing and evaluating the shot. When you take the photo, the mirror moves out of the way and light exposes the camera's sensor. It is a brilliant design.

One of the other strengths of dSLRs is the ability to change lenses. Due to the modular design that separates the body of the camera from the detachable lens, you can purchase general-purpose lenses for every occasion or highly specialized lenses for specific purposes such as the wide angle. Most dSLR lenses are also compatible with filters.

The digital SLR is the camera of choice for HDR photography. The image quality of the dSLR is nothing short of stunning. The latest dSLRs feature amazing image quality and are able to shoot at high ISO settings with little digital noise.

COMPACT DIGITAL CAMERAS

Compact digital cameras are small and light-weight, with a built-in lens. They usually have a fairly decent zoom lens built in and an LCD screen on the back. In some respects the screen is similar to the viewfinder on the dSLR. You basically see what the camera sees, and the screen is easier to use and much larger than the tiny viewfinders common to compact digital cameras.

Generally, there are four types of compact digital cameras. They are:

- **Fully automatic.** These cameras have a basic zoom lens. Zoom in and out and take the photo when it looks good. That's it. These are not very suitable for HDR photography.

- **Auto with manual controls.** These cameras are a step up from the fully automatic, with a better zoom lens and fully manual controls. You can enter the world of photography fairly inexpensively and have control over your exposures.

- **Bridge camera.** These cameras look like a dSLR but don't have the ability to interchange lenses. They have decent optical zoom ranges (the Canon PowerShot SX10 IS has a digital zoom of up to 20x) and feel good to hold. The bridge camera should also have fully manual controls.

- **High-end compact.** The high-end compacts are the photographer's compact. They have full manual controls, high ISO range, and perhaps a wider than normal lens. They may have Auto Exposure Bracketing (AEB, which is discussed in detail later in this chapter) capability and should have raw support. There are few high-end compacts, but they are growing in number.

The Canon G10 is about the best compact digital camera you can buy. It is high end, has raw support, and good ISO performance for a compact.

CAMERA FEATURES

A camera's features are very important in determining whether it will meet your needs and be a good platform for pursuing HDR photography. Price, however, is not the best way to measure a camera's ability to shoot HDR. Investigate the specifications of any cameras you are interested in fully before committing to make the purchase.

SHOOTING MODES

Fundamental to shooting multiple-exposure HDR is the ability to control exposure from the camera. You have to be able to manually control aperture, ISO, and shutter speed, even if you plan to rely on auto bracketing. Control comes in the form of shooting modes that range from auto to fully manual, and sometimes creative. The two most important modes to have are:

- **Aperture priority.** Locks the camera's aperture to the setting you designate. The camera then automatically changes the other parameters (shutter speed and sometimes ISO) to make the correct exposure. For example, if you set the aperture to f/8, you lock that in and the camera does not change it to shoot the photo. It adjusts the shutter speed to capture the best exposure.

- **Manual.** Manual mode allows you full control over the camera. You use Manual mode to bracket. You set the ISO for the general conditions, then the aperture, and finally adjust the shutter speed to get the exposures you want. This is manual bracketing in a nutshell.

 note Shutter priority mode is not discussed here because it locks shutter speed and varies aperture, which is somewhat pointless in HDR. You want to keep depth of field, therefore aperture, constant across multiple bracketed shots.

AUTO EXPOSURE BRACKETING

Auto Exposure Bracketing, or AEB, is one of the handiest features to have. HDR does not require it, but it makes capturing multiple, bracketed, images for HDR extremely easy. If your camera has an auto exposure bracketing setting, using it means you do not have to manually bracket your shots. AEB changes the camera's settings among multiple exposures automatically. It varies the exposures by the amount you determine, often up to +/- 2 EV.

 x-ref For more information on EV, please refer to Chapter 1.

For example, on the Canon EOS 30D you can set the AEB range anywhere from 0 to +/-2 in 1/3 EV increments. If you set it to +/-2 EV, as seen in 2-2 and shoot the three bracketed photos, one will be underexposed by 2 EV, one center exposure (0 EV), and one shot overexposed by 2 EV. Notice the green underscoring beneath the three EVs; this is an HDR bracket of -2/0/+2 EV.

 note Technically speaking, there are many ways to shoot brackets of varying exposures: altering ISO, shutter speed, aperture, flash intensity, and so forth. However, varying shutter speed is the most predictable and consistent (raising ISO would elevate noise levels between exposures).

2-2

ABOUT THIS FIGURE *This is the AEB menu function on a Canon EOS 30D. © Pete Carr.*

SPEED

Shooting speed, measured in frames per second (fps), is the rate at which your camera can take and store photos. Modern cameras are achieving ever-faster shooting speeds, with the new line of Nikon and Canon dSLRs attaining speeds upwards of 11fps. The average dSLR shoots between 3 and 6.5 frames per second.

Outright speed is not as important for HDR as say, sports photography, because you will most likely be taking your time as you set up and bracket your photos. There are times, however, when you want higher shooting speeds — even if you are not shooting action shots. Clouds, for example, move across the sky faster than you may realize (see 2-3). Being able to shoot auto brackets with a reasonably fast fps (5 fps) is very helpful.

 note Shooting with a tripod is usually a big part of HDR, but it doesn't have to be. Street photography and moving cars call for abandoning the tripod. Having a good camera with high fps and AEB help you bracket in these situations.

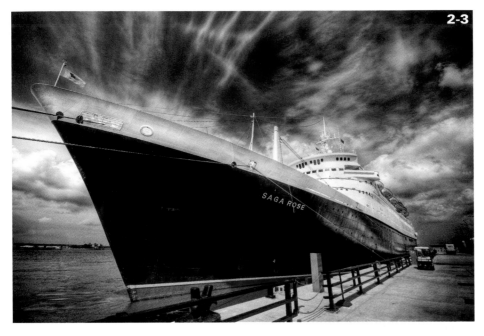

PHOTO FILE TYPE

There are three main file types used in photography: JPEG, TIFF, and raw. All modern digital cameras support JPEG as the standard photo type. Your decision will be whether or not to buy a camera that also stores raw photos for you to manipulate. TIFFs, rarely seen in cameras now, are a high-quality image format that can be used when saving tone mapped HDR files, for example.

JPEGs, TIFFs, and even raw files store EXIF metadata within the file (but out of view) to preserve information such as the camera type, aperture, shutter speed, time, and so forth. When you publish your finished product, strip out the information you don't want publicly disseminated and add copyright and other information you do want to share. Each graphic application has its own routine for accessing and altering file and EXIF information.

■ **JPEG.** The JPEG file (.jpg denotes a specific file) type has many strengths associated with it. It is very common and compatible. It can display millions of colors and can be compressed to minimize file size. JPEGs also store camera metadata such as exposure information in EXIF. As such, it is very commonly used for displaying photographs on the Web.

The downsides to JPEGs are threefold: *lossy* compression, an 8-bit data format, and limited editing choices after the photo is taken. Every time you save a JPEG image it is recompressed, causing a slight loss of data every time — even on the lowest possible compression setting — which is why it is referred to as lossy. An 8-bit file limits your ability to manipulate exposure. JPEGs are essentially "what you see is what you get." If the photo is overexposed, you are limited to about a stop

or so of exposure manipulation to bring it back. The same holds true for underexposed photos. Finally, if you get white balance wrong or oversharpen in camera, you are basically stuck with the camera's decisions.

> **note** JPEG stands for Joint Photographic Experts Group.

TIFF. Data integrity is the primary benefit of using TIFFs (Tagged Image File Format). TIFFs save data in a *lossless* format, which means you can save it over itself repeatedly and not lose any image quality. TIFFs can also be saved as 8 or 16 bits, which means they can store more information than JPEG with greater quality. TIFFs are most often used as interim files in HDR (16-bit TIFFs saved from Photomatix) and for printing.

> **note** Why is raw, raw, and not RAW? Because raw is a word, not an acronym like JPEG or TIFF. Raw is simply raw, or camera raw. There is another file type with the extension and type of "RAW", so we have chosen to go with raw to indicate raw camera data that is stored in different file types with their associated extensions.

Raw. Finally, there is raw. Raw is actually a collection of proprietary file formats, each developed by individual camera manufacturers. Therefore, a raw file may have any one of a multitude of extensions. To name a few, Canon uses .crw and .cr2, while Nikon uses .nef and .nrw. Adobe is attempting to standardize to one raw format, the Digital Negative, or .dng.

One of the major advantages of raw files is that they store data at the camera sensor's bit depth. In other words, if a camera has a bit depth of 14 bits and you save the photo as an 8-bit JPEG, you are throwing away 6 bits of exposure information. With raw files, the data is preserved, which means you have far more flexibility in adjusting exposure in software.

Probably the greatest advantage of using raw files is that most editors (anything by Adobe, for example) preserve the original exposures. In other words, you "edit" a raw file by making changes to exposure, sharpness, color, and other parameters, then save the result as a JPEG, TIFF, or other format. The raw file is not overwritten or changed.

USEFUL ACCESSORIES

You need a camera, of course, but you don't always need a tripod, filter, or automatic shutter release. You'll find that all of the gear listed here can be helpful in certain situations, but you can get by without it if your interest or budget just isn't there. However, as your skills and interest in HDR increase, you may find that any or all of these suggested accessories help you to get a better image.

TRIPODS

The tripod market is huge. There are two main types: the all-in-one and the combination of legs (the tripod) and head (which holds the camera). Each type comes in all sorts of sizes, weights, and materials. Decisions come down to these factors:

- **Size.** Smaller tripods are lighter and easier to carry and may be referred to as backpack tripods. Larger tripods are heavier, harder to carry around, and generally more expensive, but also more stable.

- **Weight.** Weight is a function of size and material. The more expensive tripods are made out of strong yet light carbon fiber.

- **Stability.** Stability depends on material and the quality of the design and manufacture. This is the reason to have a tripod, so don't skimp on stability.

- **Flexibility.** Some tripods do one thing: hold the camera. Others can be set up in different configurations with the legs and center pole out of the way so you can get to within a few inches of the ground.

- **Head.** There are two types of tripod heads: pan and ball. Pan heads are like a television camera mount: you can pan back and forth very easily. They are more prevalent, especially in cheaper models. Ball heads have a greater degree of freedom, are quicker to point, and more agile, but are less capable of linear tracking than pan heads.

- **Cost.** You can spend anywhere from $100 to $1000 on a tripod. The important thing is to know what you need and what will work best for you and your style of photography.

If you already have a compact digital camera you could have some fun with the Gorillapod (see 2-4). This is a fantastic tripod that literally attaches to anything and can be adjusted to set level on most any terrain. The legs bend so you can attach it to a car door, lamppost, or a window sill — almost anything.

ABOUT THIS PHOTO *The Gorillapod can go anywhere and attach to anything.* © Joby, Inc.

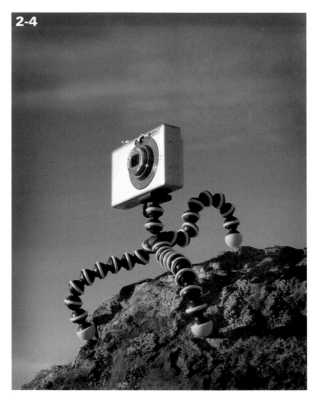

2-4

MONOPODS

Monopods are, as you would imagine, one-legged "tripods". It's like an expandable walking stick or a sailor's collapsing telescope. Touch a quick button release and the leg drops out of its telescoping body to the ground, giving your camera much more stability than if you were just handholding it. Monopods are great for panning or for times when you want to take a bit of weight off your large lens. Unfortunately, they are really not a suitable replacement for a solid tripod in HDR photography. For multiple exposures, you need the camera to be absolutely still. With a monopod there is a chance that you can move side to side or back and forth. For single-exposure HDR — in situations where you are only going to be taking one photo anyway — monopods can contribute to a steady photo.

REMOTE SHUTTER RELEASE

As previously mentioned, one of the key elements of HDR photography is lining up photos. It is important to reduce camera movement as much as possible during the brackets (with AEB or not). Even pushing the Shutter button can cause the camera to jostle from photo to photo. To reduce the chances of this happening, a remote shutter release (2-5) is the best solution because you don't have to touch the body of the camera to take the photo. Using the camera's own timer is another method of keeping the camera steady because you don't have to touch it to take the photo.

> **tip** Keep a tight rein on long shutter release cables, as it is very easy to trip over them and rip them out of your camera. Shorter cables or a wireless/IR remote shutter release work very well for HDR and are a little safer.

ABOUT THIS PHOTO *A remote shutter release for the Nikon D90. © Nikon Corporation.*

2-5

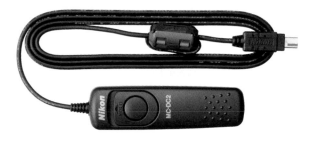

LIGHT METER

Having an external light meter can improve your ability to measure and capture the best exposure for each scene. Light meters (especially high-end models like the Sekonic L-758DR shown in 2-6) are very precise and have a greater array of features than standard in-camera light meters, In addition, if you have a light meter with spot mode, you can take independent measurements of lows, midtones, and highs without having to take your camera off the tripod or alter your composition.

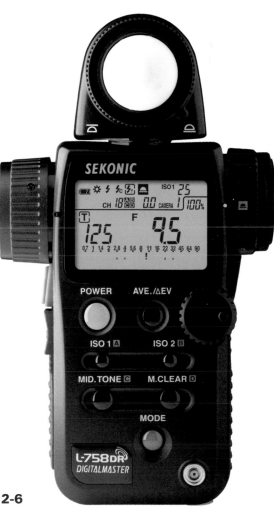

ABOUT THIS PHOTO *The top-of-the-line Sekonic L-758DR light meter helps you evaluate exposure and frees the camera up for taking photos. © Sekonic Corp.*

2-6

FILTERS

Despite software post-processing in applications like Photoshop, filters remain very powerful tools. You have far more creative control when the camera is in your hands and there is no substitute for getting a good exposure at the scene. For example, you can decide to take a shorter or longer exposure with a filter — something impossible for Photoshop to duplicate.

Within HDR, there are three primary types of filters that can help you:

■ **ND (Neutral Density).** ND filters reduce the amount of light that passes through the lens. They come in two types: normal and the graduated (or ND grad). Landscape photographers use ND filters to keep highlights such as the sky from blowing out during longer exposures. For example, a long exposure on a seascape transforms a rough sea into smooth water. This sort of image manipulation isn't possible with Photoshop.

ND filters affect the entire image, which is why graduated ND filters were developed. ND graduated filters transition from ND to clear (see 2-7). Hard ND grads transition from filtered to clear abruptly, while soft ND grad filters have a smoother transition.

The advantage of using an ND grad is being able to selectively darken part of the image. For example, you can darken a sunset so a longer exposure brings out more detail in the ground, as in 2-8.

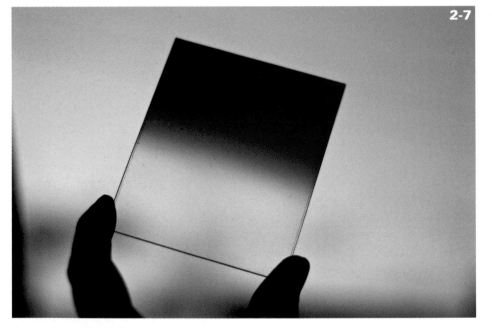

2-7

ABOUT THIS PHOTO
Here is a Cokin P.121 ND graduated filter. © Pete Carr

2-8

ABOUT THIS PHOTO *At a local park at sunset, the ND grad filter retains detail in the sky and brings out more detail in the ground. (ISO 400, f/4.5, 1/500 second, Sigma 10-20mm f/4-5.6 at 10mm) © Pete Carr*

■ **Circular polarizer.** These filters reduce glare caused by reflected sunlight, which can darken skies without darkening landscapes or buildings, as you can see in figure 2-9 where the sky is a deep blue but the building is still bright. These filters can also reduce glare from water and make foliage appear less shiny. In the right conditions they can completely remove reflections from windows.

The best time of day to use circular polarizer filters is during the Golden Hour, and the subject needs to be about 90 degrees from the sun. Rotate the filter and you should see a dramatic change in the sky from a normal blue to a deep blue.

ABOUT THIS PHOTO *The circular polarizer filter darkens the sky without darkening the subject.*
(ISO 100, f/8, 1/160 second, Sigma 10-20mm f/4-5.6 at 15mm) © Pete Carr

■ **Infrared.** Infrared filters are different, fun, and creative. These filters block visible light while passing light in the near-infrared spectrum (normally invisible to the human eye) onto the camera sensor. Fewer people use them today because some camera sensors and lenses block infrared light.

The most common issues you encounter when shooting with infrared filters are a noticeable hotspot in the center of the image, which is fixable with some work in Photoshop, and the exposure time needed. Infrared photography takes longer than normal photography, often in the range of 30 seconds at f/4, but the results (2-10) can be amazing. The trees, bushes, and grass appear white because the chlorophyll in them reflects the IR in sunlight differently than the surrounding areas.

ABOUT THIS PHOTO *This scene, taken with an IR filter, looks like winter in the summer. The colors were adjusted in Photoshop. (ISO 400, f/14, 25 seconds, Canon 50mm f/1.8) © Pete Carr*

LENSES AND HDR

You will surely be pleased to hear that there are no specialized lenses required for HDR. Good lenses are good lenses, and they will take good HDR photos. Cheap plastic lenses with significant chromatic aberrations and distortion will take bad HDR photos.

The key to choosing lenses for HDR is to choose a lens that fits your subject and application. If you want to shoot portraits or street photography, an everyday zoom, prime, and even a wide-angle lens would be appropriate. If you want to shoot a sweeping landscape or cityscape, go for the wide-angle or ultra wide-angle. Do you have a favorite lens? Use it for HDR.

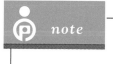

note

This section most applies to those of you who have or are considering buying a dSLR.

Before buying, make sure the lens you are looking at is compatible with your camera's lens mount and sensor size (such as full-frame or cropped, such as APS-C, Four Thirds, and so on). You should also confirm if other features that you want, such as filter size, autofocus capability, anti-shake or other lens-mounted stabilization, and so forth, are present.

EVERYDAY ZOOM

The everyday zoom lens (2-11) is a very common lens among dSLR users because most dSLRs come with this as their stock lens. Everyday zoom lenses have focal-length ranges from between 17mm and 70mm, depending on the model. Thus, they are capable of taking photos that are close to wide angle (the 17-20mm range) and yet they zoom in fairly well, too (60-70mm). This makes for a versatile lens you can carry in your bag and use in a variety of circumstances.

note

Everyday zoom lenses are sometimes called standard zoom lenses, all-in-one zoom, or wide-angle zoom.

2-11

ABOUT THIS PHOTO *The Canon EF 24-70mm f/2.8L is a classic everyday zoom lens. It is perfect for portraits and three-quarter length body shots. It lets in a lot of light and is just wide enough for landscapes and buildings. © Canon USA.*

WIDE ANGLE

Wide-angle and ultra wide-angle lenses (2-12) are where the fun really begins with HDR. They are, of course, perfect for landscapes, cityscapes, and panoramas. In addition, wide-angle lenses work very well for close shots because you can get physically close to a subject and still have a huge field of view.

They are more of a challenge to master, however. They capture such a wide field that exposure can be problematic, even in HDR. Different areas of a scene can have dramatically different lows and highs, resulting in under- and overexposure.

2-12

ABOUT THIS PHOTO *The Sigma 10-20mm f/4-5.6 ultra wide-angle zoom lens is a tremendous lens for HDR. It has low distortion compared to other lenses in the category and is solidly made. © Sigma Corp.*

PRIME

Prime lenses (as most commonly defined) have fixed focal lengths, which means they cannot be zoomed in or out. Primes tend to have a wider

maximum aperture than normal zoom lenses, which improves low-light capability. Prime lenses tend to be sharper and produce smoother bokeh, which is the out-of-focus area produced by a shallow depth of field.

As you might imagine, primes (see 2-13) work very well for HDR.

2-13

ABOUT THIS PHOTO *The Nikkor 50mm f/1.8D is a good, reasonably priced prime lens. © Nikon Corp.*

TELEPHOTO

Telephoto (2-14) lenses are the opposite of wide-angle lenses. They offer an incredible ability to see great distances and are the favored lenses of wildlife and sports photographers. These are the lenses you most often see photographers using (note that they quite often use monopods to support the weight of the lens and help stabilize the shot) during sports events.

MACRO

Macro photography is a very tricky, time-consuming discipline that requires great patience. True macro photography uses specialized lenses with a 1:1 or 1:2 magnification ratio and specialized lighting, not to mention relying on very tiny and often hard-to-control subjects.

 note | Macro lenses are not standard zoom lenses with a macro badge, like the Sigma 24-70 f/2.8. It may say macro but it is not a true macro lens.

ABOUT THIS PHOTO
The Nikkor 70-200mm f/2.8G is powerful and expensive. © Nikon Corp.

2-14

True macro lenses (2-15) may be less suitable for HDR than other types of lenses, but if you already have one, don't let that stop you from trying. Give it a go and share your results with us.

2-15

ABOUT THIS PHOTO *The Canon EF-S 60mm f/2.8 Macro is a true macro lens that can reach 1:1 magnification and can also be used normally. © Canon USA.*

SOFTWARE

As has been mentioned, HDR photography is about more than taking photographs. It certainly starts there, but it finishes within the realm of the computer. This is because no commonly available digital camera currently saves or supports anything other than a standard digital photograph. It may be possible for cameras to combine bracketed photos into 32-bit HDR files in the future, but even then, detailed tone mapping would still take place outside of the camera.

There are three types of software you should be aware of. The first and most important to HDR is HDR-specific software, such as Photomatix. HDR applications generate the HDR and provide robust tone mapping and exposure blending features. Image editors such as Photoshop Elements fall into the second category. These applications are used to further post-process tone mapped HDR files into a final product. Finally, there are raw editors such as Adobe Camera Raw or Lightroom. These applications specialize in converting and editing raw photos, which will be your source images for HDR.

 x-ref Please refer to Appendix A for a handy list of different HDR and imaging software and Web links.

PHOTOMATIX

Photomatix (2-16) is the leading HDR software on the market. While there are a number of other programs around like FDRTools, Photoshop, Dynamic HDR, and so on, nothing has been able to knock Photomatix off the top spot. The software has a variety of options that allow you to choose how far you want to push your images. You can create something nice and natural or go completely crazy turning your photograph into a surreal piece of art. It has a great feature set ranging from image auto-alignment to ghosting reduction to simple exposure blending. You can import images in a variety of formats and export HDR images in both Radiance RGBE and OpenEXR formats.

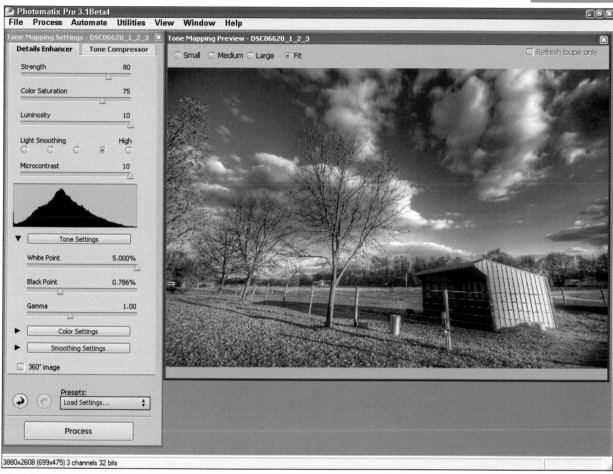

2-16

ABOUT THIS FIGURE *This is the Photomatix Pro 3.1 for Windows interface with tone mapping in progress. © Robert Correll*

> **note**
> Welcome Photomatrix users! Yes, welcome to Photomatix, without the 'r' in matrix. Photomatix is a great name, but is often misspelled or misspoken because our brains insist on putting an 'r' where it doesn't belong. People have gone months or years merrily creating HDR in Photomatrix, not realizing they were actually working in Photomatix. Now on to Photoshrop Elements.

PHOTOSHOP ELEMENTS

Photoshop Elements, shown in 2-17, is the consumer version of Photoshop. It is essentially a stripped-down version of Photoshop, designed for newcomers to the world of digital photography.

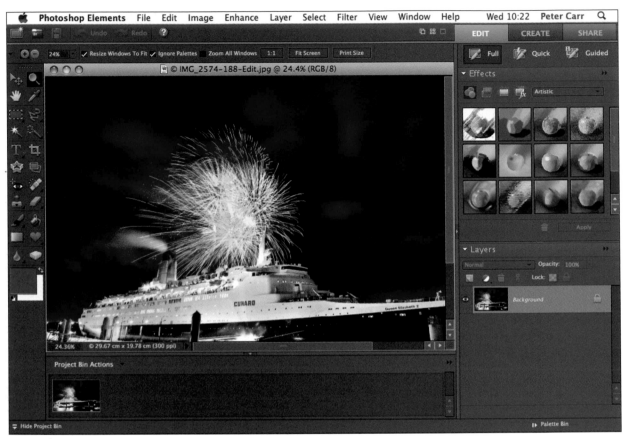

2-17

ABOUT THIS FIGURE *Here is the Adobe Photoshop Elements interface. © Pete Carr*

Photoshop Elements is a pretty solid product with a low cost of entry. The interface isn't as complex or scary looking as Photoshop, nor is the learning curve as great.

It has all the tools you need for basic and reasonably advanced image editing, but does not overload you with features you may not need. It is priced considerably cheaper than Photoshop for this reason.

The biggest challenge when using Photoshop Elements for HDR is the inability to independently create HDR files and limited support for working in 16-bit. Neither problem is insurmountable, but you will be more limited using Photoshop Elements for HDR when compared to Photoshop.

PHOTOSHOP

Photoshop is the industry-standard image-editing program (see 2-18) and has been around for nearly 20 years. Photoshop is widely used in every image-based industry. It is used for Web design, photography, print design, digital artists, and even video now. HDR support was introduced in Photoshop CS2. Photoshop is not specifically used in this book to create or tone map HDR files — it is used exclusively in a post-processing role.

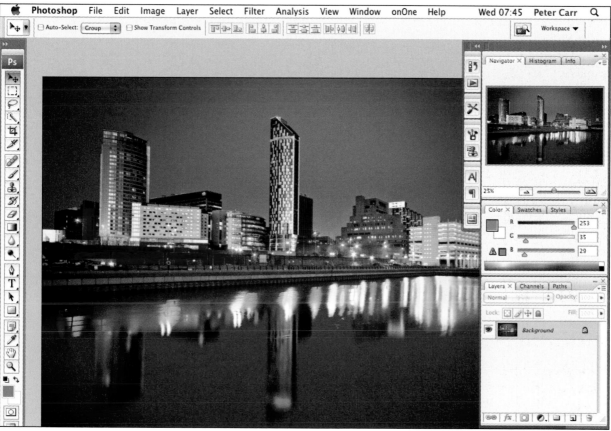

2-18

ABOUT THIS FIGURE *Here is the Adobe Photoshop interface. © Pete Carr*

COREL PAINT SHOP PRO PHOTO

Corel Paint Shop Pro Photo X2 is the main alternative to the Photoshop family, and the interface is shown in figure 2-19. While not as advanced as Photoshop proper, it has proven hugely popular since its release in 1992 and in fact is a very powerful application. The latest version has support for all major cameras, has tools similar to Photoshop, and has a native HDR routine. Unlike Adobe products, Paint Shop Pro is only available for Windows.

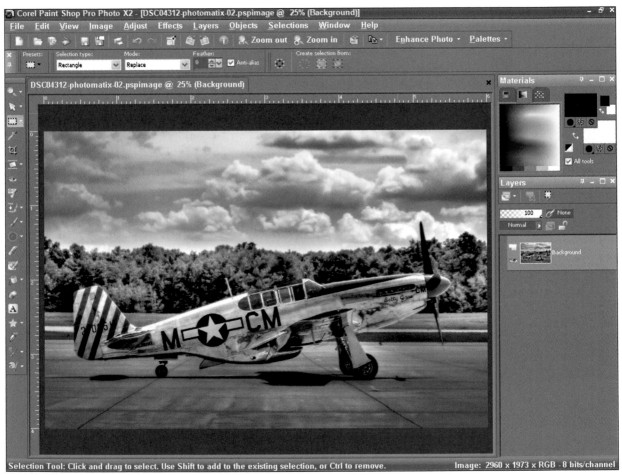

2-19

ABOUT THIS FIGURE *Here is the Corel Paint Shop Pro Photo X2 interface. © Robert Correll*

LIGHTROOM

Officially released in January 2007, Adobe Photoshop Lightroom is Adobe's photography editing program (see 2-20). It differs from Photoshop in that it is a one-stop photo library and editor. It has all the major features needed by professional photographers to do their job without resorting to opening their work in Photoshop. It has a fully featured image library that allows you to easily catalog and control your work. You have the ability to keyword, rate, group, and flag images for enhanced organization. The development side has everything to develop raw, JPEG, TIFF, and PSD files. You can adjust the exposure, white balance, levels, saturation hue and brightness per color channel, and then save these edits as presets to apply to other images later. It has revolutionized the photographer's workflow.

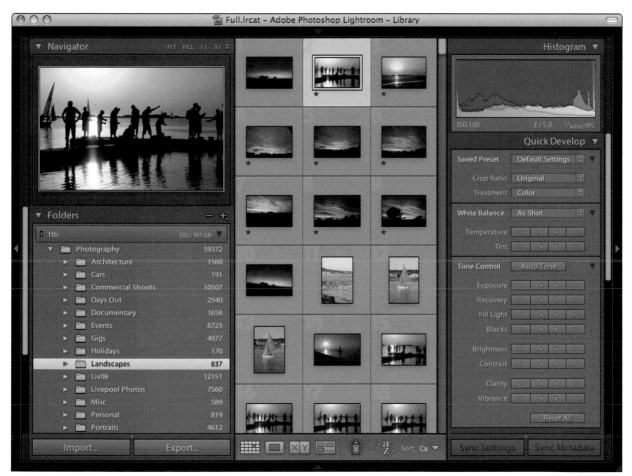

2-20

ABOUT THIS FIGURE *Here is the Adobe Lightroom interface.* © Pete Carr

APERTURE

Aperture is Apple's answer to Adobe Lightroom. As such, it shares many similarities with Lightroom. However, there are some significant differences between the programs. Rather than only being an image editor, Aperture is also a full-fledged digital asset manager. You have the option of assigning library management to Aperture or managing photos yourself. The interface, seen in 2-21, is also very different. You can access metadata whenever you want rather than having to jump back and forth between metadata and development tabs. Aperture also excels at full screen editing.

2-21

ABOUT THIS FIGURE *Here is the Apple Aperture interface.* © *Pete Carr*

Assignment

Share a Photo Using Your Favorite Setup

This is a simple assignment: Go and take the best shot with your favorite setup using all the advantages it can provide.

Pete's favorite new piece of equipment is his Nikon D700. The ISO performance has to be experienced to be believed and the camera has a weather-sealed body that can shoot in almost any weather. It also has a top-notch range focusing system. The Nikon 24-70mm f/2.8 lens can be used for portraits and close-up shots. It has a very useful zoom and the ability to shoot at f/2.8, which is especially helpful in low-light situations. These factors make it a perfect everyday lens. All of these features helped Pete go out in winter weather knowing he could capture it.

The D700's auto-ISO feature and the 24-70's f/2.8 aperture reduce the need for a tripod to stabilize the camera in low-light situations. The camera adjusts the ISO within a specified range while keeping the shutter speed faster than a set threshold to get the best exposure. This removes the worry of the shutter speed dropping too low and blurring the photo. The wide-open lens helps get as much light as possible into the camera.

This shot was taken at ISO 6400, f/2.8, 1/125 second, with a Nikon 24-70 f/2.8 lens at 24mm.

© Pete Carr

Remember to visit www.pwassignments.com after you complete this assignment and share your favorite photo! It's a community of enthusiastic photographers and a great place to view what other readers have created. You can also post comments, read encouraging suggestions, and get feedback.

© Pete Carr

This is an all-important technique chapter: The Art of HDR. This chapter explains how to take your HDR shots and process them. The "and" in the previous sentence is important. HDR is not an activity where all you do is take photographs, nor is it simply a software trick.

On the photography side, HDR involves taking three or more identically composed photos of a scene through AEB or manual bracketing. These photos, preferably raw exposures, should be converted to 16-bit TIFFs before processing in HDR software such as Photomatix, which is where they are combined and converted into HDR and then tone mapped. Later, the resulting tone mapped image can be further post-processed in an image editor such as Photoshop Elements.

When bracketing is impossible, the photographic goal is to take the best single exposure possible in raw. This raw exposure should be opened in a suitable editor where its exposure is manipulated. Three differently exposed brackets are created, which, when loaded into Photomatix, act as if they were taken separately.

HDR STYLES

HDR is a discipline of photography that has practitioners with a wide range of artistic sensibilities. There are purists who believe that photographs should look realistic — an exact rendering of the scene. No problem. You can achieve this using HDR if you tweak your settings down in the artistry department. You will have a little more detail in your photos than a standard JPEG right out of the camera or processed camera raw, but it doesn't have to look overly processed.

On the other hand, there are people who create more artistically oriented HDR. They tend to stress contrast, drama, and atmosphere. The photo in 3-1 is not what you would see from a traditionally processed digital photograph. Its colors are enhanced, the sky is dramatic, and local contrast enhances details on the Superlambananas. This photo has an explosion of details from the central subjects to the ground, sky, clouds, and far background. Clearly, HDR is very well suited to this approach.

Both are equally valid styles, as there are no right answers here. Do what you want with your camera and HDR. Pursue your dreams.

> **note** When you see the term HDR, think of (at least) a three-exposure bracket processed in software. You may have five or seven exposures, but the majority of the time you'll have three. HDR created from a single exposure is often called single-exposure HDR in this book.

SELECTING A SCENE

HDR starts with selecting a good scene to photograph. Not everything is interesting, of course, but good photographers and artists seem to be able to find and capture beauty even in the mundane. For example, the photo in 3-2 is of the tread and bogey wheels of an old tank on display at a memorial. The material is plain and rather drab. After processing as HDR, it is far more interesting. Tone mapping in Photomatix has enhanced the detail throughout the photo. The tread and wheels have a rich and satisfying texture to them. To excel at HDR, your challenge is twofold: to take a good photograph, and to learn how to use HDR to make it better.

3-1

ABOUT THIS PHOTO *This photo was taken at the launch of Liverpool's Superlambanana art installation. HDR from three raw exposures bracketed at -2/0/+2 EV. (ISO 250, f/4.5, 1/1250 second, Canon 24-70mm f/2.8 at 38mm) © Pete Carr*

LIGHT AND TIMING

HDR potential is everywhere. You just have to know where and when to find it. As you know, light is an all-important factor in photography. That's what you're trying to capture. The best time to shoot outdoor HDR photography is during the Golden Hour. This is true in both traditional and HDR photography.

A popular misconception of HDR is that it allows you to take any photo at any time of the day and Photomatix (or the HDR software of your choice) magically turns it into a great photo. Nothing could be farther from the truth. Although HDR gives you greater flexibility in capturing the dynamic range of the scene, good photography principles still apply. In other words, capturing all the bad light does not make it good.

 note Although the best time to work is during the Golden Hour, you can still take good photos at other times, depending on the scene, subject, composition, and weather.

3-2

ABOUT THIS PHOTO *The unusual angle and tone make this photo memorable. HDR brings out the tone and texture of the clouds, metal, and rust. HDR created from seven raw exposures bracketed at -4/-3/-2/-1/0/1/2 EV. (ISO 100, f/11, 1/25 second, Sigma 10-20mm f/4-5.6 at 10mm) © Robert Correll*

During the Golden Hour the light is more diffused; it is softer and warmer. You'll see the following effects, depending on the type of scene you're shooting:

■ **Portraits.** People will have warmer skin tones. There is often a wonderful golden backlight illuminating the scene.

■ **Buildings.** Harsh shadows cast by buildings are reduced and softened. Light shines on buildings from a shallower angle, which illuminates the sides of the building better.

■ **Landscapes.** Benefit from softer shadows and better illumination, which can bring out a more pleasing color palette than the one you find at noon under a harsh, vertical sun.

■ **Black and White.** Warmer tones translate well into black and white and shadows or streaming light rays can be very dramatic. The photo in 3-3 was taken in the morning as the light shone through the trees. Had this been taken at noon, there would be no shadows.

ABOUT THIS PHOTO *This photo was taken in Sefton Park, Liverpool, in the early morning. Amazing light and HDR really helped Pete capture what he saw. HDR from three raw exposures bracketed at -2/0/+2 EV. (ISO 100, f/8, 1/60 second, Canon 24-70mm f/2.8 at 70mm) © Pete Carr*

3-3

LOOKING FOR HIGH CONTRAST

Using the term high contrast is a way to qualify or describe the dynamic range of the scene. A high contrast scene is one that has a dramatic lighting difference between dark and light areas. For example, the yellow fender and gas tank of the motorcycle in 3-4 are bright, and the chrome and sun's reflection are even brighter. This is contrasted with the dark black tone of the tire, the bag, and the back of the speedometer and tachometer. This scene has a great deal of contrast.

You are, of course, seeing the motorcycle after the brackets have been converted to HDR and tone mapped. The settings you chose along the way,

which are the subject later in this chapter, accentuate or hide detail, enhance or minimize contrast, and balance or imbalance the light across the scene.

The fact that HDR excels at capturing high-contrast scenes should tip you off to what you should be looking for. The best HDR is found in scenes with high contrast. Look for deep shadows and bright highlights. You can literally find these scenes everywhere. Urban scenes, country landscapes, street photography, seascapes, your back yard, a park — they all have high-contrast possibilities. Be on the lookout for these sources of light and dark:

- **Shadows.** Clouds cast great shadows, as do buildings and other large objects. Objects between you and the sun create shadows toward you. Late and early light casts longer shadows. Dark colors and materials, whether they are in shadow or not, often anchor the dark end of the contrast spectrum.

- **Highlights.** The sun is the most significant highlight of all, as are reflections off of buildings and water, street or other lights, rays of light breaking through trees, and well-lit brightly colored objects. In addition, light colors and materials can be the source of highlights in the photo.

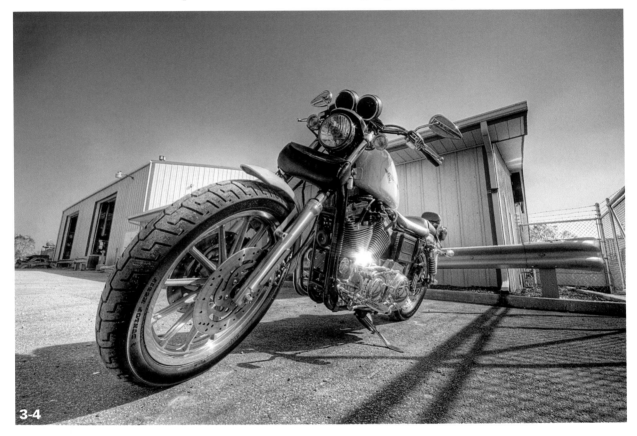

3-4

ABOUT THIS PHOTO *This is a high-contrast HDR shot of a Harley-Davidson Sportster motorcycle. It would have been nice to have fluffy clouds, but the detail and contrast of the motorcycle dominate the scene. HDR created from three bracketed photos at -2/0/+2 EV. (ISO 100, f/8, 1/1000 second, Sigma 10-20mm f/4-5.6 at 10mm) © Robert Correll*

DETAILS

Details make a photo much more interesting. Many times you can see high contrast in even small details. Interesting textures such as tree bark, concrete, wood, and bricks are loaded with highlights and shadows. Smooth objects like chrome, glass, and water often reflect shadows and highlights from other sources.

Urban scenes are great for HDR, in part because of all the details (3-5). Look for places like abandoned warehouses, dockyards, trains, and construction.

ABOUT THIS PHOTO *This photo was taken in downtown Toronto at 1 King West. HDR created from one raw photo converted to three 16-bit TIFFs. (ISO 100, f/4, 1/320 second, Sigma 10-20mm f/4-5.6 at 10mm) © Pete Carr*

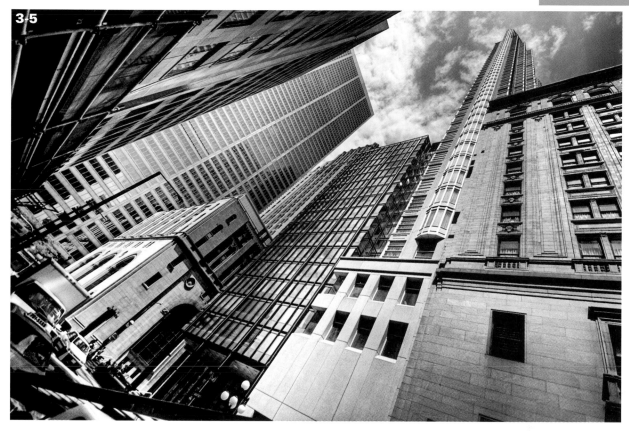

3-5

Downtown cityscapes work well because of the level of detail they contain in the architecture of the different buildings. Take this same mind-set to the country with you. Trees, barns, clouds, fences, and other objects provide much-needed detail in a photo. HDR is not just about photographing inanimate objects. Remember, people and animals have a lot of details too.

x-ref · Photographing people and street photography are two exciting topics covered later in the book, in chapters 8 and 9, respectively.

TRIAL, ERROR, AND PERSISTENCE

It will take time before you can spot these scenes straight off, and time before you get the best from them. Don't worry. The light will return tomorrow. Learn from every photo you take. Keep going out at sunrise or sunset and try different locations. If you like, try shooting at noon and then shoot the same scene during the Golden Hour and compare your results. Shoot directly into the sun and see what happens. Most likely you'll find that it will take more than three exposures to bring out the detail in the scene without the sun looking like a giant white blob. So, change the angle a bit. Hide the sun. Stand behind a tree as in figure 3-6, a sign, or a building.

3-6

SETTING UP

After you select your scene and have an idea of what you want to accomplish, it's time to set up shop. Your primary concern, unless shooting street or more casual photography, will be to stabilize the camera at a location where you can compose the shot and attach any components, such as remote shutter release, flash or filters. Aside from those tasks, you'll put your lens on and remove the lens cap. If you are using a light meter, get it out now too.

If you are shooting street photography or otherwise "on the go," you will want to set up your gear before you move out. You can get everything together and ready before you leave your staging location, whether that is your house, vehicle, or somewhere on location. Having a camera bag with you is handy if you have extra lenses you want to try, and it's always helpful to have something to clean the lens with.

STABILITY

The most effective way to capture multiple exposures that are precisely aligned is to set up your camera on a tripod. Whether you use something high-tech and expensive or use a cheaper model, the point is the same: stability. As long as the tripod supports your gear with no sway or shake, you're set. If you don't have a tripod or didn't bring it with you, use something else to support the camera. A wall, fence, your car, or even rock can work.

> **tip** Consider the wind and the weight of your lens when evaluating whether a tripod will support your gear in a specific shooting situation.

If you have a shutter release cable, connect it. This ensures that your camera remains steady while you take exposures because you don't even have to touch it.

USING FLASH

Flash, often hard to master, can be used in HDR but, unlike more traditional photography, it is more of an emergency feature. Using a direct flash is like shining a flashlight at someone — it can easily produce very hard, artificial shadows. Be careful that you don't end up capturing your own man-made shadows instead of the scene. Indirect flash can help by smoothing highs and lows, but this also lowers the overall contrast of a photo.

If you must use a flash to isolate a subject from the background, highlight additional details, or to even the light of a scene, use as little as possible. By and large, HDR is an exercise in using natural and available light to capture the dynamic range of a scene.

USING FILTERS

Filters reduce the dynamic range of part or all of the exposure, which seems to contradict the purpose of HDR. However, like flash, they allow you to get at more detail in certain situations. As with flash, if you use the wrong filter you may hinder rather than help your efforts.

Here are a few tips if you want to try using filters with HDR:

■ Use an ND filter to darken the sky and leave it on for the other brackets. This can give you more detail and a better photo overall.

■ In very bright conditions, or when the sun is in the frame, your camera may not have a fast enough exposure to keep highs from blowing out. An ND or ND grad filter will help here.

■ Circular polarizer filters can remove glare from photos, which is beneficial even for HDR.

■ Filters can emphasize certain colors or push them one way or another, which could be combined with HDR to produce interesting artistic effects.

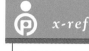 *x-ref* Please refer to Chapter 2 for more information on filters.

CONFIGURING THE CAMERA

With the camera set up nice and steady, with everything attached, it's time to enter the right settings in the camera. The most important settings to lock in are: shooting mode, aperture, auto or manual focus, ISO, and AEB settings.

Always take a close look at your camera's settings before you start, as they hold over from your last shoot. It's a real pain to get yourself dialed in and start shooting, only to realize you forgot to turn auto focus back on. Get into a routine so you are never surprised at the mode you are in or the options you have enabled at the start of every shoot.

tip Check your camera's manual to see if you should turn off your camera or lens anti-shake/stability feature if you are using a tripod or other support.

SHOOTING MODE

Set your shooting mode. For HDR, you're going to need to boss the camera around a bit. You can safely ignore all creative shooting modes on your digital compact or dSLR. Don't use Auto or Program AE modes either, as they don't give you the level of control you need. That leaves three possible modes (if your camera supports them): Aperture Priority, Shutter Priority, and Manual.

note If you are using a compact digital camera, find the mode that gives you the most control over your camera. Very often this is Aperture Priority mode.

- **Aperture Priority.** This locks the aperture. The camera modifies shutter speed to get the exposure. It is the best mode for Auto Exposure Bracketing (AEB) because it ensures a constant depth of field.

- **Shutter Priority.** This can be useful if shooting single-exposure HDR of moving subjects and you need to lock in a fast shutter speed. Ignore this mode if you are bracketing because it will not preserve the depth of field across bracketed exposures.

- **Manual.** You have the most control, but more workload, with the camera set to Manual. Use it as a modified aperture mode and leave the aperture constant. This is the best mode for manual bracketing.

APERTURE

When choosing an aperture, keep in mind the aperture that is best for your photo and work from there. If you want an extended depth of field, as in 3-7, select a larger f-number such as f/8 or higher. Notice that the clouds, buoys in the water, and landscape in the far background — elements of this photo that have detail and generate interest — remain relatively sharp and distinct. This would have been impossible to achieve with a smaller f-number such as f/2.8 or lower.

ABOUT THIS PHOTO *This HDR photo is shown after editing in Lightroom. HDR created from three raw exposures bracketed at -2/0/+2 EV. (ISO 100, f/8, 1/160 second, Sigma 10-20mm f/4-5.6 at 15mm) © Pete Carr*

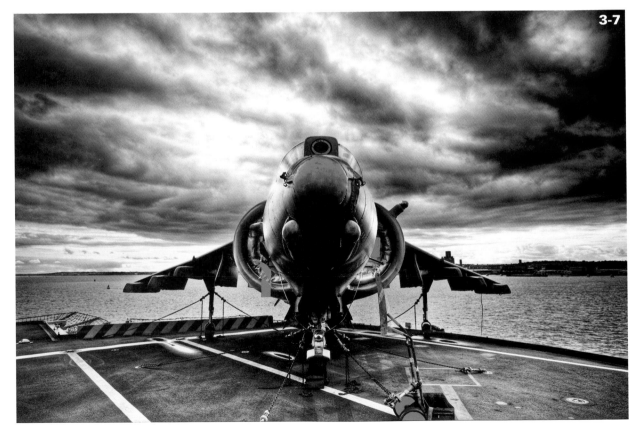

3-7

 note This point bears repeating: If you use the AEB feature of your camera, Aperture Priority will often be best because it guarantees the aperture remains fixed. If you manually shoot the brackets, you'll normally use Manual mode. Consult your camera's manual to see the specific details of how your camera is designed and how AEB works with shooting modes.

In cases where you cannot bracket and must rely on shooting a single exposure, choose the best combination of aperture and shutter speed. The ideal aperture will give you the depth of field that you want and let enough light in the camera so the shutter speed can be fast enough to avoid blurring. Use your raw editor to create brackets from the single source image later. When shooting brackets, you generally have to worry less about the effect of aperture on shutter speed unless you are shooting on a day with moving clouds or other objects like tree branches blowing in the wind. When shooting a static subject, simply choose the aperture that gives you the depth of field you want, and shutter speed will adjust to get the right bracketed exposures.

MANUAL VERSUS AUTOFOCUSING

Don't be afraid to use autofocus for HDR if you use a dSLR. Bracketing photos should not throw off the focus. Digital compact cameras have no other option, so you have to use the autofocus.

There are situations when you can try to manually focus with a dSLR. If you are shooting landscapes and your focal point is far away, set the focus to manual, and turn the lens to infinity. In quickly developing situations such as street photography, set your f-number to f/8 and manually focus on infinity. This creates a situation where you don't have to constantly worry about focus because the depth of field is so large everything you shoot at these distances should be in focus.

ISO

Unlike traditional photography, HDR often uses multiple bracketed shots to capture the dynamic range of a scene. As such, whatever noise you save to file is multiplied by the number of exposures you take. The effects of HDR processing, even on single raw exposures converted to three 16-bit TIFFs, can often add to the noise level.

Use the lowest ISO you can and still get the shot you want, typically 100 or less (if your camera supports a lower ISO), and only raise it if you absolutely have to. Every time you raise the ISO the sensor doubles its gain to simulate twice as much light hitting it, which doubles the noise, at some point causing your images to look grainy and dirty.

As always, you are in creative control. If you need to shoot at a higher ISO, do so with the knowledge that the image will be noisier. The photo in 3-6, whose brackets were shot as ISO 320, is just such an example of the tradeoff involved. The overall photo is very nice, but if you zoom in on the sky or clouds, you will see noise. This can, of course, be combated with noise removal in later processing, but it is much nicer to not have to remove it in the first place.

AUTO EXPOSURE BRACKETING

In AEB mode, the camera automatically changes the aperture or shutter speed by a given exposure range (measured in EV) across at least three photos. This results in one photo taken at the exposure you have set, plus at least two photos which bracket the central exposure point on either side by the exposure range.

AEB is beneficial in any situation, but only really necessary when you need to shoot your brackets quickly (moving clouds are a prime example of this). AEB allows you to work at the speed at which your camera can take photos — normally a few seconds or less for three photos — as opposed to the amount of time it takes you to change settings manually, without moving the camera, and shoot another bracket.

If your camera has an AEB option and you want to use it, set it now. AEB can be found in the camera settings menu for most dSLRs and many compact digital cameras. Setting the exposure range to +/- 2EV is a good place to start.

Not all cameras allow you to set a range of +/- 2EV. You may be limited to a much smaller range of +/- 1.0EV, +/- 0.7EV, or even +/- 0.3EV. If so, check to see how many brackets you camera can shoot. If, like the Nikon D700, you can shoot seven or nine photos separated by 1 EV each, you will be able to capture a wider dynamic range (+/- 7-9 EV total range) than a camera which can only shoot three photos, each separated by 2 EV (+/- 4 EV total range). If your camera is less capable, you may have to manually bracket in order to get a wide enough EV range.

Set your camera's drive mode (also called release mode) to Continuous shooting if you want to take your three brackets very quickly. Just hold the Shutter Release button down and the shots quickly fire off. If you want to take the photos more casually, leave it on Single shooting.

tip Some cameras allow you to enter timer mode while using AEB and the camera automatically takes three shots in sequence. Make sure to read your manual and understand how to enter and use all the modes necessary or advantageous for HDR photography.

METERING

Metering is the camera's way of assessing the luminance of a scene to determine the proper exposure. Your metering goal should be to find the best possible exposure for a single photo or the center, or 0 EV, bracket.

FINDING THE BEST EXPOSURE

The most natural method is to approach metering as you ordinarily would. In other words, try to take the best photograph. Quite often, the best metering results are achieved through Average metering, but always check this with test photos. If Average metering doesn't suit the subject and lighting, switch to Partial, Center-weighted, or Spot and keep trying.

After deciding how to approach photographing the subject, check your camera's meter and make sure it's perfectly exposed — reading 0EV — and then bracket or take a single exposure.

ALTERNATE METERING STRATEGY

An alternate strategy is to use a light meter to check the lows and highs in a scene, then determine a manual bracketing strategy based on picking up the exposure endpoints. This might involve taking 3, 4, 5, or more shots to capture the entire dynamic range of the scene, as opposed to standard AEB and manual bracketing where you generally take three shots. You should still evaluate the best overall exposure and take one photo at that point. This is a labor-intensive approach and is not normally necessary unless you are in situations of extreme contrast where standard brackets are not sufficient to capture enough of the dynamic range of the scene.

x-ref | For more information on metering, see Chapter 1.

TAKING THE PHOTOS

Now that you've selected a scene, set your gear up, entered camera settings, and evaluated the exposure, it's time to take the photos. Recompose the scene if necessary and take a few test shots to make sure everything is okay. You may decide to use a filter depending on what you see. Make any aperture adjustments and final exposure settings. At this point, you're ready to take the exposures for HDR through a process called bracketing.

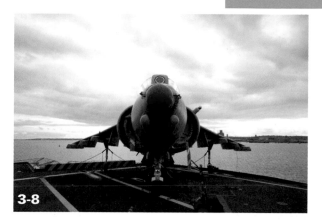

3-8

note | This section covers bracketing, which is a central but not exclusive method of shooting HDR. There are times when you cannot shoot brackets and must rely on shooting a single raw exposure. Those procedures are covered in depth later in this chapter.

AUTO BRACKETING

You should know what AEB is and what it does by now. When you're in AEB mode and ready to shoot, it's simple. Press the Shutter Release button on the camera or the remote shutter release. If you're in single-shot mode, press the button three times. If you are in continuous drive mode, you should count off three exposures and stop. That's your three photos ready to create the HDR (see 3-8 to 3-10).

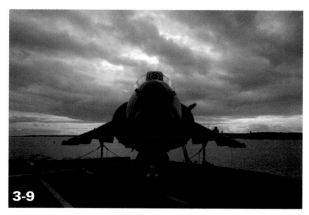

3-9

You can take more than one set of bracketed photos, either by adjusting the center exposure for another round of AEB or continue by manually bracketing.

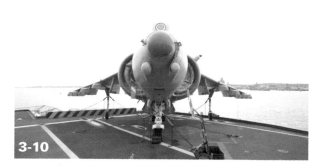

3-10

ABOUT THESE PHOTOS *These bracketed exposures were taken on the HMS Illustrious. 3-8 is exposed at 0 EV, 3-9 is underexposed by -2 EV, and 3-10 is overexposed by +2 EV. The final HDR image created from these brackets is shown in figure 3-7. (ISO 100, f/8, 1/160 second, Sigma 10-20mm f/4-5.6 at 15mm) © Pete Carr*

MANUAL BRACKETING

Alternatively, if your camera doesn't have AEB, or the AEB feature doesn't have a wide enough exposure range, you can bracket manually. Set the camera to manual single-shot mode and evaluate the exposure with the built-in or an external light meter. Make sure that you are set to take an exposure at 0 EV.

Take the first photo, which will be the center bracket at 0EV. Adjust the shutter speed manually to -2EV and take another shot. This is the low end of the bracket — the underexposed photo. Finally, adjust the shutter speed so the exposure reads +2EV, and take the final shot. This is the upper end of the bracket, or the over-exposed shot.

PROCESSING PHOTOS INTO HDR

You've taken the photos, gotten them onto your computer, and are ready to start the second half of what constitutes HDR photography: software processing. You have to use specific software to create high bit-depth HDR files that contain the entire dynamic range of the scene you shot from your source photo or photos. You then tone map the HDR file, a process where you intelligently guide the large dynamic range into a smaller space that is suitable for editing, viewing, printing, and disseminating.

The list of possible software options and their pros or cons is discussed in Chapter 2, with Photomatix a strong frontrunner. The first step in this part of the process involves processing the camera raw files and then converting them to HDR.

PROCESSING RAW PHOTOS

You could go directly into Photomatix or Photoshop with the three bracketed photos and start the HDR process, but doing so surrenders the strength of dedicated raw editors such as Adobe Camera Raw, Lightroom, or Apple Aperture. These applications were written to process camera raw files — that is their strength, and it is wise to use it. Your results will be sharper and better.

Load the images, one at a time, into your favorite raw editor, keeping the settings as close to default as possible. If there is an obvious white balance issue, correct it in each photo. Export the images as 16-bit TIFFs, if possible, in order to retain all the information from the original raw photo. Downgrading to 8 bits at this point removes much of the dynamic range hidden in the raw photo.

> **note** If you are processing 8-bit JPEGs rather than raw, you can skip this step and start with Converting to HDR.

GENERATING HDR IN PHOTOMATIX

Although you can perform this step in Photoshop (not Photoshop Elements), Photomatix provides excellent facilities to create HDR files, complete with several powerful options. You need to be working with the bracketed raw, JPEG, or just processed TIFF files, the latter being the most preferable. These are the basic steps to follow:

1. **Launch Photomatix.**

2. **Generate the HDR Image.** Mac users should choose HDR ⇨ Generate. Windows users click Generate HDR Image in the floating Workflow Shortcuts window. A dialog box appears that asks that you select the source images.

3. **Load the images.** Find the images you want to work with, select them, and click OK to get them loaded into Photomatix.

> **note** If there is a problem and Photomatix can't figure out the EV spacing of the images, a dialog box appears asking you to sort things out. For example, if you've accidentally selected duplicate exposures (this can sometimes happen with lots of photos), cancel and start again. Alternatively, you can set the EV spacing yourself or manually change it if you must. Otherwise, things should go smoothly.

4. **Select the options you want to use.** After the images load, you see the Options dialog box, as in 3-11. You have to make several decisions here. The options are:

> **Align source images.** This is almost always a good choice, even if you use a tripod. It is also wise to keep the image uncropped, as you can always crop later in the process. This is not necessary if you are using brackets created from single raw exposure, as they are already aligned.

> **Reduce chromatic aberrations.** Select this option if you notice purple fringing or other evidence of chromatic aberrations. These areas most often appear along the borders between contrasting areas.

> **Reduce noise.** This is optional. You can use your processing application's noise-deduction features or try this one. There are very good third-party noise reduction filters such as Noiseware which you can purchase and use instead.

> **Attempt to reduce ghosting artifacts.** Ghosting occurs when leaves move or if someone is walking around while you take your photos. Photomatix can try and reduce this but the results are not miraculous. Ideally, you want to keep in-frame movements at a minimum on-scene. This is not necessary if you are using brackets created from single raw exposure, as there will be no movement between frames.

> **Tone curve.** Leave this option as is if your photos have a color profile associated with them. This should be the case with TIFFs and JPEGs, whether they are taken directly out of most cameras or processed through a raw editor. For raw images, this option should be grayed out, because raw images do not have tone curves.

3-11

ABOUT THIS FIGURE *This is the Photomatix first option screen.*
© *Pete Carr*

5. **Generate the HDR.** Click Generate HDR (Mac) or OK (Windows) and wait for the result to appear on-screen. Depending on the bit depth of the originals (JPEG versus raw and TIFF), the number of brackets, their size in megapixels, the extra options you've chosen, and, of course, the speed of your computer, you could be waiting a moment or two or much longer. You will eventually see your HDR image. It will look horrible, as shown in 3-12. Don't worry — the HDR file you're looking at has 32 bits of information per channel and your display cannot handle this range.

6. **Save the HDR file.** Choose File ➪ Save As to save the HDR as an .hdr file now. You can return to Photomatix in the future and load this HDR file to start a new tone mapping session. This saves time because you won't have to re-generate the HDR and is very helpful if you want to quickly run through multiple tone mapping sessions to test out different settings and save the resulting files.

Congratulations. You've created an HDR image that is ready to be tone mapped. That's where the real magic of HDR happens.

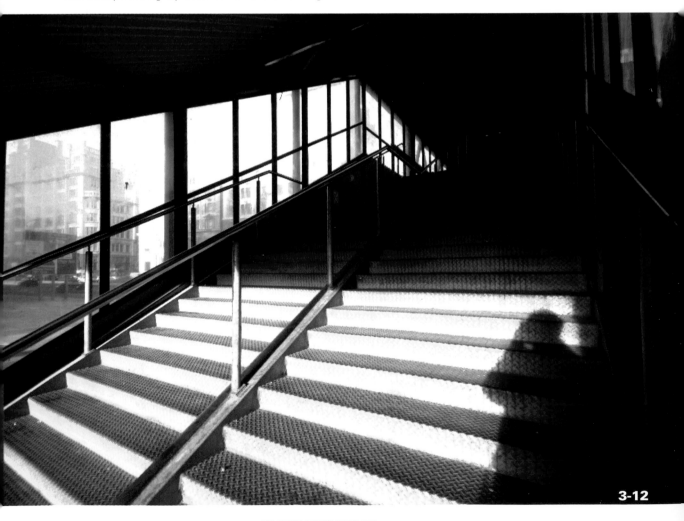

3-12

ABOUT THIS PHOTO *The HDR image after its first pass through Photomatix. © Pete Carr*

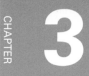

TONE MAPPING IN PHOTOMATIX

Tone mapping is the process of compressing the data contained in an HDR file into something you can see and work with on your computer. The HDR image has a potential contrast ratio of 4,294,967,296:1 compared to 256:1 for a JPEG file. That's quite a range.

If you are on a Mac, choose HDR ⇨ Tone Mapping. Windows users should click the Tone Mapping button in the HDR Viewer window that appears after you have generated or loaded an HDR file. After selecting Tone Mapping, a Tone Mapping Preview window appears that contains the image with a Tone Mapping Settings window that contains all the controls you will be using

(see 3-13). The preview window shows the effects of the tone mapping settings. Use it to evaluate the changes that you make.

This is it. This is a large part of the challenge of HDR right here. You've got all the power of Photomatix at your fingertips in the settings window just waiting to be unleashed.

> **note** Feel free to experiment with the Tone Compressor, which has simpler options and relies on a different set of algorithms (pixel and global image characteristics). You can achieve some fantastic results here as well — bordering on the realism achieved in fine art — but the focus of this book is on the Details Enhancer.

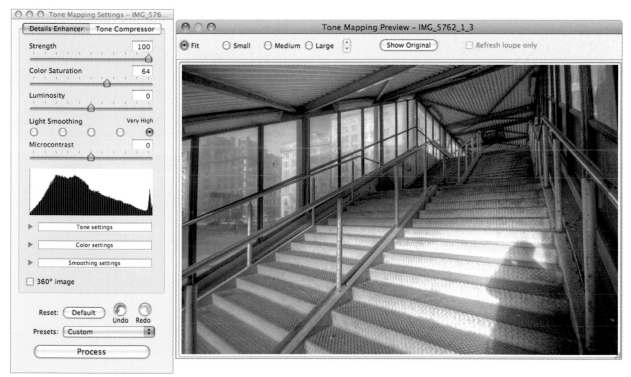

3-13

ABOUT THIS FIGURE *This is the Photomatix Tone Mapping Settings window.* © Pete Carr

At the top of the Tone Mapping Settings window are several global settings to the Details Enhancer:

- **Strength.** This controls the strength of the contrast enhancements, both locally and globally. It should be noted that increasing the strength can also increase the noise.

- **Color Saturation.** This controls the color saturation (think color strength, from grayscale to pure color) in the image. Although you can lower Color Saturation to create a grayscale image, the best time and place to do this is after tone mapping in your image editor.

- **Luminosity.** This controls the compression of the tonal range, which has the effect of adjusting the global luminosity level. Positive values increase shadow detail and brighten the image. Negative values give a more natural feel to the image. Luminosity is very helpful in balancing the light and dark areas of the image so neither one predominates.

- **Light Smoothing.** This controls smoothing of light variations throughout the image. Light smoothing is a source of much artistic discussion. Lower settings have a distinctive look but can leave halos around objects, which often look artificial. Higher settings are preferred if you want to avoid this.

- **Microcontrast.** This sets how much local details are accentuated. Higher settings can make the image appear more contrasted and bring out details.

Below these options is a histogram of the image, and below that there is a box with three arrows pointing to different types of adjustments: Tone, Color, and Smoothing. Each of these, in turn, has a few options you can adjust.

x-ref For more information on creating black-and-white HDR, see Chapter 7.

The Tone setting options are:

- **White & Black Point.** Tone mapping compresses the image down from a high-contrast ratio to a more manageable tonal range. These options control the clipping points at either end of this range. Moving them to the right clips the image, increasing contrast. Watch that you don't clip the highlights too much and create overexposed areas or the shadows so much you lose details in darkness.

- **Gamma.** This adjusts the midtone of the image. Moving it right makes the image brighter and moving it left makes the image darker.

The Color settings are:

- **Temperature.** This is similar to white balance. Moving it to the right gives the image more red tones and to the left gives it blue tones. This can be useful for sunsets or when Photomatix creates an image that is too red or blue.

- **Saturation Highlights & Shadows.** This adjusts the color saturation of highlights and shadows relative to the Color Saturation slider. Move it right to increase and left to decrease. Be careful of oversaturation, which can increase noise levels in an image.

The Smoothing settings are:

- **Micro-smoothing.** Higher settings smooth local details enhancements, which can create a more natural look in a photo. This can reduce noise by smoothing it out. If you feel the image doesn't look real, increase Micro-smoothing to produce an image similar to what you may get with exposure blending.

- **Highlights smoothing.** Higher settings smooth highlights, therefore reducing contrast enhancements in them. Use it to prevent highlights turning gray or reduce halos around objects.

- **Shadows smoothing.** Higher settings smooth shadows, reducing contrast enhancements in darker areas of the image.

- **Shadow clipping.** This controls the shadow clipping, which is handy for reducing noise in dark areas of an image taken in low light. Higher settings clip more shadows, resulting in those areas darkening. Don't push it too far or the shadows may look unnatural.

There are so many settings to the Details Enhancer — and they interact with each other in so many different ways — you will spend a lot of time experimenting with different looks.

tip Once you find a combination of settings that work, save those settings as a baseline using the Presets drop-down list at the bottom of the Details Enhancer section of the Tone Mapping Settings window. You can also choose to save settings every time you save a tone mapped image. Load and apply these settings to other images and make adjustments to customize each individual photo. For photos that do not look right, you may find it helpful to start from the default settings.

When you are happy with the look of your photo, click Process. This applies all the tone-mapping settings to the high-bit HDR photo and produces a product suitable for further post-processing.

Save the resulting HDR-processed file as a 16-bit TIFF. This preserves the highest-quality file, which can be manipulated and ultimately converted to a more suitable viewing format.

TONE MAPPING EXAMPLES

The large number of settings within Photomatix Pro's Detail Enhancer can seem overwhelming at first. You may wish to start from a series of good settings you have saved as a baseline, which is exactly what the next example will show.

Figure 3-14 illustrates a good group of general settings that illustrate what HDR and Photomatix do best: blend exposures together to enhance details in shadow without a loss of details in highlights. The settings are shown in their entirety in the list that follows and explained in regard to use.

- **Strength set to 75%.** Setting the Strength to 75% makes the image seem more detailed and contrast is added to the photo.

- **Color Saturation set to 60%.** Raising Saturation above the default setting adds more color to the image.

- **Luminosity set to +5.** Luminosity is increased to get an even exposure. In other words, the highs are nicely balanced across the image with no blown areas. If there are blown areas, drop the White Point down to compensate.

- **Light Smoothing set to Very High.** Light Smoothing is raised to keep the image looking natural. Lower settings increase the chance that it will begin to look very unnatural.

- **Microcontrast set to 0.** 0 is the default setting. You can adjust this on an individual basis to accentuate details.

- **White Point set to 1.** Increasing the White Point increases highlight contrast.

- **Black Point set to 1.2.** Increasing the Black Point increases shadow contrast.

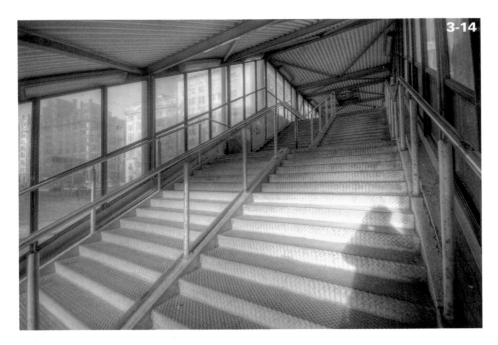

3-14

- **Gamma left at 1.** 1 is the default setting. The image does not need lightened or darkened.

- **Temperature left at 0.** 0 is the default setting. There are no color temperature problems in this photo.

- **Saturation Highlights left at 0.** 0 is the default setting. The saturation level of the highlights looks fine.

- **Saturation Shadows left at 0.** 0 is the default setting. The saturation level of the shadows looks fine.

- **Micro-smoothing left at 0.** 0 is the default setting. This photo does not look overly processed or noisy, so Micro-smoothing is not necessary. It is not so unrealistic that this needs to be increased.

- **Highlights Smoothing left at 0.** 0 is the default setting. The highlights do not need smoothing.

- **Shadows Smoothing left at 0.** 0 is the default setting. The shadows do not need smoothing.

- **Shadows Clipping left at 0.** 0 is the default setting. The shadows do not need to look darker in this image.

Figure 3-15 shows the effect that the Luminosity setting, set to -10, has on an image. The light here is not as balanced as in 3-14 and the result defeats the purpose of HDR. There are no details in the shadows that extend up the steps.

The difference is more dramatic when you compare 3-15 with 3-16. They have almost exactly the same settings except that Luminosity has been raised to +10 in 3-16. The level of detail in shadow has been greatly increased and the image is better balanced when compared to 3-15. This is

ABOUT THIS PHOTO *Showing the effect of minimizing the Luminosity setting in Photomatix.* © Pete Carr

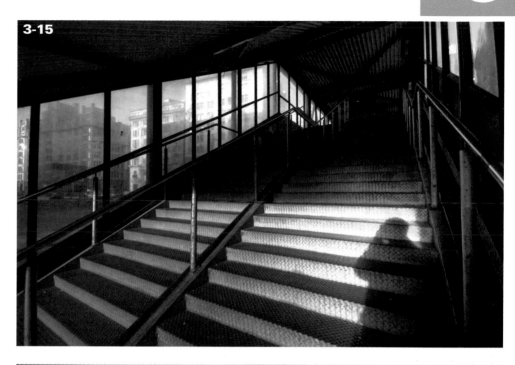

ABOUT THIS PHOTO *Showing the effect of maximizing the Luminosity setting in Photomatix.* © Pete Carr

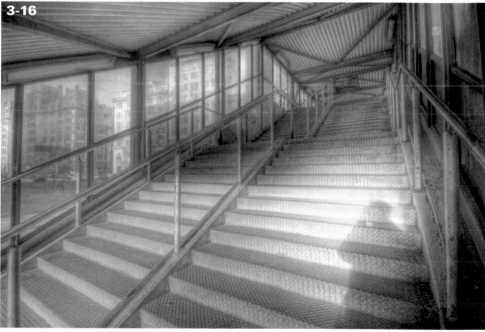

why it is normally best to keep Luminosity above 0. If the image looks washed out (as it does here), lower Luminosity until it starts looking better, which should be about +5. In this case (3-16), raising Luminosity to its maximum has created an image that has too much detail and not enough contrast.

In the next example, 3-17, Light Smoothing has been set to Very Low. Other than that, all the settings are the same as 3-16. The effect is huge — and bad. The structure is tinted blue and there is a halo around everything, most noticeably the silhouetted figure. In general, setting Light Smoothing to anything other than Very High will cause these sorts of problems.

ALTERNATE PROCESSING PATHS

The preceding section illustrated one path to this point: creating an HDR file from bracketed photos and then tone mapping that file using Photomatix. This section very briefly discusses how to create HDR using three other popular applications.

ABOUT THIS PHOTO *The image now shows the effects of reducing Light Smoothing to Very Low. It is a dramatically different image that seems quite plastic — more noise, harsh light, and extreme local contrast. If this is your artistic vision, go for it, but it is not a very faithful interpretation of the actual scene.* © Pete Carr

CHAPTER 3

PAINT SHOP PRO PHOTO X2 AND HDR PHOTO MERGE

Paint Shop Pro Photo X2 has a very capable feature called HDR Photo Merge that allows you to create 16-bit tone mapped files from bracketed photos. The options are sparse — you are limited to Brightness and Clarify — but it works well.

To generate HDR in Paint Shop Pro, follow these steps:

1. **Choose File ⇨ HDR Photo Merge.** This opens the HDR routine, which is seen in 3-18 with images loaded, options, and settings in place.

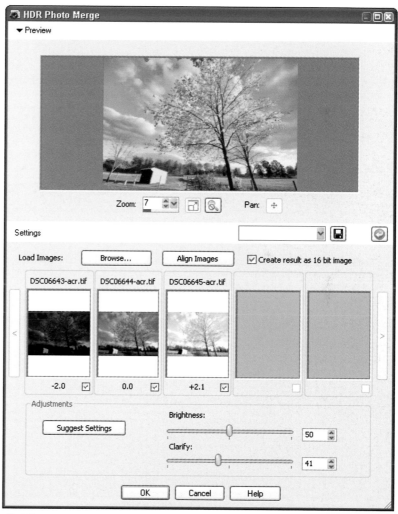

ABOUT THIS FIGURE
This is Paint Shop Pro Photo's HDR Photo Merge dialog box.
© Robert Correll

3-18

2. **Click Browse and select the bracketed photos from your computer that you want to use.** Choose two or more standard JPEGs, unprocessed raw, or TIFFs to create the HDR image. They will be prepared by Paint Shop Pro and loaded into the HDR Photo Merge dialog box. You will see the EV of each photo below its thumbnail and a preview of the tone mapped result at the top of the dialog box.

3. **Choose your options.** Click Align Images to align source images, select the Create result as 16-bit image option to create a 16-bit image as the result of the process, and if you want to remove a photo from processing, deselect the check box underneath the image.

4. **Make any adjustments.** Click Suggest Settings to see what Paint Shop Pro Photo suggests are good settings. Otherwise, adjust Brightness and Clarify to taste.

5. **Click OK to finish.** This opens the resulting tone mapped file into Paint Shop Pro Photo for saving and further processing.

MERGE TO HDR IN PHOTOSHOP

Photoshop has a feature called Merge to HDR that takes two or more bracketed photos and processes them into HDR. Photoshop, however, differs from Photomatix in its approach to creating HDR images. There are far fewer choices and options.

Once you have your photos, follow these steps:

1. **Choose File ⇨ Automate ⇨ Merge to HDR.** This launches Photoshop's HDR routine.

2. **Browse for and select the files you want to load.**

3. **Leave the Align images option checked and OK.** A new dialog box appears with the separate images on the left, a large preview in the center, and options on the right as shown in figure 3-19.

4. **Set the Bit Depth to 32 Bit/Channel and click OK.** Like Photomatix, what you see next doesn't look very good. That's okay — it is not the final image you work with.

5. **Choose Image ⇨ Mode menu ⇨ 16 Bits/Channel or 8 Bits/Channel.** The HDR Conversion dialog box appears, as shown in figure 3-20.

> **note** At this stage there is not as much difference between converting to 8 or 16 bits as you might think. If you want to save on space, go with 8 Bits/Channel.

6. **From the Method drop-down menu, choose Local Adaptation.** Other available options are Exposure and Gamma, Highlight Compression, and Equalize Histogram, but Local Adaptation works best in most instances and offers more control and artistic creativity. The image on-screen should change and look a bit more natural. The sky and foreground are more nicely exposed.

7. **Set your options.** You have three options to work with here, as shown in figure 3-20:

 > **Radius.** This setting essentially controls the strength of the effect.

 > **Threshold.** This setting defines the area the effect applies to. Higher Threshold settings produce halos on the photo. Ideally, set the Threshold low — between 0.50 and 1.

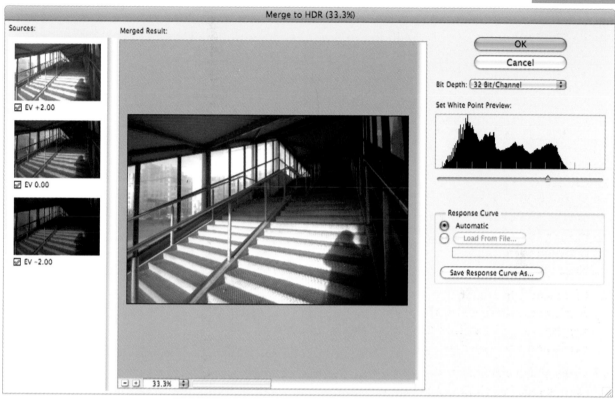

3-19

ABOUT THIS FIGURE *This is Photoshop CS3's Merge to HDR dialog box. © Pete Carr*

> **Toning Curve and Histogram.** If you are familiar with Curves, adjust the Toning Curve and Histogram to add a bit more contrast.

8. **Click OK to convert the image (3-21).** The image is now ready to be saved and further processed in your image-editing application.

3-20

ABOUT THIS FIGURE *This is Photoshop CS3's HDR Conversion dialog box. © Pete Carr*

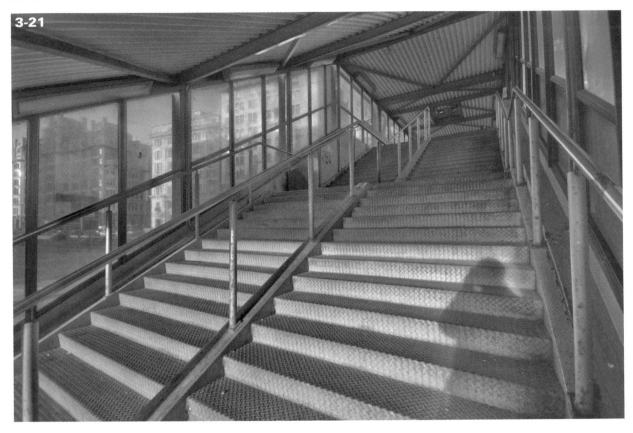

3-21

ALTERNATE APPROACH: SINGLE-EXPOSURE HDR

By now you should have a good handle on shooting and creating HDR images from multiple exposures that are bracketed around a central exposure value of 0EV. There is an alternate approach, which is technically not as effective at capturing as much of the dynamic range of a scene as possible, but is nonetheless valuable and often very effective. This alternate approach is called single-exposure HDR.

x-ref For more information on dynamic range and bit depth, see Chapter 1.

Single-exposure HDR uses one raw file and relies on the fact that raw photos have a bit depth equal to the camera's sensor and processing design. This is normally 12 to 14 bits. As a result, there are several stops of information in the raw file that are irretrievably lost when it is converted to an 8-bit JPEG or TIFF. This is enough room to create pseudo-brackets out of a single exposure. They will not be as effective as actual bracketed exposures, which extend the true dynamic range of the camera, but this is a valid way to access the hidden raw data and process it to maximize the use of the existing range of the photo.

You can open single raw photos in Photomatix and create pseudo-HDR without having to create brackets in a raw editor. There is no way to

predict which one you will like best without trying both techniques. However, converting the single raw to three photos bracketed at -2/0/+2 EV tends to reduce noise and lessens the over-processed feel to the photo. If you want to experiment, try using a single raw photo as a test image to evaluate the HDR potential in the shot. After tone mapping the single image, start over, only create brackets using the steps that follow. Compare the results and decide on your own.

The process to create your bracketed files from the single raw starts with taking the single raw photo and creating three separate exposures: one exposed for shadows, one for mid-tones, and one for highlights. Afterward, use these to import into Photomatix and create the HDR.

Here are the general steps to follow:

1. **Launch your raw editor or image application and load the raw file.** This can be Adobe Photoshop Elements, Photoshop, Lightroom, Apple Aperture, your camera manufacturer's raw software, or whatever else you use to convert raw files to standard TIFFs.

> *tip* Dropping the raw file onto Elements or Photoshop automatically launches Adobe Camera Raw.

2. **Load your raw editor defaults.** How you do this will depend on the raw editor you use. In the case of Adobe Camera Raw, it depends on whether you are using Photoshop Elements (which has basic setting management) or Photoshop (which has many more setting-saving features). The point is to make sure you are working with the default settings so you start with a clean slate. Your primary goal is to process the raw image and convert

it into 16-bit TIFF, not to over process it. Loading the default settings will apply them to the photo.

3. **Save the file as a 16-bit TIFF file.** This is the center of the bracket, containing the mid-tones. Do not close this file. Keep it open for the next two steps.

4. **Set the exposure setting to -2EV and save the file as a new 16-bit TIFF file.** This is the underexposed end of the bracket, containing highlight detail.

5. **Set the exposure setting to +2EV (from the original) and save the file as a new 16-bit TIFF file.** This is the overexposed end of the bracket, containing shadow detail. You now have three new files to work with, each created from the original raw exposure.

6. **Exit your raw editor and open your HDR application.** Load the three TIFF files you just created and proceed to create the HDR as if they were three separate photographs.

Photomatix may have a hard time interpreting the exposure values of your three images because it reads the EXIF information from the files. If this happens, the Exposure Correction dialog box appears as in figure 3-22. Select the correct value (2) from the Specify the E.V. spacing drop-down menu and click OK.

At this point, continue to generate the HDR and then tone map the image the same way you would for any other HDR image.

> *note* You can drop the single raw image right into Photomatix, but you'll generally find the resulting image is noisier than converting the one image to three, 16-bit TIFFs.

ABOUT THIS FIGURE *Use the Photomatix Exposure settings for generation HDR image dialog box to determine correct exposure spacing.* © Pete Carr

3-22

ADDITIONAL PROCESSING

Using Photomatix to create an HDR image and then tone mapping it isn't the final step. You will want to put the finishing touches on your images in further processing. This involves fixing problems such as noise, color balance, and contrast as well as optimizing local contrast and tone through dodging and burning and improving sharpness.

You can use your image-editing application of choice for additional processing. The procedures and results should be similar to those shown here. The point is to use all the tools at your disposal to create the best product you can. Photomatix and other HDR applications excel creating HDR files and tone mapping them. In and of itself, however, tone mapping is not image editing.

REDUCING NOISE

Tone mapped HDR images can be noisy, even if you shoot at ISO 100. Shooting at higher ISOs multiplies this problem. There are ways to reduce the noise as you take your photos. First, use the lowest ISO you can. Second, shoot brackets if possible — at least three photos — rather than a single exposure.

In software, the first line of defense against noise is your raw editor. This is another reason why it is good practice to convert your raw photos into 16-bit TIFFS to process in Photomatix — you have the ability to fix things before you ever get to HDR. Adobe Camera Raw, for example, has two noise-reduction options: Luminance (which is grayscale noise) and Color. The next method of fighting noise is to check the Reduce noise option when generating HDR in Photomatix. Finally, you can use your image editor to reduce noise in your image.

The thing you should be aware of when using any noise reduction routine are:

- **Settings.** Noise reduction filters normally have settings that allow you to set Strength plus other options. For example, Photoshop Element's Reduce Noise filter has three settings: Strength, Preserve Details, Reduce Color Noise, and an option to Remove JPEG Artifacts. Some routines may ask you to set a Threshold, which is often based on a pixel radius.

- **Selectivity.** Raw editors, Photomatix, and the standard noise reduction filters in image editors reduce noise across the entire image by default. If you want to selectively apply noise reduction to limited areas, select the areas with the application's selection tools first, and

then apply the noise reduction. For example, if they sky is noisy, select it first. When selecting an area, make sure you have smoothed its edges so that it blends nicely. In Photoshop Elements, after you have made the selection, choose Select ⇨ Refine Edge to enter Smooth and Feather amounts that will ease the transition from the noise removal in the selected area and the rest of the image.

■ **Native versus third-party.** All of the top image editors (Photoshop Elements, Photoshop, Corel Paint Shop Pro, and so on) have native noise reduction tools. In fact, you may have several options to choose from. Paint Shop Pro has no less than five major tools (One Step Noise Removal, Digital Camera Noise Removal, Edge Preserving Smooth, Median Filter, and Texture Preserving Smooth) to remove noise in addition to other texture and softening aspects. If you aren't happy with any of these, consider purchasing a third-party plug-in such as Noiseware.

■ **Perfection.** No image is perfect, and no photo is absolutely noise-free. Don't fret over not being able to remove every trace of noise in your photos. At times, especially in black and white, some noise can add texture and ambience. Work first at removing the most obvious or distracting noise.

■ **Sharpness.** The cost of noise reduction is often sharpness. Applying full noise reduction to an image can make it look soft because you're smoothing areas of the image to hide the noise. Edges lose their sharpness. With patience, you can find a balance between sharpness and softness that suits your photo. You may also find it necessary to sharpen areas of your photo after you reduce the noise.

CORRECTING COLOR

At times, Photomatix produces images where the color can look a little odd or oversaturated. Sometimes the effect is limited to individual color channels like red or blue. At other times the effect is across all color channels. Approach color problems from the beginning and work your way through the process.

■ **In camera.** Make sure you have the right white balance and no other creative settings enabled that could alter the colors of the scene or oversaturate a color channel.

■ **Raw conversion.** If you need to correct white balance problems, this is the best place because you can move onto HDR/tone mapping with good images. Your raw editor may also offer robust hue and saturation options as well. One word of caution, however; the goal of processing raw for HDR is not the same as processing raw to present the best possible photo. Be careful that your changes do not alter the exposure (which is the point of bracketing) or make one photo of a bracket fundamentally different than the others in terms of hue and saturation.

■ **Tone mapping.** Photomatix has saturation and color temperature controls that affect how color appears in your image. Don't settle for "I'll just fix it in my editor" if you can fix or avoid creating the problem in Photomatix.

■ **Post-processing.** If you cannot resolve the problem using other techniques, you'll have to address it in additional post-processing.

To correct color hue and saturation problems using Photoshop Elements, follow these steps.

1. **Choose Enhance ⇨ Adjust Color ⇨ Adjust Hue/Saturation.** You can control saturation from the Hue/Saturation dialog box (see 3-23).

3-23

3-24

2. **Choose a color from the Edit drop-down menu and make changes.** If the reds are a little too red, select Red from the list and make changes. Move on to each color within the list to correct problems or accentuate certain colors. All the changes accumulate, so you can make a hue change to red and a saturation change to yellow at the same time.

3. **Alternately, leave Master as the default choice in the Edit menu and make Hue and Saturation changes.** These Hue, Saturation, and Lightness changes affect the entire range of colors in the image as opposed to selective hues.

MAKING HISTOGRAM ADJUSTMENTS

There are times when images from Photomatix look a little underexposed and flat. You can fix this in a few different ways. First, try a Levels adjustment on the entire image. You can also select areas to make individual adjustments to them in isolation. The Levels tool is easy to use:

1. **Choose Enhance ⇨ Adjust Lighting ⇨ Levels.** The Levels dialog box appears, as in 3-24.

2. **Analyze the histogram.** You see a histogram of your image, which shows the distribution of lows, mids, and highs, from left to right. Ideally, you don't want the graph to hit either side of the window, as that means you've lost shadows and highlights. In general, you will see the distribution of levels weighted to the left if the photo is underexposed and to the right for an overexposed image.

3. **Make lighting adjustments using the sliders.** To fix a dark area, drag the white triangular slider (at the far right) to the left, which brightens the image. To fix a light area, drag the dark triangular slider (at the far left) to the right to darken it. Extreme settings can produce noise or blow out shadows and highlights.

4. **Make contrast adjustments.** Using the center slider, which controls gamma (or contrast), drag it left to reduce contrast and drag it right to increase contrast. Bunching up the left and right sliders also has the effect of increasing contrast.

Assignment

Photograph a High-Contrast Scene and Apply HDR

Taken as a whole, Chapters 1 through 3 have given you everything you need to both understand and create HDR. It's a lot of information to digest. Now it's time to put it to the test. This assignment is a continuation of the assignment in Chapter 1, where you took a normal photograph of a high-contrast scene. The purpose then was to get you to see how problematic it is to capture extreme highs and lows with one photograph. Now it's about getting out there and shooting for HDR.

Try and re-create the same conditions and circumstances as the photo you took for the assignment in Chapter 1, such as the time of day and location. Follow the workflow presented in this chapter and take three (or more if need be) bracketed photos of the scene. Afterward, take the photos and process them into HDR, and then tone map them in Photomatix. Finally, open the tone-mapped file in your graphics editor and finish post-processing.

Compare the results of this assignment with what you did in Chapter 1. Pay attention to the level of detail you were able to bring out in HDR and the effects of capturing the dynamic range of shadows and highlights of the scene. Make sure to share your results on the Web site. This HDR version of the image in Chapter 1 was created from six bracketed photos at -6/-4/-2/0/+2/+4 EV, taken at ISO 100, f/11, 1/15 second, Sigma 10-20mm f/4-5.6 at 10mm.

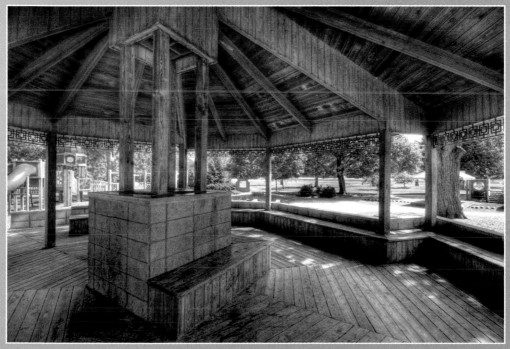

© Robert Correll

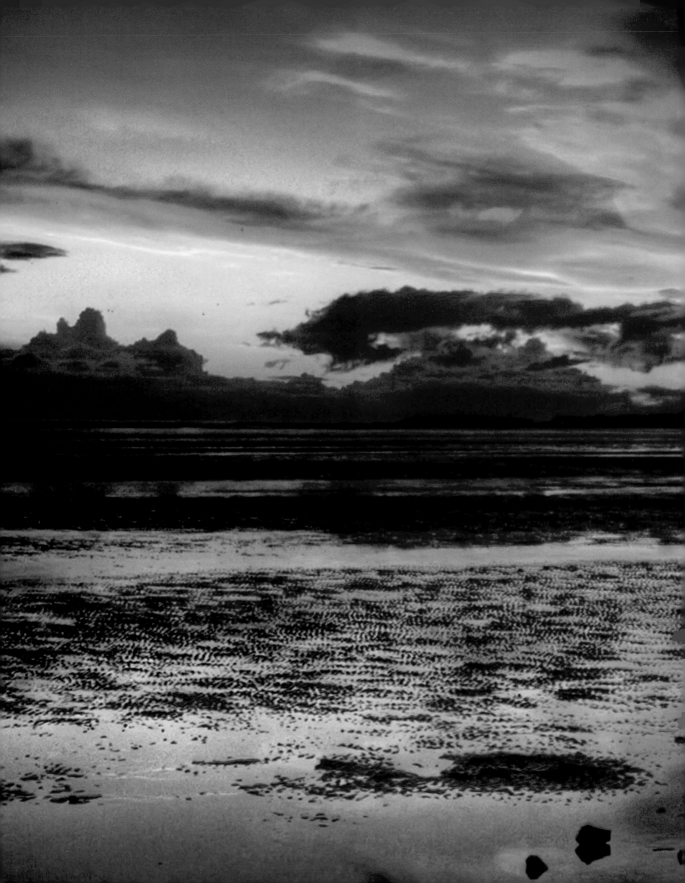

CHAPTER

4

LANDSCAPES

© Pete Carr

This chapter begins the rest of the book. Chapters 1 through 3 covered the theory behind HDR, the gear required to shoot it, and general HDR processing techniques. From here on out you learn how to apply the general principles of HDR in specific situations. It's going to be fun and exciting.

First up — landscapes. Landscape photography, within the realm of HDR, is the study of light and an attempt to bring detail out of high-contrast scenes. Landscapes, by their very nature, are wide open and expansive. They lend themselves well to wide and ultra wide-angle lenses and panoramas.

Don't worry so much about camera settings as you work your way through this chapter. There is a phrase that might help: "F8 and be there." Set your aperture to f/8 (see 4.1) so you have a large depth of field. Carry a tripod or watch that your shutter speed is fast enough to prevent camera shake. And... be there. Enjoy.

4-1

ABOUT THIS PHOTO *This fall farm landscape was shot near sunset. Light cascades off nearby trees and colors abound in this vibrant photo. HDR from four bracketed raw exposures at -2/0/+2/+4 EV. (ISO 100, f/8, 1/100 second, Sigma 10-20mm f/4-5.6 at 10mm) © Robert Correll*

EVALUATING LANDSCAPES

Anyone can go out and take thousands of uninteresting landscape photos. Many capture good photos. Only a few capture great ones. Part of the difference is finding the right landscapes to capture. After that, it comes down to how you evaluate the scene and plan your HDR assault.

BE SELECTIVE

Don't just grab a wide-angle lens and expect to go out and create stunning landscapes in HDR. Wide-angle lenses are good but they can often be too wide. If you get the composition wrong in a photo of a vibrant green field with some old trees arching above and a stunning sky, it can look like two boxes of green with a blue line in the middle. Composition means showing what you want rather than showing everything there is. Be selective.

BRINGING LANDSCAPES TO LIFE WITH HDR

Ideally, you want a fantastic view that has something interesting to say. HDR is best suited for high-contrast scenes. Be on the lookout for amazing sunsets with deep reds, blues, and oranges. Look for clouds, because HDR brings out their glory.

> **note** Rules are meant to be broken. If you have a clear blue sky with nary a cloud, but a very interesting foreground subject, you may still be able to achieve the look you want.

This isn't always possible, however. You may have older photos that you've taken, such as the photo in 4-2. This was captured in Scotland several years ago with no thought of HDR.

ABOUT THIS PHOTO
This photo was taken on the road to Inverness in Scotland. (ISO 100, f/11, 1/45 second, Canon 28-105mm f/3.5-4 at 30mm) © Pete Carr

4-2

The sun is on the other side of the hill to the left and there is no direct light on this scene. There is nothing that makes this photo stand out. One good thing is that there are no harsh shadows and the dynamic range is nice and tidy. That means nothing has been lost. However, it is a rather boring photo. There is nothing contrasting — and HDR allows you to, among other things, increase the amount of visible detail by enhancing contrast.

Because the photo was captured in raw it is possible to rescue it with HDR (see 4-3) years after it was taken.

As you can see, HDR brought out a huge amount of detail. There is more detail in the sky, the ground is clear, and you make out a lot more in the landscape. Now you can actually see what makes this landscape good. There are interesting trees in the foreground to the right. The river leads you up to a lake. There are nice mountains, lots of green fields, and a really good sky to look at. It's a scene you can get lost in.

In Photomatix, Luminosity was set high to balance out the sky and ground. The original photo really needed this because the shot was metered for the sky rather than the ground. Because this did not need to be overly dramatic, Micro-smoothing was raised to reduce noise.

4-3

ABOUT THIS PHOTO *This is the tone-mapped photo from one raw image that was converted to three 16-bit TIFFs. (ISO 100, f/11, 1/45 second, Canon 28-105mm f/3.5-4 at 30mm) © Pete Carr*

ANALYZING THE SCENE

The most effective and easiest way to analyze a scene is called the Rule of Thirds. When you apply this rule in your mind's eye, turn the scene into a grid that looks like a tic-tac-toe board, three squares high by three squares wide.

tip Check to see if your camera has a framing grid in the viewfinder or LCD display. It may be a default feature or you may have to turn it on.

With this grid in mind, place the focal points of the image along the lines and where they intersect (see 4-4). As you can see, Blackpool Tower in England sits perfectly on the left line with the top of the tower at an intersection.

In Photomatix, Strength was raised to bring out the detail in the clouds. It was shot directly into the sun, which had to be cloned out. The amount of detail retained from using HDR is very impressive. Luminosity helped balance the light across the scene and brought out details in the buildings. Micro-smoothing was kept at 0 to keep from losing details in the sky.

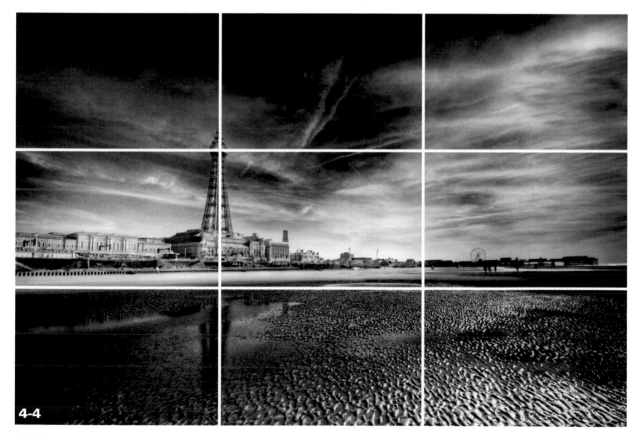

4-4

ABOUT THIS PHOTO *Blackpool Tower in Blackpool, England, lies perfectly on the left hand side of the Rule of Thirds. HDR from three bracketed photos at -2/0/+2 EV. (ISO 200, f/6.3, 1/1000 second, Sigma 10-20mm f/4-5.6 at 10mm) © Pete Carr*

x-ref | For more on black-and-white HDR, please refer to Chapter 7.

Figure 4-5 illustrates the rule without the grid. Most of the elements of this photo (a more complex composition) are generally lined up according to the rule, but not with scientific precision. Nature doesn't always allow this. However, the trees at the top right are situated close to the intersection of the image, along with the large boulder on the bottom left.

Because this photo was intended to be black and white, the settings could be turned up in Photomatix. Any noise issues would be written off as atmosphere and it would work as part of the image. Strength was raised to emphasize drama in the clouds and Luminosity was maximized to balance the light across the shot. This provided a solid foundation for the high contrast black-and-white conversion.

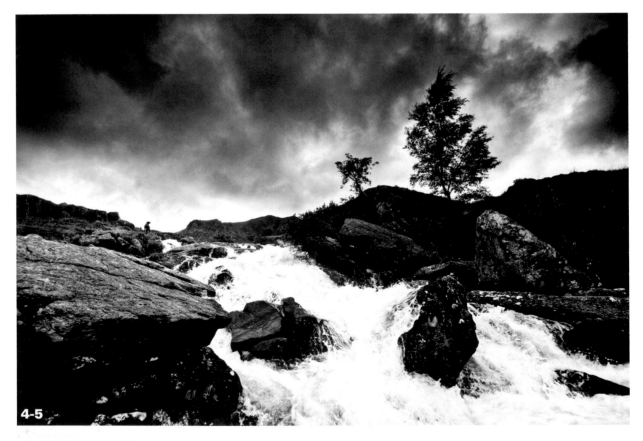

4-5

ABOUT THIS PHOTO *This waterfall in Snowdonia, Wales, helps illustrate the Rule of Thirds. HDR from a single raw exposure converted to three 16-bit TIFFs. (ISO 200, f/6.3, 1/1000 second, Sigma 10-20mm f/4-5.6 at 10mm) © Pete Carr*

LIGHT

Understanding light is a critical aspect of landscape photography. This understanding doesn't come in the box with your new dSLR, either. You have to work to develop it. Reading and studying are an important part of that — soak up everything you can — but you have to go out into the field and practice as well.

tip Read anything by Ansel Adams, the famous American landscape photographer. He was rigorous and methodical. He thought and studied — it was not just a feeling to him. His photographs evoke powerful feelings, but he was the consummate professional in his approach.

The fact is, every landscape is subject to light from the sun, and because the earth rotates, the sun moves across the sky creating different light at different locations throughout the day. Your photographs are birthed into this situation — not the other way around. Therefore, you need to know when to go out and when not to.

SHOOTING AT SUNSET AND SUNRISE

As you read earlier in the book, the Golden Hour (the hour before sunset and after sunrise) is the best time to shoot landscapes. The light is different during these times compared to the rest of the day. The sun is much lower on the horizon and casts much longer, more interesting shadows. The fact that light from the sun has to pass through more of the atmosphere to reach you at sunrise and sunset, compared to when the sun is overhead, changes the wavelength of the light that reaches you. This results in colorful sunsets and sunrises.

Sunrise and sunset are magical hours that can contribute to some of the most stunning images you can take — highlights are tamed, the light is diffused, and the photo appears warmer. Cloud formations, coupled with the warm sunset light, can produce amazing skies, as seen in 4-6.

ABOUT THIS PHOTO
This is sunset at West Kirby Marine Lake, Wirral, UK. (ISO 200, f/6.3, 1/1000 second, Sigma 10-20mm f/4-5.6 at 10mm) © Pete Carr

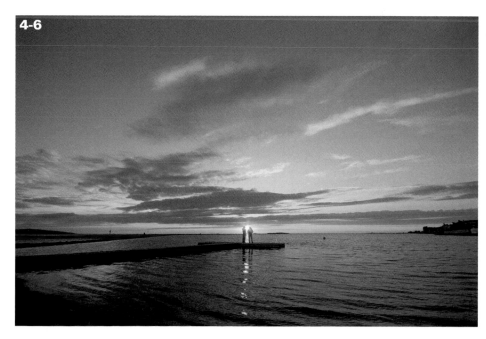

4-6

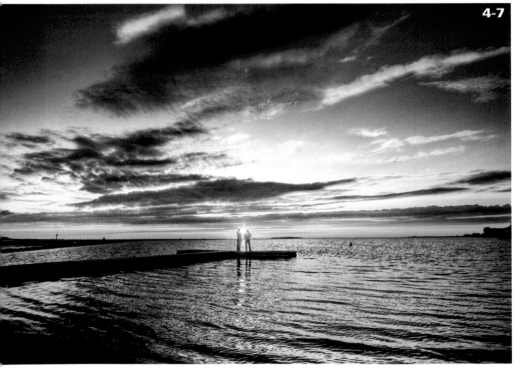
You can see how dramatic sunset light can be. The lovely warm orange tones on the horizon blend nicely into the blues. The same scene from figure 4-6 rendered in HDR accentuates the colors and brings out much more detail in the clouds, the sky, and the water, as you can see in figure 4-7. The HDR was generated from a single raw file so there is a bit of noise, but not enough to take away from the overall impact from the image.

Tone mapping caused a bit of noise in this image, so Micro-smoothing was raised to +2. Noise was greatly reduced, illustrating how large an effect a minor change can have. Strength was set fairly

high, which causes the clouds at the top of the photo to be darker than perhaps they should be, but the image as a whole still works fine.

Looking the other way, away from the sun is just as beautiful during sunset and sunrise because you can catch the sun shining onto clouds and the landscape at the best angles. Figure 4-8 shows the effect of a golden sunset projecting its light onto a landscape.

The sky is particularly dramatic because the light is shining right onto the clouds from close to the side — not from above. The same can be said for the beach and the iron man. The light brings out the details and bathes the entire landscape in a warm orange light. Shadows are also elongated, which can be a powerful visual effect. The bluffs in the distance serve as a focal point for catching the rays of the setting sun.

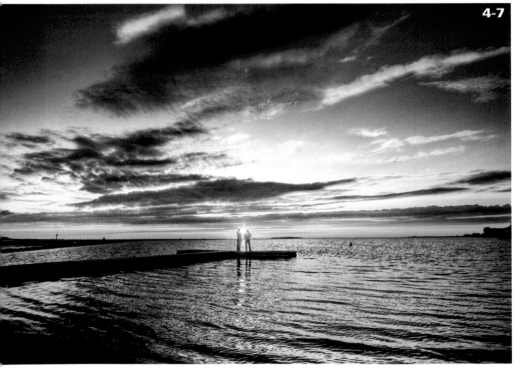

4-7

ABOUT THIS PHOTO
The sunset at West Kirby Marine Lake image has been processed as an HDR photo. HDR created from a single raw exposure converted to three 16-bit TIFFs. (ISO 200, f/6.3, 1/1000 second, Sigma 10-20mm f/4-5.6 at 10mm) © Pete Carr

ABOUT THIS PHOTO *This is Anothony Gormley's "Another Place" at Crosby Beach, Liverpool. (ISO 200, f/6.3, 1/1000 second, Sigma 10-20mm f/4-5.6 at 10mm) © Pete Carr*

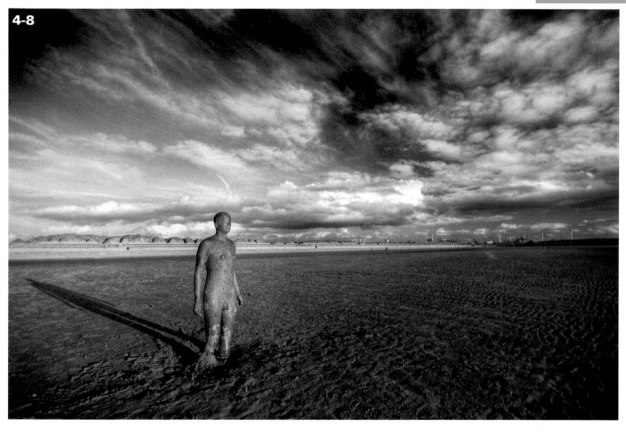

4-8

Because this image is about drama, the main settings in Photomatix were pushed hard. Strength was maximized to bring as much detail as possible out of the clouds and sky, at the expense of some vignetting. Luminosity was also maximized to balance the light and help bring out detail in the clouds. Micro-smoothing wasn't needed, so was minimized. Raising it would reduce detail and drama.

The obvious issue with sunset and sunrise is that you will sometimes be shooting into the sun, which is very bright. This is why the many sunset photos are silhouettes. The camera meters for the sun and reduces the shutter speed and/or aperture to keep the exposure as short and as limited as possible. In 4-9, the sun is quite diffused by the clouds, which makes this shot possible. The downside is that there is no light on the field in this traditional photograph.

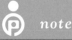 *note* Midday is the worst time of day to be out and about shooting landscapes. The disadvantages to shooting at high noon can be negated by interesting cloud coverage (not solid gray clouds) or intervening objects.

This sunset is still high contrast, however, which makes an HDR interpretation of the same photograph (4-10) work well. There was enough light falling on the flowers to bring them up and make it possible for them to be enjoyed. In Photomatix, Strength was set high to make the sky stand out. Luminosity was also set high to help balance the light between the sunset and the field. A touch of Micro-smoothing helped reduce.

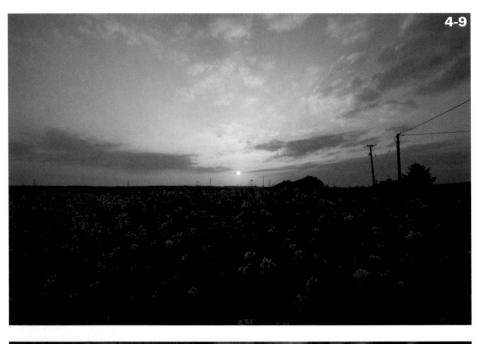

4-9

4-10

Had the sun been situated behind, shining onto the field rather than into the camera, it would have been possible to bring even more detail out of the dark foreground, but at the expense of the beautiful sky.

HAZE

Hazy mornings work much like diffused sunsets. The sun is tucked strategically behind a tree in 4-11 on a hazy early morning, which made it possible to shoot into the sun. Haze, however, can present its own set of problems. Specifically, you have to be on the lookout for halos around objects when shooting in hazy conditions.

While 4-11 is a nice photo, 4-12 shows why HDR is so powerful — and illustrates a powerful way to approach it. Figure 4-12 was processed to bring out additional detail hidden in the contrast of an otherwise good photo. For the most part, HDR lifts a veil off of photos and reveals what is already there. Luminosity and Light Smoothing were set very high, because of the high contrast nature of the scene, to reduce the haloing effect as much as possible. The Strength slider was set high to give the image a nice rich feel.

The haze was compensated for in the HDR version shown in 4-12 by adding a lot more Micro-smoothing in Photomatix, which reduced the overall tone-mapping effect and resulted in a more natural image.

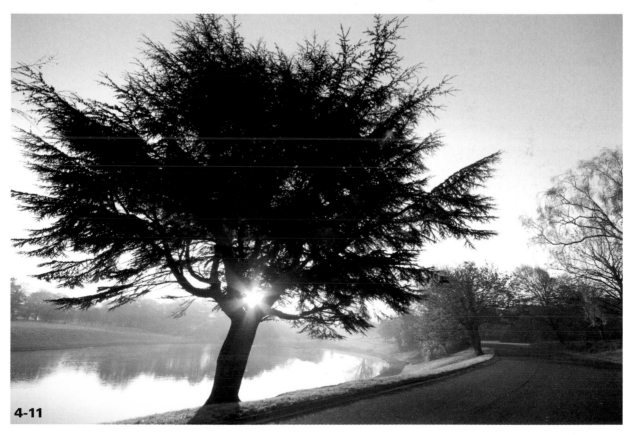

4-11

ABOUT THIS PHOTO *This is sunrise over Sefton Park Lake, Liverpool. (ISO 100, f/9, 1/40 second, Sigma 10-20mm f/4-5.6 at 10mm)* © Pete Carr

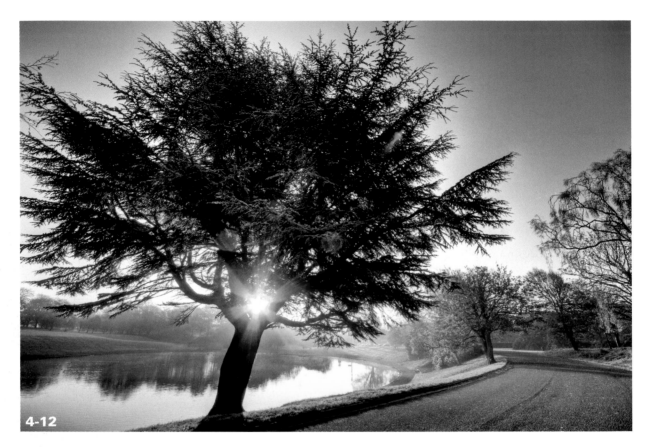

ABOUT THIS PHOTO *This is the tone-mapped image of the sunrise over Sefton Park Lake, Liverpool. HDR created from three bracketed raw images at -2/0/+2 EV. (ISO 100, f/9, Sigma 10-20mm f/4-5.6 at 10mm) © Pete Carr*

WHITE BALANCE

One of the great features of raw editing is that you can adjust the white balance (which adjusts color temperature and tint) after you take the photo. You might be photographing a wedding and you may have misread the scene a little bit, producing a more yellow-tinted image. This can happen in churches due to the candles. Thanks to raw, you can adjust that tint. In Adobe Camera Raw, for example, you can select the White Balance Correction tool, click on what you know is white and the image is adjusted. It's a brilliant feature of the software.

note Not all applications have White Balance controls. You cannot directly edit color temperature or white balance in Photoshop Elements, for example, but must use Remove Color Cast. Although there are many ways to adjust color in Photoshop, none involve adjusting color temperatures. One application that does allow this, however, is Paint Shop Pro Photo, in which you can choose specific color temperatures and tints from the Color Balance dialog box.

You can use white balance (and hence color temperature) adjustments artistically as well as functionally. For example, if you take a photograph of an amazing sunset, but when you look at it on the screen it just doesn't seem as golden as you remember, you can adjust it using the White Balance setting, as in figure 4-13. Here, the white balance was adjusted to produce a photograph with a warmer feel in keeping with the autumn sunrise look. Compare that to 4-14, which was adjusted by dropping the color temperature down

to make the light look bluer. The result is a more wintery look and feel to the image. Both images work nicely and it is simply a matter of taste as to how you adjust your white balance.

Other notable settings in Photomatix included Luminosity, which was set to medium to high for this image. Setting it too high risked reducing the shafts of light in the early morning sun. Strength was set high to bring out more detail and emphasize the beams of light.

COLOR TEMPERATURE Color temperature can be confusing because it is related to white balance and the overall mood imparted by a photo. Technically, color temperature is the temperature of the light source. It is measured in units called Kelvin (K). Color temperature should not be confused with the wavelength of the light emitted, although wavelength and temperature are related. When measuring color temperature, hotter light sources appear blue and cooler light sources appear red. For example candlelight, which humans perceive as having a yellow color, has a color temperature between 1000K and 2000K. Midday sun, which humans perceive as being a colorless white light, has a color temperature between 5000K and 6500K. Shade, which humans see as having a blue tint, measures between 7000K and 8000K.

These light sources should be familiar, as they are White Balance presets in many cameras. Setting a specific white balance in a digital camera helps eliminate color casts in the photos you shoot. For example, when shooting in fluorescent lighting, white objects do not appear white, but often look reddish-orange. Therefore, objects (white objects especially, hence the need to set the correct white balance) are colored according to the temperature of the predominant light source.

The main confusion surrounding color temperature is how it contradicts our association of color with a feeling of coolness or warmth. We label blue as a cool color and associate red with warmth. This is the opposite of their true color temperatures, where blue color temperatures are hotter than red. When editing, you can make your photo appear cooler, which humans perceive as being bluer, when in fact you are raising the color temperature of the light source by altering the white balance.

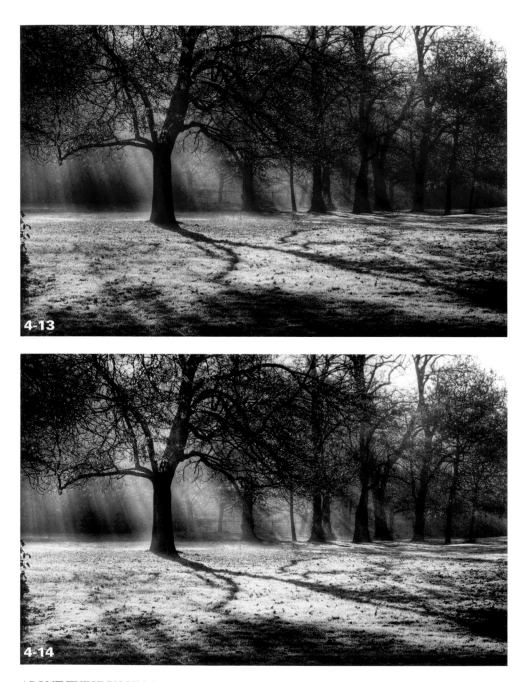

4-13

4-14

ABOUT THESE PHOTOS *Figure 4-13 shows a warmer-feeling sunrise over Sefton Park, Liverpool while 4-14 shows a much cooler-feeling sunrise. (ISO 100, f/8, 1/1600 second, Canon 24-70mm f/2.8 at 70mm) © Pete Carr*

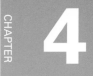

CAPTURING GREAT SKIES

One of the great things about HDR is how it brings out the details and color of clouds, adding drama to a photograph. The incredible details are already there — but traditional photography is often incapable of showcasing them.

The trick to shooting clouds is to be patient enough to wait for them. Notice them. Find them. Shoot them. Sunsets and sunrises often produce stunning scenes with deep reds and oranges reflected off the clouds. These are breathtaking scenes that HDR can enhance by pulling the details.

> **tip** Don't just photograph clouds. Look for a stunning landscape or a story to tell — and then look up. If it is the middle of the day and the lighting is too harsh, try shooting anyway and see what you can capture. Come back closer to sunset and shoot during the Golden Hour for better light.

WORKING WITH CLOUDS AND HDR

When working with HDR, you don't have to bring out every detail in a scene. In 4-15, because the photo is a silhouette, much of the photo's details are in the clouds. They provide a great backdrop to the iron man figure. In Photomatix, Strength was set very high to add detail to the clouds and make them more dramatic. Luminosity was kept medium to high to balance the light and dark areas of the clouds.

Due to the sun's proximity, an overexposed image to bring out details of the iron man wouldn't work. The sun would bleed into the scene, causing a whiteout. Besides, there is a wonderful ambiguity here preserved by the silhouette that leaves you wondering if the man is facing the sun or the camera. The detail in the clouds helps create tension between what you can see and what you can't see.

> **tip** Details. Tension. Story. Ambiguity. These are some of the things you should be thinking about when you take your photographs. Their presence can make a photo of one sunset stand out from another — even if the viewer doesn't perceive it on a conscious level at first. Captivate your audience. Show them something they weren't expecting. Tell them a story they don't know. Don't reveal everything. These factors come into play from composition through final post-processing. Use them to one degree or another throughout your workflow.

CAPTURING WIDE-ANGLE SKIES

Wide-angle lenses offer tremendous advantages when capturing skies. You can tell a larger story because more of the sky fits into the frame, and the sky is one of the largest stories there is. Remember, you can achieve much better results if you shoot during the Golden Hour. It's annoying, yes, that you only get a few of these precious hours each day, but these are generally considered to be the best lighting conditions for many scenes.

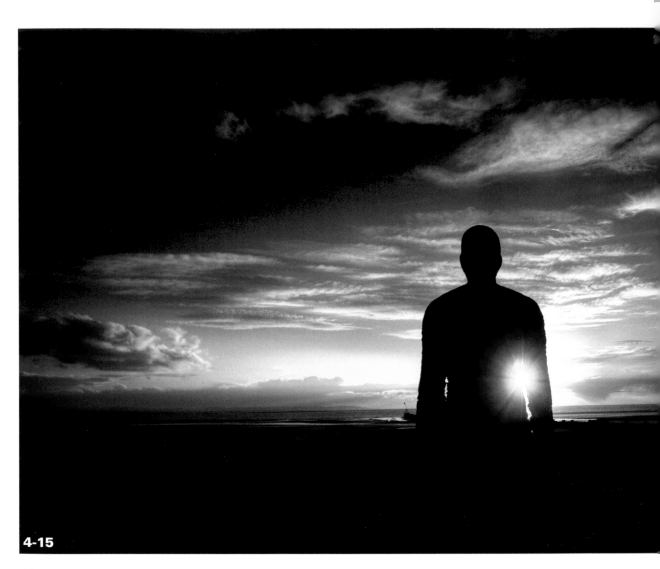

4-15

ABOUT THIS PHOTO *This photo of a sunset over Crosby Beach, Liverpool features Anthony Gormley's "Another Place." HDR from three raw photos -2/0/+2 EV. (ISO 200, f/5.0, 1/250 second, Sigma 10-20mm f/4-5.6 at 10mm) © Pete Carr*

The ideal equipment for capturing clouds and the sky is an ultra wide-angle lens. For cropped-sensor cameras such as the Canon 450D, 50D, or Nikon D40 to D300, the Sigma 10-20mm F4-5.6 is a great lens. For full-frame cameras you want something like the Nikkor 14-24mm f/2.8 or Canon 17-40mm L f/4. These lenses give you an incredible field of view, but are not fisheyes.

An example image of an ultra wide-angle sky is presented in 4-16. It was taken on a ferry between Toronto and Toronto Island using a Sigma 10-20mm lens and produced from one raw exposure. Toronto is a large city and the ferry wasn't that far away, but the lens is so wide the city appears tiny, dwarfed by the sky above.

It was incredibly fortuitous to be photographing the city at the exact time when the sun burst through between two buildings to create the star-like effect. Processed into HDR, the same photo is shown in 4-17. It's a great example of how HDR helps with wide-angle skies. The details in the sky are clearly brought out and the sky as a whole now balances the city below. The sense of drama is palpable.

Because of the very high contrast nature of this scene, and the fact that it was developed from a single raw photo, there was no real chance of getting detail out of the buildings. Therefore, manipulating settings in Photomatix centered on trying to get as much out of the sky as possible. That meant Strength was set very high and Luminosity quite high to balance the brighter areas of the clouds with the sunset. Micro-smoothing was not applied.

tip
Be careful when looking through the viewfinder with wide-angle lenses. Your depth perception is skewed and it can get a little disorienting. Be careful not to walk off a cliff or into a passing bus.

4-16

4-17

WORKING WITH FAST-MOVING CLOUDS

One issue that you may have to deal with is fast-moving clouds. When you shoot three bracketed photos, the clouds move between shots. How far they travel between frames depends on many things: the speed of the clouds, whether you are using AEB or manual bracketing, and how fast your camera is.

Moving clouds can be a problem, but it is a problem that can be overcome. The simplest way is to shoot one raw photo and generate HDR from that single raw image. That way you're only working with one image and you don't have to worry about cloud movement. Another way of dealing with fast-moving clouds is to use their movement to your advantage. Shoot with slower shutter speeds. The effect will be reminiscent of shooting water with longer exposures, which smoothes it.

The example in 4-18 is an example of a quirky art installation that was shot at night, which necessitated a longer exposure time. In this case, the center bracket was a 10-second exposure that allowed the clouds to move overhead and imparted a wonderful sense of movement. It's not every day that you run across a large green rabbit affixed to the tower of an old, unused church.

4-18

ABOUT THIS PHOTO *This rabbit, installed on the tower of St. James Church in Toxteth, was the last of a series of light installations as part of the Liverpool Biennial's Winter Lights program. HDR created from three bracketed exposures at -2/0/+2 EV. (ISO 100, f/8, 10 seconds, Sigma 10-20mm f/4-5.6 at 10mm) © Pete Carr*

The orange, fast-moving sky and strong greens of the grass and rabbit combine to make a memorable photo — one that had to be taken at night to show off the lighting.

Within Photomatix, Micro-smoothing was raised to a medium setting to help create a more natural-looking image. Luminosity was set to maximum to reduce the brightness of the bright neon sign and balance the light across the scene.

CREATING PANORAMAS

Landscapes present unique opportunities for creating magical scenes that don't always fit in frame, even if you are using an ultra wide-angle lens. Panoramas offer a challenging but rewarding solution to this problem.

In one sense, panoramas are simple because digital technology enables us to stitch photos together in software far easier than in the darkroom. However, panoramas shot in HDR, like the one shown in figure 4-19, require a lot more work than even traditional HDR. Not only do you have to line up all the initial photographs correctly, you must bracket three times the amount you would ordinarily. This takes time, and if clouds or other objects in your scene are moving you have to be quick about it. In this case, a 5fps camera and AEB helped speed things along.

In Photomatix, Strength was set almost to maximum, which made some areas of the sky turn black. Luminosity was also set quite high because the conditions weren't perfect, and it helped balance the clouds and ground more. Micro-smoothing was increased just a touch.

4-19

ABOUT THIS PHOTO *This shot of the Liverpool docks was taken from on top of the Hilton Hotel. The panorama was created from three sets of bracketed images each at -2/0/+2 EV. (ISO 100, f/6.3, 1/800 second, Sigma 10-20mm f/4-5.6 at 10mm) © Pete Carr*

TAKING PANORAMIC PHOTOGRAPHS

The setup for taking panoramic photographs essentially requires a tripod, and a remote shutter release is very handy. If your compact digital camera or dSLR has a panorama feature, excellent. Use the on-screen display to line up the next set of brackets with the previous one. Most dSLRs do not have this capability, however, so you have to line up the photos yourself. Ideally, you want an overlap of 20 to 30 percent between each set of images.

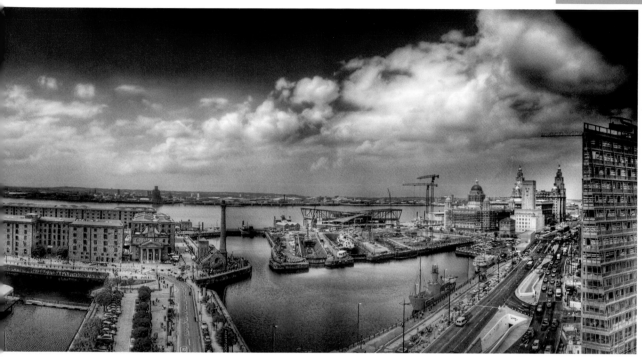

tip | Use the focus points in your camera to line up landmarks.

To get started in creating panorama photos, follow these steps:

1. **Set up your shot.** Get your gear out and ready. Attach the camera to your tripod and attach the remote shutter release, if you have one.

2. **Center and level the camera for the first set of bracketed images.** Frame the center of the scene.

3. **Pan your camera left and right to make sure it doesn't tilt too much.** Ideally, you want the camera level with the horizon as you pan.

4. **Align the camera where you want to start and shoot the first set of images.** Begin with the left or right side of the panorama. It doesn't really matter which. It helps to note your focus points and the objects you want to use to ensure overlapping coverage.

5. **Reposition the camera for the next set of images and continue.** After completing the first series of brackets, reposition the camera (remembering to overlap) and continue shooting bracketed photos along the panorama. Continue this step until you have all the bracketed coverage you want.

This is a fairly straightforward process once you get the hang of it. Shoot brackets, pan, shoot brackets, pan, shoot brackets, done. If you have a steady eye and a firm hand, you may even be able to accomplish it on the fly without a tripod.

CREATING THE HDR

The next step is to convert each frame to HDR before proceeding to merge the left-to-right frames together as a panorama. Creating the HDR first distills the large number of photos with different exposures you have to work with down and ensures a level playing field for stitching the panorama together. This is opposed to creating panoramas from each layer of the bracket and then trying to push the entire bracketed panorama though Photomatix or another HDR application.

Follow these basic steps to create the HDR files that you can then stitch into a panorama:

1. **Convert raw files to TIFF images.** This ensures the best results going into the HDR software.

2. **Load the center frame bracketed images into Photomatix and decide on your HDR settings.** Figure 4-20 shows the center frame of a series of vertical shots for a panorama loaded into Photomatix with the Tone Mapping

4-20

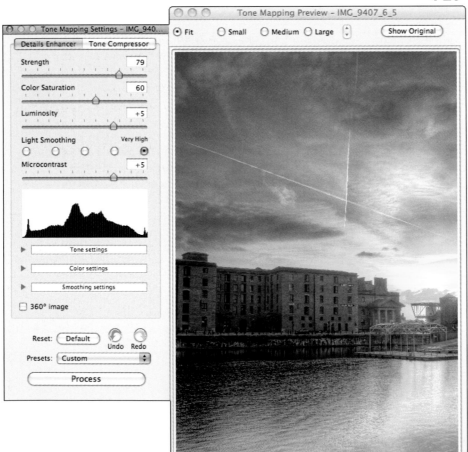

Settings pane open. To bring out the clouds and create a dramatic sky, Strength is set quite high. Luminosity is also set fairly high to bring out detail in the darker areas while retaining detail in brighter areas.

3. **Process and save the result.** Make sure to save the tone-mapping settings with the image so you can use them for the other parts of the panorama.

> **note** Save panorama files as 16-bit TIFF images for the ultimate quality. However, 8-bit TIFFs and JPEGs are smaller and work almost as well in this situation.

4. **Open and view the frame you just processed outside of Photomatix to make sure the look is exactly what you want.** If not, return to Step 3 and tweak the image further.

5. **Process the remaining images that make up the panorama one at a time.** Make sure to load the saved settings each time so the tone mapping will be identical for each frame.

At the end of this process, you will have three or more (the exact number depends on how wide the panorama is and how many images it took you to photograph it) tone-mapped files that are ready to be stitched together to form the completed panorama.

STITCHING THE PHOTOS TOGETHER

Both Photoshop and Photoshop Elements come with a superb feature called Photomerge. It is nothing short of brilliant and takes a lot of effort out of creating a panorama. To stitch your photos together, follow these steps:

1. **Launch Photomerge.** Elements users should choose File ➪ New ➪ Photomerge Panorama. Photoshop users should choose File ➪ Automate ➪ Photomerge. The Photomerge dialog box appears, as shown in figure 4-21.

2. **Click Browse to find and select the tone-mapped HDR images you want to use.**

4-21

ABOUT THIS FIGURE
The Photoshop Elements Photomerge start-up dialog box is where you can select the images you want to merge.
© Pete Carr

3. **Leave the option for Auto selected in the Layout portion of the dialog box.** If you encounter any problems, come back and try the other options, but this is the best place to start.

4. **Click OK.** This starts the merging process. Let it run. After a few minutes, you should see your new panorama. A resulting example is shown in figure 4-22.

4-23

ABOUT THIS FIGURE *Hiding a layer allows you to see a merge point of the photos. © Pete Carr*

6. **Select the Crop tool and draw a crop box within the image in the desired location and double-click to apply the crop.** Some material is clearly lost but you end up with a stunning piece in the end.

7. **Choose File ⇨ Save.** Make sure to save your work.

4-22

ABOUT THIS FIGURE *This is the result of three HDR images (nine original bracketed photos) combined into a panorama created in Photoshop Elements using Photomerge. Notice that it isn't perfect and still needs a bit of work. © Pete Carr*

5. **Hide one of the panorama layers by clicking the eye symbol next to the layer in the Layers palette, as shown in 4-23.** This allows you to see where the layers of the panorama merge together.

As with any other image, you may need to eliminate some noise, clone dust away, make levels adjustments, and dodge or burn. You can convert the image to black and white or add some contrast to give it that final dramatic touch.

The image in 4-24 sums up everything in this chapter nicely: wide-angle skies, dramatic clouds, interesting scenery, shooting into the sun, and panoramic HDR. It shows how all of these elements combine together to produce dramatic effects. The overall cost to create such stunning art is quite low. The location, sunset, and scene? Priceless.

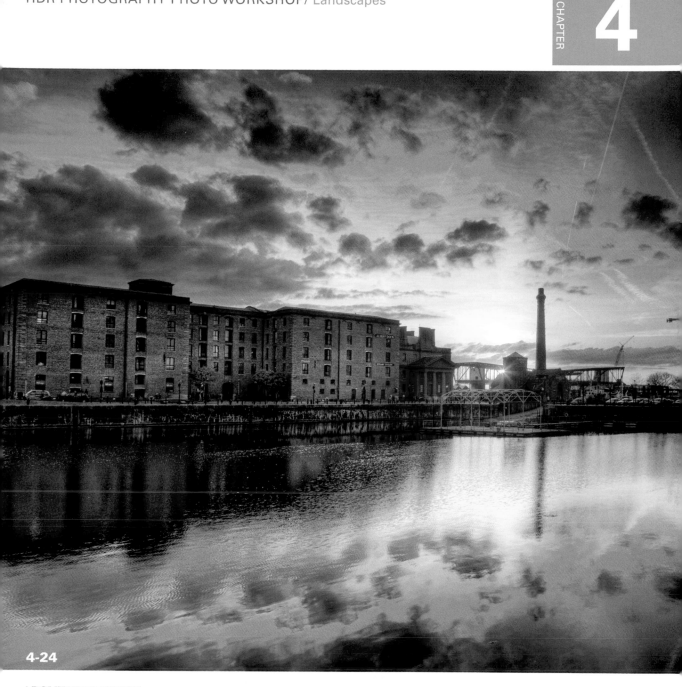

4-24

ABOUT THIS PHOTO *This panorama of Albert Docks in Liverpool was created from six sets of bracketed images (18 total photos) each at -2/0/+2 EV. (ISO 100, f/8, 1/200 second, Canon 24-70mm f/2.8 at 24mm) © Pete Carr*

Assignment

Use HDR to Capture a Landscape at Sunset

Sunsets are a great time of day. Nature puts on a stunning display of color and light. It is incredible stuff.

This assignment asks you to join the club. Go out and be inspired by a landscape at sunset. Travel the world if you need to, but find that inspiration and capture it. Remember to take three or more bracketed photos to blend into HDR. You could even try your hand at a panorama.

Your goal is to apply the knowledge you have learned in this chapter. Maximize detail in shadow, the area that is most often lost in sunsets.

This example shows a local field near Storeton Woods, Wirral, UK at sunset. An idyllic setting; horse riders can often be seen galloping around this area. Three bracketed photos were taken very quickly at 5fps without a tripod. ISO was raised to give a little so that shutter speed could be faster. The original raw image has lost detail in the shadows and looks a bit underexposed. However, by putting the bracketed photos together in Photomatix, the details in the grass and sky are accentuated without causing a loss of detail in either. The sun is a little overexposed, but within acceptable levels.

The HDR image was created from three bracketed photos at -2/0/+2 EV. ISO 200, f/8, 1/160 second, Sigma 10-20mm f/4-5.6 at 10mm.

© Pete Carr

Remember to visit www.pwassignments.com after you complete this assignment and share your favorite photo! It's a community of enthusiastic photographers and a great place to view what other readers have created. You can also post comments, read encouraging suggestions, and get feedback.

110

© Pete Carr

Architecture and cityscapes are the modern landscape. Unlike traditional landscapes, cityscapes are most often a hodgepodge — the accumulation of humanity's ever-changing footprint over many years. When isolated, however, individual structures can tell a singular story.

Buildings reflect many things — the age in which they were built, the character of the builders, and the dreams and aspirations of the community or nation. Buildings can be linear and rigid or flowing and esoteric. Whether new or old, they can inspire us. And, in this chapter, you learn what to look for when selecting buildings and cityscapes to photograph, and how to capture them the best way possible for conversion to HDR.

CAPTURING ARCHITECTURE

Evaluating architecture as a subject for photography, and specifically for HDR photography, is an important skill. As you develop it, you are able to spend more time capturing appealing buildings or scenes and pass over the rest. As with much of photography, the challenge is to see how light interacts with the subject to reveal details, contrast, and color. It's your job to capture that light.

LINES AND STYLE

There are various types of buildings that all sit differently in a landscape. Unique architectural styles include Georgian, Edwardian, modern, art deco, postmodern, Gothic, classical, blobitecture, and deconstructivist, to name a few. The techniques you use (framing, distance, angle, time) can often be suggested by the style of the building you are photographing.

To begin analyzing a scene, look at the lines that make up the building. Some are straight and others are curved. Lines and the shapes they bound form powerful visual objects that must fit within the scene. The lines that compose the skyscraper in 5-1 stand out clearly and lead up and to the right, pointing to the sky. There is balance between the lower left and the upper right of the photo because it was composed with the Rule of Thirds in mind. Also, notice that the lines of the building are at odd angles to the border of the frame. The lines are so powerful that in some respects the actual building is lost.

The image in figure 5-1 was produced using one raw shot that was converted to three 16-bit TIFFs and then run through Photomatix. By setting Strength and Luminosity to their highest settings, along with setting Light Smoothing to High, the drama of the photo is really highlighted. A high Strength in particular gives the image a dramatic, edgy feel while Luminosity plays its familiar role of balancing light across the image between sky and building.

BUILDING SURFACES

Buildings can be constructed from a variety of materials; glass, concrete, plastic, metal, adobe, brick, stone, and wood have their own distinct mood and feeling. Modern materials often appear smooth, cold, and precise while natural building materials are warm and tend to be more inviting.

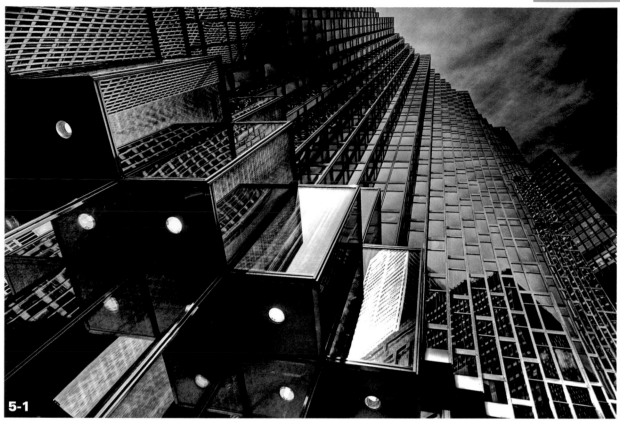

5-1

ABOUT THIS PHOTO *The lines of this skyscraper in Toronto lead you toward the sky. HDR from three raw exposures bracketed at -2/0/+2 EV. (ISO 200, f/5.6, 1/100 second, Sigma 10-20mm f/4-5.6 at 10mm) © Pete Carr*

HDR reacts differently according to the surface of the building. The reason is something called local contrast. Local contrast is not the same as the overall contrast of the image. Rather, edges that make up the surface texture of the object you are photographing — a building, a face, the street, trees, water — can be accentuated and enhanced through the tone mapping process. This is something you can turn up or down based on the

settings you use. While it may be fun to bring up local contrast and make details more visible, it can also be powerful to smooth them over. Therefore, buildings with rough surfaces have the potential of greater local contrast and hence more details than buildings with smooth surfaces, regardless of other aspects of contrast in the photo. Examples of both types of surfaces are presented in 5-2 and 5-3.

The Lloyd's building in London was built inside-out (see 5-2). It is, frankly, a bizarre and arguably ugly building. Aesthetics of the building aside, it is a brilliant building to photograph and use for HDR. It presents a challenging study of HDR with less local contrast and fewer surface details. This is because the building uses smooth metals and plastics for exterior surfaces and therefore has a cold, industrial look. For this image, Strength was set moderately high. This, along with a high Luminosity setting, brings out more detail in the darker areas on the sides of the building without overexposing the sky.

The final image is purposefully skewed from the natural in Adobe Lightroom. The blue sky was altered — shifted toward purple in order to contrast more with the cold feel of the building. This took a few steps. First, the white balance was adjusted to add the blue tone. Then saturation was reduced significantly. Finally, the hue on the Blue channel was adjusted to change the sky from blue to purple.

> **note** You can overcome a lack of surface contrast from smooth elements if they interact in complex and contrasting ways.

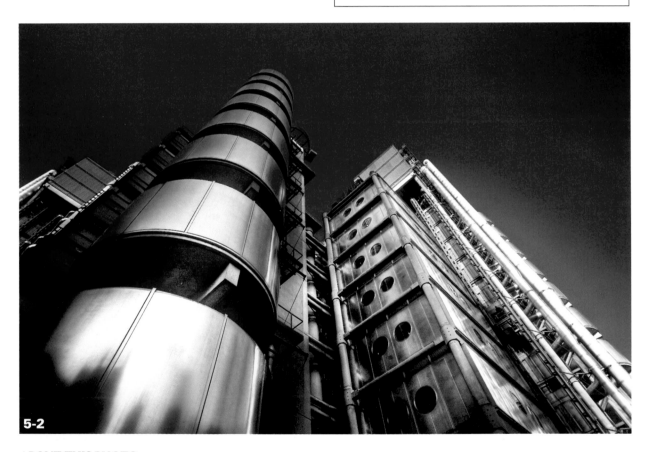

5-2

ABOUT THIS PHOTO *This photo of the Lloyd's building in London is a tone-mapped photo from one raw image converted to three 16-bit TIFFs, (ISO 100, f/11, 1/45 second, Canon 28-105mm f/3.5-4 at 30mm) © Pete Carr*

The William Brown Library and Museum in Liverpool, shown in figure 5-3, is on the opposite end of the local contrast spectrum. This building was created with a rough, natural exterior that warms rather than cools and has intricate edges that can be enhanced in tone mapping. The sunset enhances the feeling of warmth, bringing out the earthy tones of the building. From color to surface detail, this building presents a different challenge.

In Photomatix, Strength was set moderately high. Too great a Strength can sometimes cause *vignetting*, which is an effect that turns the edges of a photo black. In this photo, vignetting is just barely noticeable and adds to the image rather than taking away from it. Luminosity was raised halfway so the photo didn't look too detailed due to local contrast getting out of control. A higher Luminosity also helped keep the clouds from becoming overexposed. Micro-smoothing was raised a bit to handle issues with noise and banding in the sky.

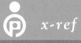

x-ref For more information on converting raw images to 16-bit TIFFs before creating HDR, whether a single source image or multiple brackets, please refer to Chapter 3.

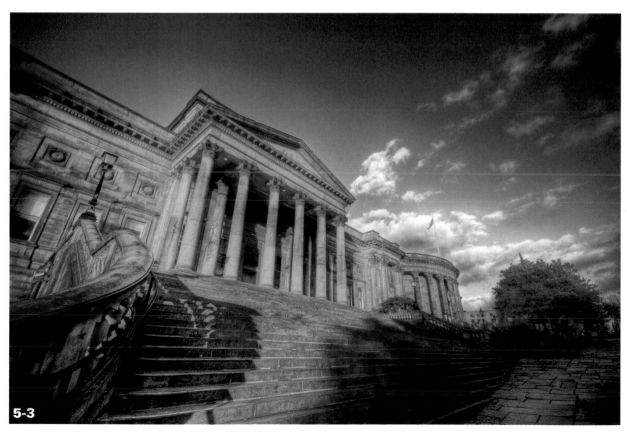

5-3

ABOUT THIS PHOTO *This photo of the William Brown Library and Museum in Liverpool is a tone-mapped photo from three bracketed images at -2/0/+2 EV. (ISO 100, f/11, 1/45 second, Canon 28-105mm f/3.5-4 at 30mm) © Pete Carr*

SHOOTING FOR DETAIL

Buildings don't always have to be captured with wide-angle lenses and shown in their entirety. You can find lines, details, curves, angles, and light in just about any part of a building. Look at stairs, a window, or corner of a building. Walk around and take it in closer. Don't step back. Don't try to get the entire skyline. There is a level of intimacy in the details of a building that is lost if all you ever do is shoot sweeping, expansive cityscapes.

Ideally, shooting for detail requires taking three bracketed photos with the help of a tripod. The HDR process as a whole doesn't change — just the way you look at the building. Essentially, you're looking to capture a small bit of the building, something that may hint of a larger picture. Look for detail in stonework, metal, glass, and wood. Find angles in crazy, abstract buildings.

The scene may not have the same level of contrast compared to a building with the sun setting behind it, but you're after a different type of photo, as in 5-4. This is a tight close-up of a small part of a building. You can't tell how large it is, how many floors it has, or what is around it. Those details aren't important for this shot.

ABOUT THIS PHOTO *This is the side of a building in Liverpool. HDR from three raw exposures bracketed at -2/0/+2 EV. (ISO 100, f/5.6, 1/400second, Canon 24-70mm f/2.8 at 28mm) © Pete Carr*

This scene was composed to show a limited but interesting view. The staircase has been brilliantly detailed on the outside of the building and is framed by four completely different windows. The photo fits nicely into a grid, but you don't feel constrained.

Strictly speaking, the side of the building shown in 5-4 was not a high-contrast scene with ideal HDR qualities. The photo was taken late in the afternoon in the middle of summer on an overcast day, which helped soften the shadows. During HDR conversion, tone-mapping settings were not needlessly maximized, which would have resulted in an unrealistic shot. The idea was to bring out a little more detail, not hit you over the head with it. Therefore, Luminosity only needed to be a bit above its minimum. Strength was set high to bring out detail in the stone work, but was not overdone.

The original color of the building was a very pale yellow, which was unattractive enough to warrant converting the final result to black and white. This focuses the attention on the details of the building rather than its dingy shade of yellow. Afterwards, a slight tint was added to the photo to replicate the feeling of a black-and-white print.

x-ref For more information on converting HDR photos to black and white and tinting them afterwards, please refer to Chapter 7.

Moving even closer in 5-5 you see a photo of a sculpture on the side of a door. There is quite a bit of detail throughout the frame that can be brought out with HDR without resorting to complex masking techniques in Photoshop. Look for small details like these that make an interesting photo.

Although it is best to try and use three bracketed photos, you can work with one raw exposure in a pinch. In this case, the original raw image was converted to three 16-bit TIFFs and then processed into HDR. Following that, it was tone mapped in Photomatix.

The tone-mapping settings were extreme in order to bring out a significant amount of detail, which was the goal of the photographer. There were no issues related to overexposure because the original image did not have very much contrast. In

5-5

ABOUT THIS PHOTO *The lion artwork is on the side of a metal door as processed and adjusted in Photomatix, without any other processing. HDR from a single raw exposure converted to three 16-bit TIFFs. (ISO 200, f/6.3, 1/1000 second, Sigma 10-20mm f/4-5.6 at 10mm) © Pete Carr*

Photomatix, high Strength, Luminosity, and Microcontrast settings were an important part of bringing out the small details of the door and emphasizing contrast. In fact, Strength and Luminosity were both set to maximum.

INCLUDING THE SKY FOR DRAMATIC EFFECT

When you move your perspective back a bit, you can shoot a single building and have enough room to include the sky for dramatic effect. This is not yet a cityscape. Use a wide-angle lens to capture buildings and sky together. They can play off each other by being alike or different. One area may accentuate drama while the other may be calm, which is illustrated in 5-6. The light that day was rather dull, but by underexposing the photo by two stops, the clouds were not blown out. Later, HDR brought out detail in the sky and building. In Photomatix, Strength and Luminosity were set to maximum to increase drama in the sky and balance the light between the sky and building.

Although the subject of the photo is the building, the sky completes the image and helps set the tone. It's dramatic but it doesn't take anything

5-6

ABOUT THIS PHOTO *This is Liverpool's iconic Metropolitan Cathedral. Three bracketed raw photos at -2/0/+2 EV. (ISO 100, f/8, 1/250 second, Sigma 10-20mm f/4-5.6 at 10mm) © Pete Carr*

away from the building and is balanced both vertically and horizontally. Although single-exposure HDR is always an option, the best result was achieved in this case from three bracketed photos. This enabled a full range of details to be captured from an otherwise featureless sky.

note With too much sky, even buildings can get lost in a photo. Pay attention to tone and contrast. In 5-6, the sky and building have similar tones and lower contrast between them. As a result, the building needs to be larger, so it takes up two-thirds of the image. In 5-7, the contrast between the sky and the building is huge (blue versus orange tones), so the building can be smaller and not disappear.

CAPTURING CITYSCAPES

When you photograph architecture, your focus is on buildings. You might be capturing part of a building, the whole building, or perhaps the

building in its immediate environment. When you move on to cityscapes, your focus is on a much larger subject. In other words, architecture is about buildings and cityscapes are about cities.

Photographing cityscapes and processing the results as HDR is a much different proposition than working with a single building or detail of a building. Instead of zeroing in on the materials and details of a specific building, you are looking at how many buildings sit together to form a cohesive, or perhaps disjointed, whole. The scope is much larger and your techniques will shift to take this into account. Many of these techniques are the same as those found in landscape photography.

The cityscape photo of Liverpool, seen in figure 5-7, reveals a particularly dramatic evening. It was shot with an ultra wide-angle lens in order to capture the mood, the bold colors in the sky, and the fantastic clouds. It would be impossible to

WIDE-ANGLE LENSES It might seem a bit obvious to suggest that using a wide-angle lens is beneficial when shooting cityscapes and HDR. If you don't have one and are trying to justify going out and buying an expensive lens, however, you should know that they are indispensable for shooting good cityscapes. Wide-angle lenses work wonders with cityscapes because you can fit so much more in every photo than with an everyday zoom lens — the sky, buildings, streets, the city. Everything you need, and then some.

Pay attention to "and then some". You may be tempted to include too much in a scene. Ease off on the field of view if you find yourself constantly cropping your photos to improve the composition.

One drawback of using a wide-angle lens is that they are particularly prone to distortion. To prevent buildings from tilting towards or away from you, hold the camera or mount it on a tripod with the lens parallel to the ground. You can use the Lens Distortion filter to correct this in Photoshop Elements, but you may also want to leave some distortion in as an artistic effect. Removing horizontal or vertical distortion sacrifices part of the image and can create other distortion in the process.

For more information on lenses in general and wide-angle lenses in particular, please refer back to Chapter 2.

5-7

capture this scene with a normal lens. Notice the composition and light. Even though the center of attention is on the Liver building at the right, the sky prominently shows off the clouds while the setting sun bathes the skyline in golden light.

Within Photomatix, Luminosity was maximized in order to increase contrast and Micro-smoothing minimized to produce as dramatic a photo as possible. Strength was lowered to a bit to keep the photo grounded in reality. After tone mapping, the photo was loaded into Photoshop, where contrast was again enhanced with Curves. Finally, the clock face had to be selectively desaturated, as it had picked up the color of the building.

Another powerful cityscape, of Canning Dock in Liverpool, is shown in 5-8 as a traditional photograph. Compare it to 5-9, which is the same scene in HDR. The overall case for HDR and the specific case for shooting cityscapes is impressive. The HDR looks stunningly good. There are more details, the buildings are not reduced to silhouettes, and the sky has gone from flat to extraordinary compared to the original. The HDR image is full of color and clarity. As a cityscape, it combines elements of a beautiful sunset, dramatic sky, still water, and picturesque buildings in dramatic fashion. This is the essence of what a cityscape in HDR should be.

ABOUT THIS PHOTO
Traditional photo of Canning Dock in Liverpool. Although it is a beautiful scene in its own right, the details are all hidden in shadow and silhouette. (ISO 100, f/9, 1/25 second, Sigma 10-20mm f/4-5.6 at 17mm)
© Pete Carr

ABOUT THIS PHOTO
This HDR photo of Canning Dock in Liverpool was created from three raw exposures bracketed at -2/0/+2 EV. (ISO 100 f/9, 1/25 second, Sigma 10-20mm f/4-5.6 at 17mm)
© Pete Carr

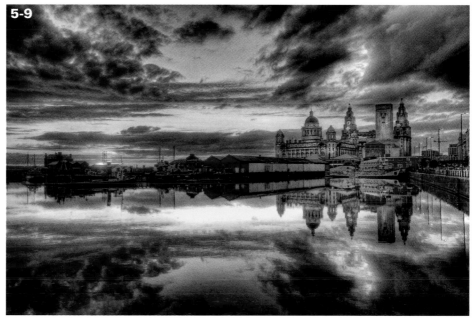

Notice that the distance to the main subject is across water and much farther than the last example. Try both approaches when you compose your shots. Having a wide-angle lens will help you get up close and still have an incredible field of view, but will also allow you to shoot farther away. Get to know your lens and its focal length range. Compare the difference between this example (17mm) and the last (10mm).

To achieve this look in Photomatix, Strength was set at a high level but not to its maximum. It is a balance between realism and enhanced detail, especially in the clouds. With Strength set to maximum, the clouds looked too heavy and those on the edge of the photo were too dark. Luminosity was maximized to balance light across the image. In its neutral setting, the buildings were too dark and lacked detail. Micro-smoothing was turned off in order to preserve the drama of the shot, which works better with a strong tone map.

After tone mapping, the contrast was increased and other adjustments were made to finalize the image in post-processing. You may find yourself making different noise, level, curve, and other tweaks to your photos as well. For example, you may find that HDR alone doesn't bring out all the detail you want. You can get around this by dodging to bring out detail and burning to remove it.

URBAN CONTEXTS

The urban landscape is a fantastic gallery of textures, details, buildings, streets, and contrasting lighting and tones. You can find them on every corner, and they are always changing. New buildings go up and old buildings come down. Structurally, a landscape may change once in 10 to 20 years. A city can change dramatically in a much shorter period of time, providing new angles and shapes to play with. Look for high-contrast scenes where you can extract huge amounts of detail.

THE PROBLEM WITH FILTERS

Urban landscapes present serious problems for filters. While filters, especially ND and ND grad filters, are great for darkening a sky over a lake at sunset, cities have uneven and jumbled horizons. There isn't a filter designed with an outline for Bold Street, Lord Street, Main Street, or Times Square.

An urban scene typical of larger cities is shown in 5-10. The view looks up and the line of tall buildings is neither horizontal nor regular. Normally, the buildings would be in shadow because you should expose for the sky to keep it from blowing out. In this case, an ND grad filter was used over the lens in an attempt to balance the light of the sky and lighten the buildings. The result is a photo with artificial shadow lines and halos. This is most evident on the building in the foreground. If you look carefully, there is a dark shadow running across the top of the building from the center of the photo leftwards and a halo in the sky at the top right. These distracting elements were caused by the filter.

By now you should be thinking in terms of HDR. In figure 5-11, three bracketed photos were taken of the scene and processed into HDR, which allowed the buildings to be captured with enough

ABOUT THIS PHOTO
This is a small part of a block in downtown London, including "The Gherkin." (ISO 100, f/4, 1/80 second, Sigma 10-20mm f/4-5.6 at 10mm) © Pete Carr

ABOUT THIS PHOTO
This is the HDR photo of downtown London, including "The Gherkin." HDR from three raw exposures bracketed at -2/0/+2 EV. (ISO 100, f/4, 1/80 second, Sigma 10-20mm f/4-5.6 at 10mm) © Pete Carr

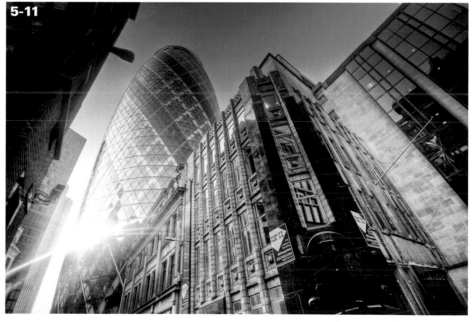

light and detail without letting the sky get out of hand. Although mainly in shadow, the left side of the scene is now better exposed. The building in the center is clearly visible with interesting color, texture, and detail. There are no shadow lines caused by a filter. Within Photomatix, Strength was lowered and Micro-smoothing was raised to achieve a more natural look. Luminosity was set to its maximum for this shot due to the high contrast between the bright sky and darker buildings.

x-ref For more information on filters, see Chapters 1 and 3.

There were, however, a few problems that had to be corrected in post-processing. This is often the case, even in HDR. There was a halo at the top of the building on the right, but it was corrected in Adobe Lightroom using Recovery. Unfortunately, this tool is not available in Photoshop or Photoshop Elements except as a feature in Camera Raw.

note Although Photoshop Elements is a capable program, it pays to invest in more professional-level applications, such as Photoshop CS4, Lightroom, or Apple Aperture if you want more problem-solving power.

If you are using Photoshop Elements, choose Enhance ⇨ Lighting ⇨ Shadows/Highlights to try to correct halos by darkening the highlights. It's not as clean a solution as Recovery, but it keeps you from having to manually burn those areas.

CONSTRUCTION

Construction is a great subject for HDR. While normal building photos focus on lines, angles, details, and composition, construction photos capture a scene in an unfinished state, contrary to our normal experience. The focus is on visually interesting material, details, color, and exposed structures.

Cranes and other construction gear often stand out or are at odd angles to the rest of the scene. They aren't supposed to be there, which is what makes them so interesting to photograph. The vibrant color of the construction crane stands out in 5-12, and HDR enhanced the details of the linear contrails in the sky, which adds to the amount of detail in the photograph. The contrails balance the right side of the photograph with the crane on the left.

This is another example of why it is important to keep an open mind and try alternate approaches. Originally, three bracketed photos were shot. However, there was a slight alignment issue with a passing car, whose movement caused ghosting. Therefore, a second attempt was made, this time from a single raw photo, converted to three 16-bit TIFFs. This approach solved the ghosting issue without unduly compromising the HDR. Within Photomatix, Strength was lowered by about a third, as high settings caused unwanted vignetting, which are dark edges to a photo. Lower strengths also increase the realism of an HDR photo. A high Luminosity helped bring out detail in the contrails.

Figure 5-13 was taken in Liverpool at the largest construction site in Europe at the time. The effort signaled the resurgence of Liverpool and is another great example of how to use HDR. It was an overcast day and the sun was behind the building. Metering for the sky resulted in the building being completely lost in shadow. Metering for the building resulted in the opposite effect — the sky was totally blown out and unusable.

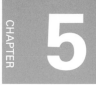

ABOUT THIS PHOTO *This is the Malmaison construction in Liverpool. HDR created from a single raw photo converted to three 16-bit TIFFs. (ISO 200, f/8, 1/160 second, Sigma 10-20mm f/4-5.6 at 10mm) © Pete Carr*

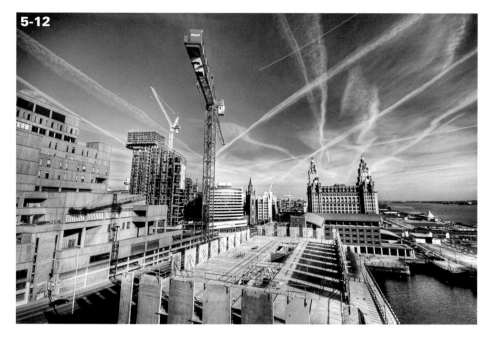

5-12

ABOUT THIS PHOTO
This is the Liverpool One construction site. HDR from three raw exposures bracketed at -2/0/+2 EV. (ISO 100, f/5, 1/2000 second, Sigma 10-20mm f/4-5.6 at 10mm) © Pete Carr

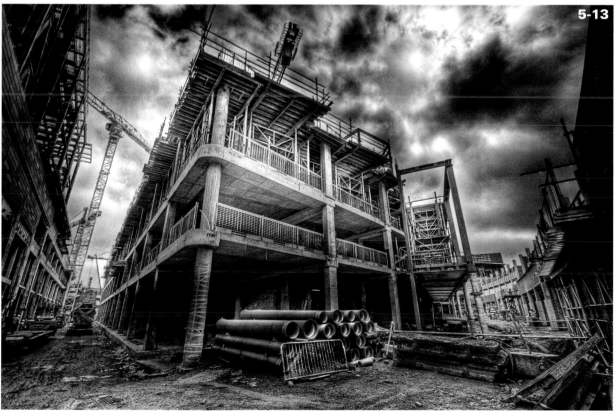

5-13

HDR allows you to work around this problem and capture detail in shadow while not blowing out highlights. Three shots were taken, and at just the right moment the clouds broke and let the sun shine through, enhancing the sky. Everything — clouds, building, dirt, crane, pipes — benefited.

Tone mapping resulted in a more artistic interpretation of the scene — there is a distinct drawing or painting quality to this image. This is because the Strength and Luminosity are set to their maximum levels. The result is slightly unrealistic, but not in an unappealing way. There was little detail in the sky at the time so the strong Luminosity setting helped balance the light across the image. Drama, personality, and atmosphere are present, which all work together to depict a compelling scene with a hyper-real and bold look that is indicative of the current situation in Liverpool.

DECAY AND DEMOLITION

While shiny, new buildings are beautiful and fun to photograph, capturing decay is just as rewarding for a photographer. Run-down areas and demolition sites contain as much or more detail than new areas. The photo in 5-14 is a standard shot straight from the camera of a door to nowhere. As is, it is sort of featureless, drab and dull. What details there are remain hidden in low-contrast darkness.

Processing this single photo as HDR results in a wonderfully varied palette of colors and textures as shown in 5-15. Strength was set to its maximum in order to bring out as many details as possible, and Luminosity and Microcontrast were maximized as well, which brings out the grit in this photo. Notice that the ISO is very high,

which would normally cause noise problems. The varying textures and interesting detail make this scene relatively immune to noise issues, however.

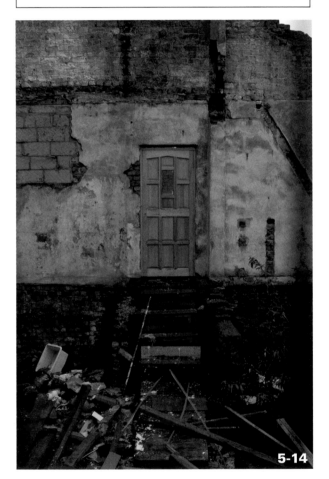

5-14

128

It's a great transformation. HDR was able to bring out the muted colors of the walls and paint a vivid portrait of the brick and stonework more than raw editing in Lightroom was able to. This is an important point. The difference between the standard photo and HDR is much more than a simple saturation adjustment, which is shown for comparison in 5-16. Notice that increasing the saturation looks nothing like the HDR version.

If anything, increasing the saturation of the colors covers up detail in the photo. Continuing to edit the photo by increasing contrast and brightening simply do not compare to the clarity of the HDR.

Decay or demolition sites also work very well in black and white, as seen in 5-17. This photo of Liverpool was compared by residents to what the area looked like after the bombings of World War II. It was close to sunset, so the fantastic light was

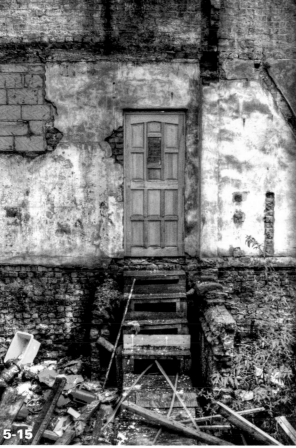

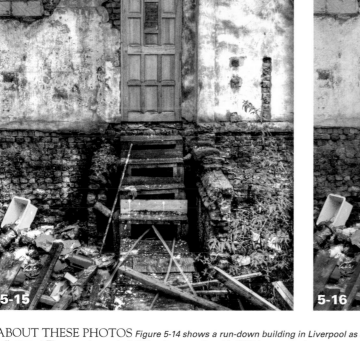

ABOUT THESE PHOTOS *Figure 5-14 shows a run-down building in Liverpool as it was taken, with no adjustment. The same image in 5-15 has been rendered in HDR from a single exposure converted to three 16-bit TIFFs, creating a kaleidoscope. In the version shown in 5-16, the saturation was increased on the original photo to compare with tone-mapped HDR. (ISO 1600, f/5, 1/200 second, Canon 24-70mm f/2.8 at 24mm) © Pete Carr*

5-17

ABOUT THIS PHOTO *Construction is shown here at Mann Island in Liverpool near Albert Docks. HDR created from a single raw exposure converted to three 16-bit TIFFs. (ISO 400, f/8, 1/125 second, Canon 24-70mm f/2.8 at 43mm) © Pete Carr*

able to shine right across the waterfront and onto the scene. The photo was converted to HDR, tone mapped in Photomatix, and converted to black and white in additional post-processing. As the sun was quite bright in places, Luminosity was set to high to balance out the image. Strength was set nearly to maximum to bring out details. The photo looks older than it is because of the level of detail and the fact that there is a level of noise. There is also a great sense of depth to the scene.

This photo has a good deal of noise in it primarily because an ISO of 400 on a Canon 30D is noisier than ISO 100. This fact may not be immediately apparent when looking at the original exposure, but is emphasized because noise is cumulative. Even though this started as a single exposure, three converted exposures were used to generate the HDR. Therefore, the final result has three times the noise as a single photo. Starting with a single exposure is not really the issue unless when you increase the exposure for the overexposed bracket it becomes obvious you are pushing it too hard.

OLD BUILDINGS

Older buildings are one of the best subjects to photograph and process with HDR. They are commonly made of brick and stone rather than the more modern materials of steel, glass, and plastic. This results in interesting textures and surface details for HDR to bring out.

The building in 5-18 was shot during the Golden Hour when the light was hitting it more directly instead of during the middle of the day with the sun overhead. The blue sky, with filaments of clouds, contrasts nicely with the color of the building. Notice that the building does not present a totally flat surface to you. It dips in and juts out in a complex but regular dance of detail. The building seems to tilt away because the camera is pointed upwards slightly. This can be fixed in an image-editing program such as Photoshop Elements by using the Lens Correction filter. In this case, it is aesthetically acceptable and an unacceptable side-effect of removing the distortion is to sacrifice part of the building and sky.

In Photomatix, Strength was maximized to bring out as much detail as possible in the building, which greatly benefits from it. Luminosity was increased to bring the sky back, but not so much as to cause vignetting. To combat a noisy sky, Micro-smoothing was raised.

CHURCHES

Old churches, especially large cathedrals, are fantastic subjects in HDR. Many of the oldest structures took generations to build and were built with passion and devotion. These buildings contain amazing details that can be captured and preserved in HDR.

An initial photograph of York Minster in England (see 5-19) shows that the camera simply can't capture enough detail in the sky while exposing the cathedral properly. Therefore, three bracketed images were taken at -2/0/+2 EV. The underexposed photo captured detail in the sky while the overexposed photo enhanced details in the cathedral.

ABOUT THIS PHOTO
The Tower Building in Liverpool presents a detailed surface. HDR created from three bracketed raw exposures at -2/0/+2 EV. (ISO 100, f/5.6, 1/250 second, Sigma 10-20mm f/4-5.6 at 16mm) © Pete Carr

5-18

In Photomatix, Luminosity and Strength were set to maximum to bring out details in the cathedral and the sky, but the result still lacked something. The sky remained a problem because it was dull and gray, even after tone mapping. In the end, converting the photo to black and white removes color distractions and turns the focus to brightness and contrast, as shown in 5-20.

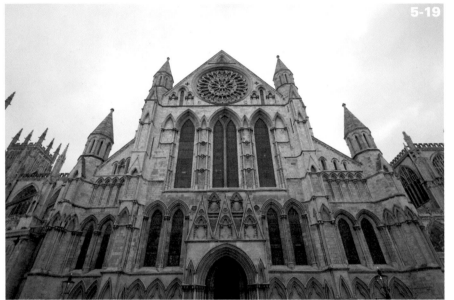

5-19

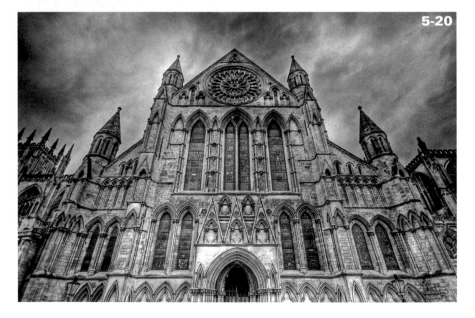

5-20

The end result is fantastic. The details of the building's design come out, and although they aren't in color, you can clearly see the individual panels of the stained-glass windows.

BARNS

Barns are another great subject for HDR photography. Each barn presents unique challenges and opportunities for you as a photographer. Many are red, but others are white, yellow, gray, brown, or green. Some have windows; others have stalls for horses and other animals. There are many shapes and sizes of barns as well, including rectangular barns and round barns.

> **note** Despite the lovely nature of many barns, success still requires seeking out the right barn and photographing it in the right conditions to create an interesting and compelling photograph.

The earthy, rustic look of a barn against a scenic landscape and dramatic sky is a powerful combination, as you can see in figure 5-21. The sun was setting and the sky was magical, resulting in the perfect combination of subject and environment. Details in the clouds, barn, windows, grass, fallen leaves, and nearby trees are brought out nicely in HDR.

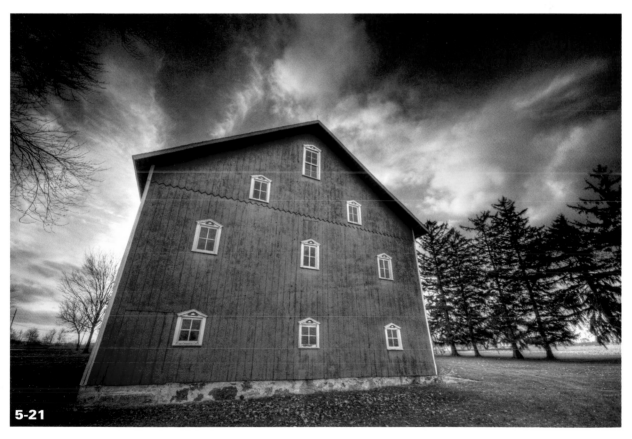

5-21

ABOUT THIS PHOTO *This classic red Indiana barn at sunset as fall moves toward winter beckons the photographer. HDR created from three raw exposures bracketed at -2/0/+2 EV. (ISO 100, f/8, 1/60 second, Sigma 10-20mm f/4-5.6 at 10mm) © Robert Correll*

In Photomatix, Strength was maximized to accentuate the drama in the image and bring out details in the barn, clouds, and ground. Luminosity was raised halfway to brighten the barn and balance it with the sky. Microcontrast was also increased, which made the image feel sharper and crisper. Slightly increasing Micro-smoothing also helped balance light across the image.

If you can, walk around the structure and take many bracketed shots from several angles. There may be more than one perfect angle or story to tell, but you won't know unless you try. An alternate scene is presented in 5-22. The barn sets farther back, allowing the grass to expand its role in the photo. The tree adds interest to the foreground. Tone-mapping settings in Photomatix are identical to 5-21.

Unfortunately, the wind was blowing in 5-22 and the smaller tree branches looked double-exposed after the bracketed photos were converted to HDR. If this happens to you, try using a single raw image instead of bracketed exposures. In this case, however, the red barn didn't look right. Therefore, the tree branches were processed separately from a single raw image and blended over the problem areas of the original bracketed and tone-mapped photo. The end result is the best of both worlds.

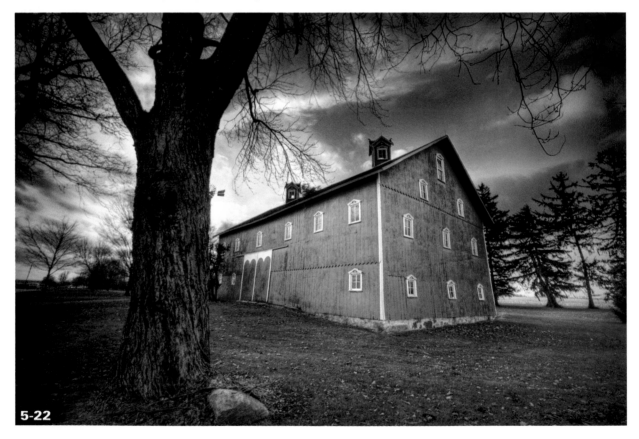

5-22

ABOUT THIS PHOTO *An alternate angle and distance change the scene from that shown in figure 5-22. HDR created from three bracketed raw exposures of -2/0/+2 EV. (ISO 100, f/8, 1/60 second, Sigma 10-20mm f/4-5.6 at 10mm). © Robert Correll*

In 5-23, you see the original, tone-mapped image created from three bracketed photos occupying the bottom layer in Photoshop Elements. This is the shot that has problems with the moving branches. The layer is currently invisible to show where the mask is applied. At the end of the process it will be turned back on and merged with the top layer.

The top layer contains the tone-mapped shot created from the center bracket. This image eliminates any problems with movement because it was created from a single exposure. However, you don't need to see all of it. The only part that has to show contains the branches that aren't moving. Therefore, the other areas are masked out and hidden.

5-23

ABOUT THIS FIGURE *Masking in Photoshop Elements to blend two tone-mapped HDR shots together. The upper layer hides movement in the lower layer.* © Robert Correll

CLASSIC ARCHITECTURE

Like churches, classical architecture (typically inspired by ancient Greek temples and other public buildings such as theaters) is very rewarding to photograph. Large stone halls such as St. Georges Hall in Liverpool (5-24), shot in the early morning to benefit from a low sun, are fantastic subjects.

After creating three TIFFs from the original raw image, the brackets were converted to HDR and tone mapped. In Photomatix, Strength, Luminosity, and Microcontrast were all maximized in order to accentuate the small details in the building and foreground as much as possible. Afterwards, the image was converted to black and white. Classical architecture works very well with HDR, and black and white brings out the details in the ground, building, and sky in the photo.

ABOUT THIS PHOTO
St. Georges Hall, an epic building, is showcased in HDR. HDR from a single raw exposure converted to three 160-bit TIFFs. (ISO 100, f/8, 1/320 second, Canon 24-70mm f/2.8 at 24mm) © Pete Carr

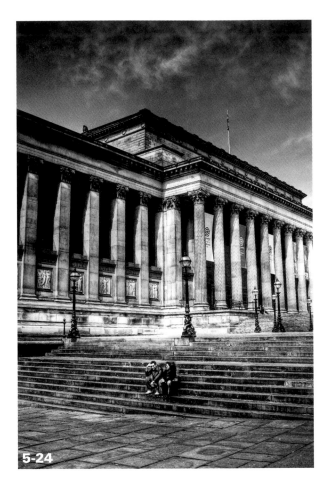

5-24

Assignment

Frame Buildings with a Dramatic Sky in HDR

This assignment asks you to frame buildings with a dramatic sky in HDR. Find a structure or building worth photographing. Make it interesting. It can be new, old, classical, Gothic, minimal, avant-garde, or any other style that captures your attention. It can be under construction or being taken down. Find an interesting angle that tells a story. It could be about depth, height, angles, texture, or color.

The catch is, capture the scene with a dramatic sky.

Pete shot this photo of North Pier in Blackpool, UK, on a cold winter morning. HDR processing brought out details in the sky and sand with a high Strength setting in Photomatix. The contrast of the cold blue sky with the brown sand is spectacular, and the white of the pier divides the image. There is a fantastic sense of depth to this photo. Luminosity was raised to get at more detail under the pier, an area that was mostly in shadow. The Black Point was also raised to increase the contrast of the image by clipping the blacks in this photo. HDR created from three raw exposures bracketed at -2/0/+2 EV. Taken at ISO 200, f/6.3, 1/500 second, Sigma 10-20mm f/4-5.6 at 10mm.

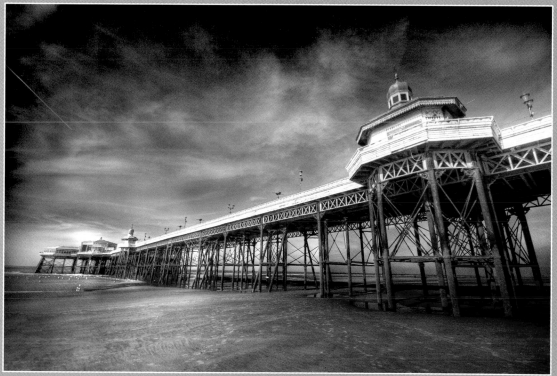

© Pete Carr

Remember to visit www.pwassignments.com after you complete this assignment and share your favorite photo! It's a community of enthusiastic photographers and a great place to view what other readers have created. You can also post comments, read encouraging suggestions, and get feedback.

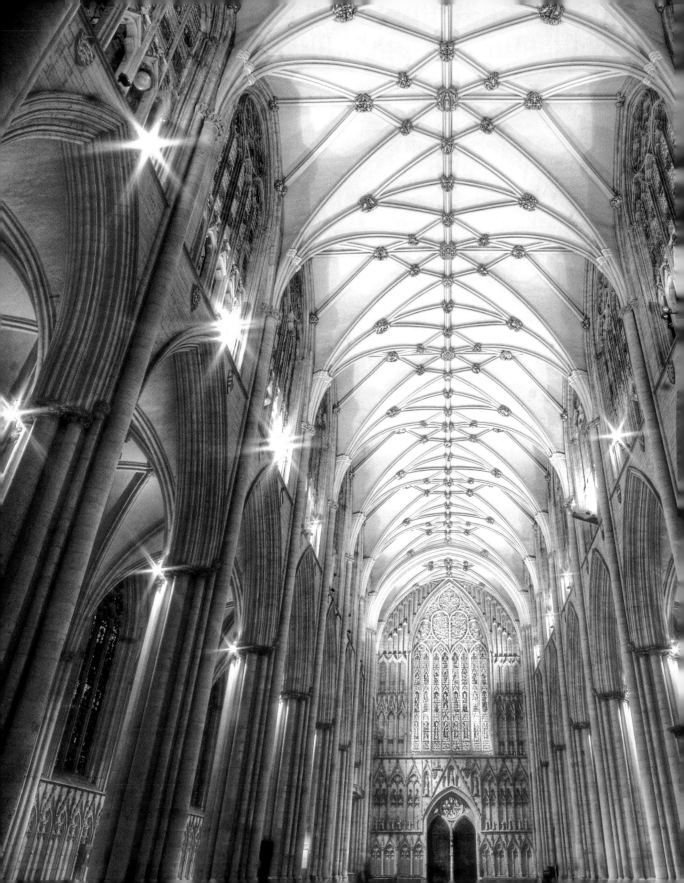

© Pete Carr
Reproduced by kind permission of the Dean and Chapter of York

In this chapter, you take the information you've learned and the skills you've practiced and learn to shoot interiors in HDR. You generally won't have to worry about the Golden Hour, clouds, the time, or the weather. From that perspective, shooting inside is a lot easier and often more comfortable than waiting for the perfect conditions outside.

However, it's still a challenging endeavor. The variety of sizes, shapes, colors, and types of interior spaces is staggering. You'll be dealing with man-made environments, both large and small, that demand the most from your creativity and your use of space and lighting.

The most common post-processing challenges are related to white balance, because different interior lights have different color temperatures — each one potentially throwing your photo's color off (that's called a color cast). Interior lighting is also darker than you might think when compared to natural light. This becomes a problem when you try to balance indoor and outdoor light in the same scene.

UNDERSTANDING INTERIOR SPACES

By their very nature, interior spaces are constrained by walls, ceilings, and floors that serve as boundaries. You also have to contend with interior lighting that replaces the sun as the primary light source. You may use diffused sunlight as a light source. In some buildings, there will be competing sources of man-made and natural lighting at different intensities, which greatly complicates exposure. All of these differences have tremendous implications for your photographs.

SIZE, SHAPE, AND SPACE

Unlike landscapes, interiors come in many sizes and shapes. They can be square, rectangular, cubes, have curved walls, be oddly shaped, have vaulted or curved ceilings, staircases that break up the scene, and contain furnishings of all sorts.

When you look at an interior scene, you must decide what story you want to tell. It may be about the size, scale, color, shape, or interior details. The shopping center captured in 6-1 is filled with details, garish color, and the complexity of life. Despite the busyness, there is symmetry to the photo. Notice that the photo is from above. That makes it different and interesting. Using wide-angle lenses up high (or down low) in tight spaces can accentuate unique perspectives.

In this case, HDR was used to accentuate the detail and color of the scene. In Photomatix, settings were used that brought out details in the darker areas. To do this, Strength and Luminosity were set quite high. As it happens, maximizing these settings can make a photo look a little artificial. Therefore, Micro-smoothing was increased a bit to reduce the tone-mapped look.

tip When you look at a photo in Photomatix and light areas dominate the dark or dark areas overpower light, there is a balance problem. Finding the right setting to counter this is sometimes a product of trial and error, but Micro-smoothing, Luminance, White Point, and Microcontrast all play roles. Move a setting from one extreme to another to see how it affects balance. You will see lightness flip-flip from top to bottom and back again. Find the sweet spot in the middle where the image balances out nicely.

ABOUT THIS PHOTO *The interior of Grand Central shopping center in Liverpool is full of color. This was created from a single raw photo which was converted to three, 16-bit TIFF brackets. (ISO 800, f/4, 1/50 second, Sigma 10-20mm f/4-5.6 at 10mm) © Pete Carr*

6-1

INTERIOR LIGHTING

In many situations, you have to work with existing interior lighting. A scene at a shopping mall in the United States (6-2) reveals a number of competing light sources that play off the walls, floor, and ceiling. You can see outside light at the end of the far hall, interior store lighting to the right, a small amount of direct lighting, recessed lighting in the hall and central space, and light from a skylight coming down on the fountain.

The original photo wasn't bad, but was too light in various areas of the photo — much like a sky that is almost blown out. HDR works very well in these situations by enhancing contrast and uncovering detail. In Photomatix, Strength was set very high, which had the effect of increasing local contrast. Micro-smoothing was raised to balance the light across the fountain and ceiling.

> **tip** Artificial lighting has a different color temperature than sunlight. Most cameras have white balance settings that can be set to account for the predominant lighting of a scene. If your photo looks too yellow, try changing the white balance to tungsten or fluorescent. Shooting raw enables you to correct this in software. For more information on color temperature and white balance, see Chapter 4.

Note that this is a relatively realistic HDR scene. In other words, it looks more like a photograph and less like an artistic representation of the same scene. The beauty of HDR is that you have the power to create both interpretations.

NATURAL LIGHT AND SHADOW

You may find yourself shooting in natural light, even indoors. Light coming in from windows, skylights, and doors is generally not adequate to light interior spaces to the level required for good exposures. You'll find yourself either overexposing the exterior to see details inside or underexposing the interior to avoid blowing out details outside. The point is to see both, as in 6-3. The interior of the barn and the fall trees outside are both important to this scene. One without the other doesn't work as well.

For this photo, the Luminosity setting in Photomatix was raised to bring out details in the wood grain while Microcontrast was raised to increase contrast. Strength was maximized to produce a dramatic, exaggerated effect.

ABOUT THIS PHOTO *This HDR image of a rustic stall in an Indiana horse barn looking outside at the fall foliage during the Golden Hour was created from three bracketed raw exposures at -2/0/+2 EV. (ISO 100, f/8, 1/8 second, Sigma 10-20mm f/4-5.6 at 20mm) © Robert Correll*

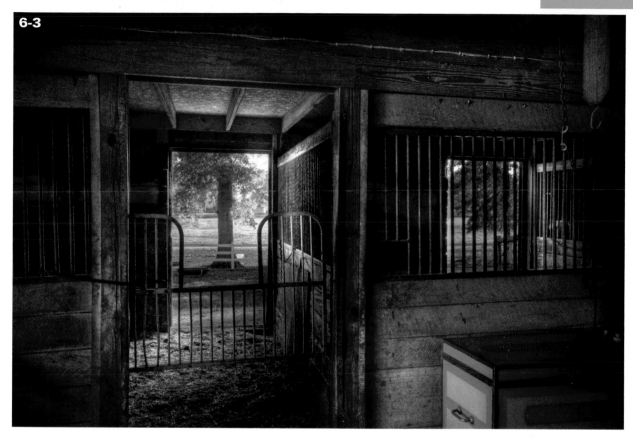

6-3

EXTREME CONTRAST

You will often find extreme contrast ratios when working with interiors, as in 6-4. The foreground is very dark, and only gradually lightens toward the exit, which is so brightly lit from the sun that details have been washed out. To get any detail out of either end of the extremes, HDR is required. The final HDR image, as seen in 6-5, was created from three bracketed handheld exposures taken at the construction site. The idea wasn't to create an overly dramatic HDR photo but to produce a photo that suited the environment — something that captures what is there. Not every detail is brought out, but enough in the walls, floor, ceiling, and exterior to make it a more balanced, functional photograph.

This was a very high contrast scene due to the low light interior and bright exterior. In Photomatix, Luminosity was set to maximum to balance that out. Strength was turned up fairly high, and to reduce the noise, Micro-smoothing was turned up a bit.

> **note** The point of HDR is not to remove all contrast. That leaves you with a flat, gray blob. It's to take too much contrast and intelligently map that to a lower level that you can work with and display. In many cases, you actually elevate the contrast of highly detailed areas of the photo. The point is to place that within the dynamic range of what we can see in an image file.

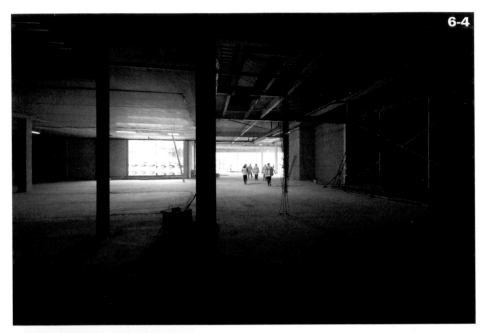

6-4

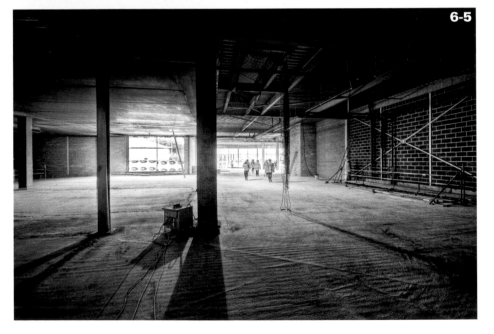

6-5

SHOOTING LARGE INTERIORS IN HDR

The size and scale of large interiors evoke feelings similar to the awe generated by sweeping landscapes and cityscapes. Seek out impressive structures like Grand Central Station in New York City or The British Museum in London to photograph. Tall ceilings are what you should be looking for, and if possible, grand vistas. Buildings with domes, arches, grand central staircases, or large interior gathering areas which are open to many levels qualify. Government buildings, cathedrals and other religious buildings, libraries, and even modern hotels may have very large, open, interiors.

Larger spaces are hard to light evenly or at all, however, making traditional photography problematic. HDR addresses this concern very nicely. Armed with a good wide-angle lens and a tripod if you want to bracket, you can capture large interior scenes that rival anything else in HDR.

CEILINGS IN SHADOW

Large, tall rooms often hide their ceilings in shadow, producing significant variations in light intensity throughout the room. For example, 6-6 shows the interior of a large, old, building. The ceiling design is stunning but is not well lit. Existing light from the windows does not reach the ceiling in adequate strength to use for traditional photography without an excessively long exposure, which blows out the details of the windows (see 6-7). The answer is HDR.

Ideally, you want to set up the shot and take three bracketed exposures to capture details across the dynamic range of the scene, but that isn't always possible. This scene shows the power of converting a single raw photo to three bracketed TIFFs and generating HDR from them as

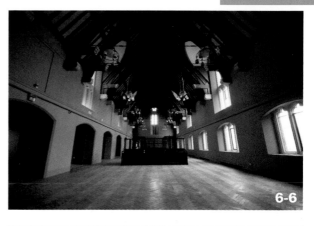

6-6

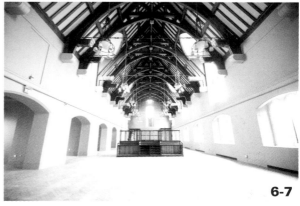

6-7

ABOUT THESE PHOTOS *These photos of the Victorian Building in Liverpool are a practical illustration of dynamic range. Figure 6-6 is underexposed to keep highlights from blowing out. Figure 6-7 is overexposed to reveal details in shadow.*

you would from three bracketed photos. Details in the ceiling are now visible, as shown in 6-8, without sacrificing details in the windows.

To balance the image between the darker unlit ceiling and the rest of the room, Luminosity was set high. Strength was increased fairly high to enhance the image and Micro-smoothing was increased a bit to reduce the noise in the image.

 x-ref

For more information on converting HDR to black and white, please refer to Chapter 7.

ABOUT THIS PHOTO *This is the HDR version of the image shown in 6-6 and 6-7. HDR created from one raw image converted to three 16-bit TIFFs. (ISO 1250, f/4, 1/60 second, Sigma 10-20mm f.4-5.6 at 10mm) © Pete Carr*

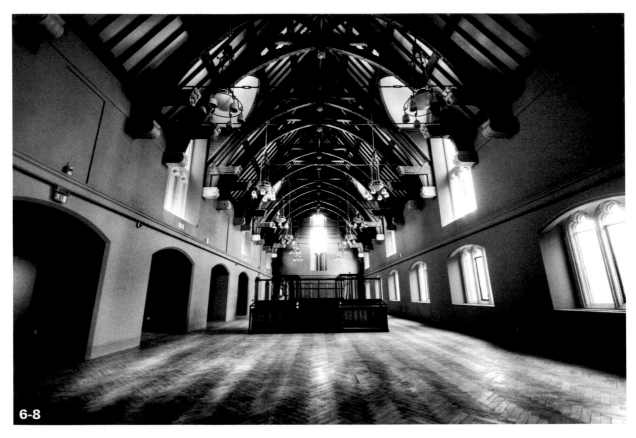

6-8

SINGLE-EXPOSURE HDR

Some purists may object to the process of creating HDR from one Camera Raw file. While it is true that using a single photo versus three bracketed exposures technically captures less overall dynamic range, experiment with both techniques on your own and decide for yourself which one you want to use in a given circumstance.

Using single exposures allows you to pull impressive amounts of detail out of the raw file and bypasses the current limitations of raw editors. Processed correctly, you can show the true potential of a photo. In addition, it is also a more flexible technique with less setup and effort involved than shooting brackets. You can use it on the go and for subjects that are moving.

However, shooting at least three bracketed exposures gives you a far better chance of capturing the complete dynamic range of a scene. Take a tripod, shoot three bracketed photos, and explore the full potential of HDR. The more you work at it, the faster you will become — and you can always use the center bracket to experiment with and create single-exposure HDR images for comparison.

LOW-LIGHT CONDITIONS

Liverpool has two world-class cathedrals. One is very Gothic and the other looks rather abstract. Although their designs differ, they share one key feature: a large and inspiring central space. They are so large and tall inside that it makes you wonder how the buildings don't collapse on you.

Of course, these cathedrals are lit in accordance with their purpose, which has nothing to do with photography. Their lighting reflects the religious nature of the space, which generally encourages quiet reflection and worship. This lack of light makes it a problem to capture the large, open spaces with any level of detail as you can see in figure 6-9.

You can see what's in front of you but not much else. While the building itself doesn't need every detail lit up to serve its purpose, those details need help to work in a photograph. HDR allows you to get at them without having to rig extensive artificial lighting.

A surprising amount of detail can be captured from a single raw file, as seen in 6-10. The deep shadows are gone and the building looks as if it were lit for a photographer. Most surprisingly, the far end of the cathedral appears out of the darkness. It was in the raw data, of course, but the HDR brought out what was overlooked in a standard raw editor.

Within Photomatix, everything was set high for this image. Luminosity and Strength bring out detail in the cathedral all the way to the back. Light-smoothing was kept very high, as always, to avoid halos and an artificial look. Micro-smoothing was not applied.

x-ref

For detailed information on converting a single raw photo to brackets, see Chapter 3.

ABOUT THIS PHOTO
The interior of Liverpool's Anglican Cathedral is not lit with photography in mind. (ISO 200, f/22, 30 seconds, Sigma 10-20mm f/4-5.6 at 10mm) © Pete Carr

6-9

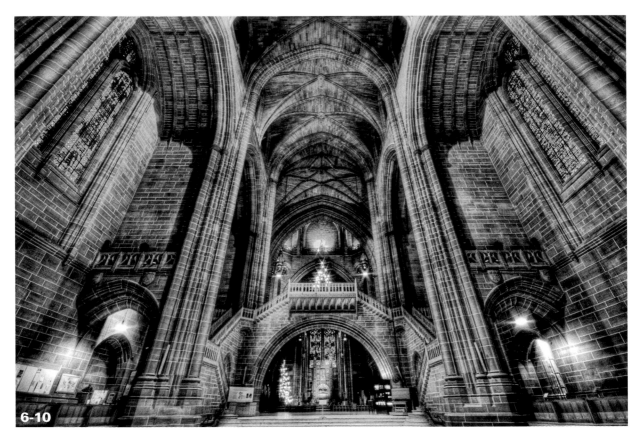

6-10

ABOUT THIS PHOTO *In this interior shot of Liverpool's Anglican Cathedral, the HDR image was created from one raw image converted to three 16-bit TIFFs. (ISO 200, f/22, 20 seconds, Sigma 10-20mm f/4-5.6 at 10mm) © Pete Carr*

FLOORS

Many people don't think about floors, but floors of large, old buildings often contain a treasure trove of detail. And, HDR is just the thing to bring out that glory. For example, a traditional photograph of St. Georges Hall is shown in 6-11. The scene contains a huge room with amazing chandeliers, stone work, pillars, and ceiling. Look down. The floor contains over 30,000 hand-laid pieces, the details of which are lost because the photo is flat and muted (which also causes the window at the back to lose detail).

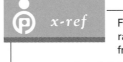 *x-ref*

For more information on processing raw photos prior to generating HDR from bracketed photos, see Chapter 3.

The other serious problem with this photo is the white balance. You can see that it is overly warm and tilted toward orange. The chandeliers are causing this problem. This is easily fixed in camera (if you catch it and reshoot the photo), or during raw processing. In this case, Auto White Balance takes the orange out quite nicely. If that

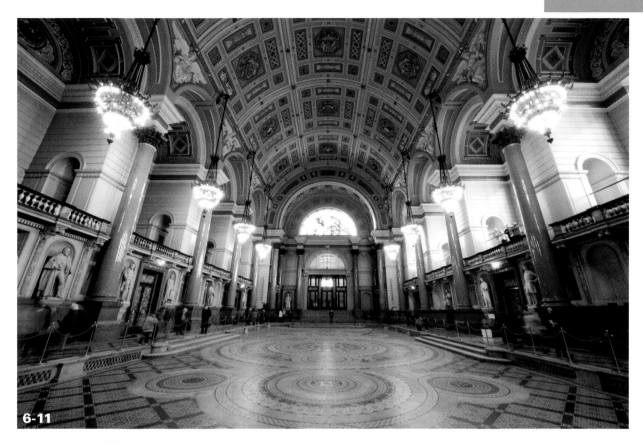

6-11

ABOUT THIS PHOTO *This is the interior of St. Georges Hall in Liverpool. (ISO 200, f/22, 2 seconds, Nikon 14-24mm f/2.8 at 14mm) © Pete Carr*

doesn't work, adjust the color temperature (and tint or hue, if necessary) manually until the photo looks right in your raw editor.

After the white balance was corrected for the three exposures (standard brackets of -2/0/+2 EV) in Adobe Camera Raw, the HDR was generated and tone mapped in Photomatix. By adjusting the Luminosity, Strength, Microcontrast, Microsmoothing, and Light Smoothing in Photomatix, the lost details in the far window and the floor, which are rarely shown, were brought back.

The tone-mapped image was loaded into Lightroom for post-processing. The same adjustments could easily be accomplished in Photoshop Elements. Namely, levels were adjusted to enhance contrast and the white balance was further tweaked. The final result is shown in 6-12, which features significantly more detail than the original photograph.

> **tip** Use the Levels tool to precisely alter the contrast of a photograph in discrete tonal ranges. Click and drag the sliders to adjust shadows, midtones, and highlights as you see fit. By comparison, simple contrast adjustments affect the entire image, regardless of tone.

6-12

ABOUT THIS PHOTO *This interior shot of St. Georges Hall in Liverpool shows more detail than the original photograph. HDR from seven raw images bracketed at -3/-2/-1/0/+1/+2/+3EV. (ISO 200, f/22, 2 seconds, Nikon 14-24mm f/2.8 at 14mm) © Pete Carr*

ENHANCING DETAILS

Another reason to use HDR for interior shots is to enhance details. The photo in 6-13 is of the Large Ballroom within Liverpool's Town Hall, a building that attracts various exhibitions and a large number of weddings because of its beautiful design. Unfortunately, this photo is very dark and most of the details in the floor are lost. Lighting is a real problem here. The chandeliers create a very yellow light and the background is lit in blue.

HDR, of course, isn't designed to fix everything. Blue lighting still appears blue after you tone map an image unless you completely alter the color

balance or throw the original hues out the window in your raw editor before you generate the HDR and tone map it.

HDR can, however, bring out details. The HDR result, shown in 6-14, is another great example of the strengths of HDR. The details have been greatly enhanced in an unevenly lit room with a wide range of shadows and highlights. Notice the railroad tracks, the large mirror to the left of the photo, the chandeliers, and the exhibit itself. In Photomatix, Strength and Luminosity were both set high. The bright lights, a problem area, are now more balanced due to the Luminosity setting.

HDR AND SMALLER SPACES

There's no rule that says you must have a 10mm ultra wide-angle lens and only shoot landscapes, cityscapes, and impressively large interiors. At the opposite end of that spectrum, and no less a part of HDR photography, are smaller spaces. The key point for shooting in smaller spaces is the same as for HDR in general: look for high-contrast scenes with details that can be brought out.

A NARROWER VISION

The photo in 6-15 illustrates an effective use of HDR in a small space. The vision is much more limited than the main room of a cathedral. It is simply a staircase going up. The original photo lacked contrast and detail, which are brought out with HDR. This is another example of how single-exposure HDR can work. Like many images in this chapter there is an issue with bright windows and darker interiors. By increasing the Strength slider you can enhance detail and by increasing the Luminosity you bring out that detail and balance the image out.

6-15

ABOUT THIS PHOTO *This HDR image of a staircase inside the Victoria Building in Liverpool was created from one raw image converted to three 16-bit TIFFs. (ISO 1250, f/4, 1/100 second, Sigma 10-20mm f/4-5.6 at 10mm) © Pete Carr*

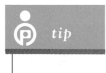 *tip*

Wide and ultra wide-angle lenses are not just useful for large scenes. These lenses allow you to be in a small space and capture it fully. The vertical orientation in 6-15 enables the entire height of the staircase and the ceiling to fit within a single frame and yet retain a feeling of intimacy.

LESS DRAMA, MORE DETAILS

Moving even closer to a subject, it is possible to shoot for interesting details that capture your attention and do not require a billboard-sized print to see. It's HDR on an even smaller scale. In fact, you may find compelling subjects within the same rooms in which you are shooting large scenes. The photo in 6-16 is a good illustration of this. It is the same chandelier as seen in St. Georges Hall in 6-12, but zoomed in much closer — the focal length is 70mm.

The problem is clear in this photo. The camera is metered for the lights instead of the details of the chandelier, underexposing it by a wide margin. This is the same problem that occurs in many traditional photographs — cameras meter for highs and details are lost in shadow. Spot metering

might have helped bring up details in the chandelier, but then the lights would probably have been overexposed and blown out. This is not only annoying, but tragic because the chandelier is a stunning piece.

The results in 6-17 again prove the worth of HDR. The camera may be able to capture the bright lights and details in shadow of the chandelier at the same time in raw (forget about it in JPEG, which has far less dynamic range), but standard processing techniques are inadequate to bring out the best of the photo.

Ideally, you would take three bracketed photos to make sure you get most of the dynamic range of a scene, but that wasn't possible in this case, so a single raw image was processed into three 16-bit

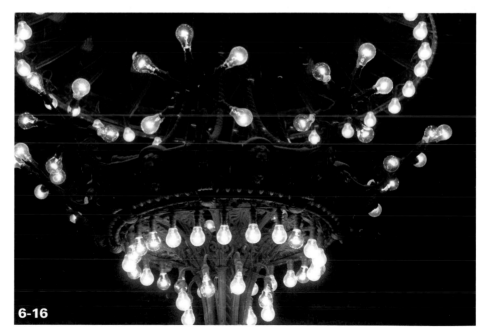

ABOUT THIS PHOTO
This photo of a chandelier inside St. Georges Hall has been metered for the lights rather than the details of the chandelier. (ISO 200, f/4, 1/125 second, Sigma 24-70mm f/2.8 at 70mm) © Pete Carr

6-16

TIFFs. Luminosity was the key in this image to reducing the bright light bulbs while retaining detail elsewhere. Strength enhanced the detail in the chandelier design.

x-ref For more information on converting a single raw image into brackets, please see Chapter 3.

After being tone mapped in Photomatix, it was post-processed further to correct some of the colors brought out by the HDR process that don't look right.

ABOUT THIS PHOTO *This is the HDR image of the chandelier inside St. Georges Hall. (ISO 200, f/4, 1/125 second, Sigma 24-70mm f/2.8 at 70mm) © Pete Carr*

To correct the problems, such as green dashes from the lights and overall yellowish tint, the white balance was nudged a bit cooler and the saturation of the Green channel was reduced. The latter is effective because there is very little green elsewhere in the photo. However, even with these corrections, the center of the chandelier still looked a little underexposed. This is not uncommon. Use the Dodge brush to lighten an area and bring out more details.

note Don't be dismayed at the fact that HDR often requires additional post-processing to look its best. Most of the photos in this book required a good deal of effort and attention to detail during this final stage of the process.

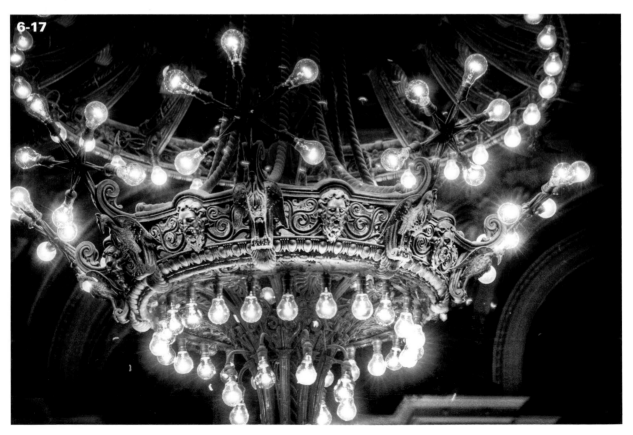

6-17

The final result is amazing, considering the original photo. Far more details in the body of the chandelier are visible and there are gorgeous starbursts on many of the light bulbs. Notice that the light bulbs themselves look clearer without blowing out the rest of the scene.

PROBLEM-SOLVING WITH HDR

There are times when the scene you want to photograph is not ideally suited for HDR. It may be inside in a room with low contrast, and you may already have reasonable lighting or plan on using a flash. You may not need to embellish or accentuate the details. Despite when HDR is not the most obvious choice, it can be the ideal solution.

The photo in 6-18 is of a Superlambanana, the object of an art installation. The photo shoot involved placing them in interesting local scenes — this one is on the stage at The Magnet, a Liverpool music venue.

The scene did not immediately cry out for HDR. It was not high-contrast and lights were brought in to make the Superlambanana stand out from the ever-present red lighting of The Magnet. The lighting had only been rigged to effectively light the stage, however, and not the rest of the room. The background needs more lighting to show details.

HDR is a viable answer to many lighting problems, even in situations that don't strictly call for HDR. If possible, use three bracketed shots when the background light is so poor. If you are tempted to use a single raw image as the basis of HDR with so many dark shadows in a room, you are likely to end up with a very noisy image.

During tone mapping, the Strength was set high to emphasize the detail in the room. Luminosity was also raised to balance the light between the

ABOUT THIS PHOTO
The Superlambanana was shot inside The Magnet, a poorly lit musical venue in Liverpool. Not surprisingly, the only area that is well lit is the stage. (ISO 100, f/8, 0.8 second, Sigma 10-20mm f/4-5.6 at 14mm) © Pete Carr

6-18

darker areas and the semi-lit stage. Micro-smoothing was raised about a third. This level of Micro-smoothing reduced an overdone HDR look with halos, and helped keep the noise levels down.

In the end, however, the HDR didn't look quite right. Therefore, the Superlambanana was selectively desaturated. To do this yourself, follow these steps:

1. **Use the Quick Selection tool in Photoshop Elements to select the object you want to adjust.** This protects the rest of the photo.

2. **Choose Enhance ⇨ Adjust Color ⇨ Adjust Hue/Saturation.**

3. **Set the Saturation to the desired level, in this case 0.**

The result is shown in 6-19. There is much more detail on the stage, the central floor, the walls, ceiling, and rear of the room. It's interesting to note that the subject of the photo was probably the least affected by HDR. Everything around it, however, now contributes greatly to the ambience of the photo.

6-19

ABOUT THIS PHOTO *Here is the desaturated HDR image of Superlambanana taken inside the music venue The Magnet. (ISO 100, f/8, 0.8 second, Sigma 10-20mm f/4-5.6 at 14mm) © Pete Carr*

MIXING IT UP

Thus far, you've seen how to take photos inside large and small spaces. Now it's time to mix it up and shoot HDR in high-contrast scenes that capture interior and exterior details. With the right light and processing, you'll be able to capture a significant amount of detail both inside and out.

CAPTURING FROM THE INSIDE OUT

It pays to be shooting during the Golden Hour when you are interested in capturing exterior details — even if you shoot from inside. The photo in 6-20, for example, was taken in the café of a large store, complete with a lovely view of a neighboring park outside the windows. When the shot was taken, the sun was just hitting the park and part of the café.

The shot almost works. It could be acceptably processed and shown to a client and would probably be approved. However, there are a few problems. The far right side is quite dark. Attempting to fix that in raw would then cause the left side to become blown out. An ND graduated filter might help here, but that would have darkened the ceiling and other interior details on the left side of the photo, not just the bright exterior.

 x-ref | Please refer to Chapter 2 for more information on filters.

HDR generates a more balanced photograph, as seen in 6-21. Three bracketed images were used in Photomatix to create the HDR for tone mapping. Although the photo is still a tad darker on the right, it has balanced out overall. The red accent on the interior wall has been greatly enhanced and keeps your eyes from always drifting left. The contrast is better; details have improved, and notice that the floor has an attractive glow

ABOUT THIS PHOTO
The original image of the café inside a shopping center. (ISO 100, f/9, 1/50 second, Sigma 10-20mm f/4-5.6 at 10mm)
© Pete Carr

6-20

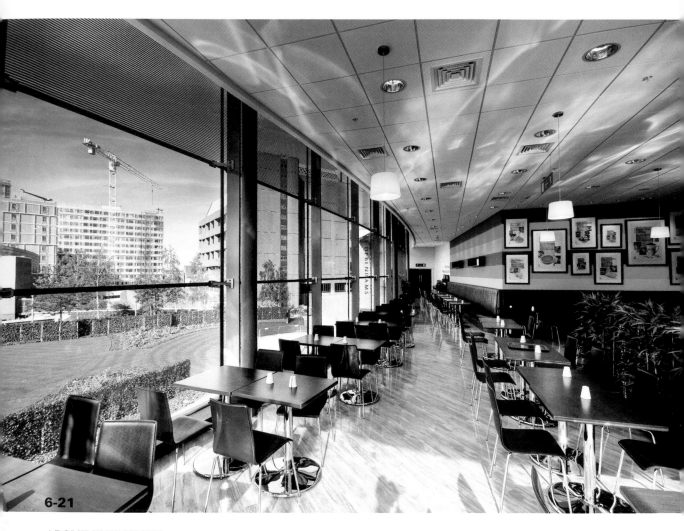

6-21

ABOUT THIS PHOTO *Here is the café inside a shopping center after HDR processing was applied. HDR from three bracketed photos at -2/0/+2 EV). (ISO 100, f/9, 1/50 second, Sigma 10-20mm f/4-5.6 at 10mm) © Pete Carr*

compared to the original. Also, notice that the sky has clarified. The photo has more punch, which was the idea.

The idea in this shot was to capture the outside without the image looking fake or computer generated. In Photomatix, Strength was set just above medium as was Luminosity. It was early morning and the light was good. HDR helped to

bring out some extra detail in the clouds outside and the cafe inside through Luminosity and Strength settings.

In this case, it would have been overkill to attempt to create an overly dramatic, artistic photo. The point was to balance the scene, increase the level of detail, and present the café as a nice place with a great view. No special lighting was used and details within and without were captured easily.

LOOKING IN FROM THE OUTSIDE

Don't think that you can only shoot from the inside out. It's entirely possible with HDR to shoot from the outside in. You can retain detail on the outside of buildings and peer inside, which is often impossible with traditional photography. This is the case in 6-22.

The building is captured acceptably, but the interior, which is an art installation that is supposed to look like a reflection of the street outside, is blown out. The photo was taken at dusk, and because the camera was set for evaluative metering, it exposed the building to bring up details. The bright interior lighting overpowers the image and most details are lost inside.

x-ref

For more information on camera metering, see Chapters 1 and 2.

Three bracketed photos were taken to create the HDR. One was exposed normally, one exposed for the building exterior, and another for details on the inside. The result is shown in 6-23. The image is more balanced between details on the inside and outside. It's much closer to what you would see if you were standing there. Like 6-21, the idea was to get a normal looking image and balance it so you could see in as well as out. Strength was set just above medium to bring out some detail without overdoing it. The same rationale was applied to Luminosity, which helped balance the interior lighting with the exterior.

ABOUT THIS PHOTO
This shot of an art installation in a shop window in Garston, Liverpool, shows the exterior of the building but the interior is blown out. (ISO 100, f/8, 20 seconds, Sigma 24-70mm f/2.8 at 25mm) © Pete Carr

The main challenge that had to be overcome in additional post-processing was correcting the white balance. The interior lights were a different color temperature than the outside street lamps. Any adjustment to one would have affected the other, so, in Photoshop, two gradient layers were used on the top and bottom (arranged as bands over the brickwork at the top and the road at the bottom) with saturation set to -20 on each. This reduced the yellow tint.

tip Remember that you can use HDR to get around everyday problems you face in photography as well as create stunning works of art.

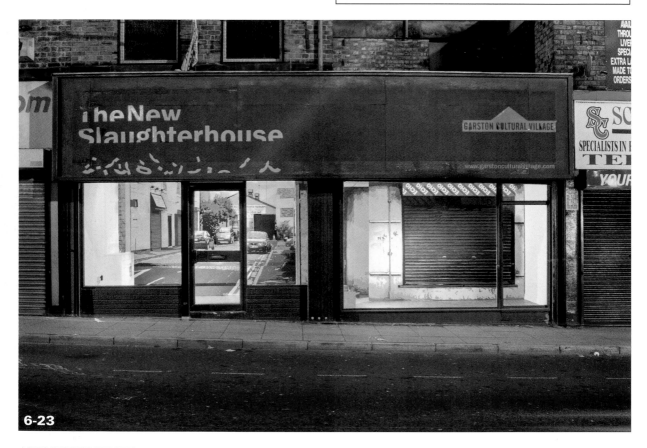

ABOUT THIS PHOTO *Here is the HDR image of the art installation in a shop window in Garston, Liverpool. HDR from three bracketed photos at -2/0/+2 EV. (ISO 100, f/8, 20 seconds, Sigma 24-70mm f/2.8 at 25mm) © Pete Carr*

Assignment

Capture an Interior Scene Lit with Ambient Light in HDR

This chapter covers a lot of different material connected to photographing interiors in HDR. You saw examples of common problems when shooting inside, and learned how to shoot large and small spaces from the inside out or from the outside in.

For this chapter's assignment, put what you have learned into practice. Find a high-contrast interior that you want to shoot. It can be large, small, contain details, have drama, odd angles, finely crafted fixtures, or have wild and crazy décor. Accept the challenge of shooting without a flash or any other lighting accessories. It's just you and the interior. Remember to compensate for white balance issues and other problems in camera or in post-processing.

Pete shot this photograph from within Birkenhead Tunnel, which connects Wirral and Liverpool in the UK, looking out. It is a deceptively high-contrast scene. Because the lighting inside the tunnel is very mild (and orange, to aid the traffic) and the outside is incredibly bright, he used three bracketed photos at -2/0/+2 EV. Taken at ISO 200, f/4, 1/125 second with a Sigma 10-20mm f/4-5.6 lens at 10mm.

See if you can find a similarly contrasted interior and use HDR to bring out details in shadow and highlights. Post it to the Web site to share with others.

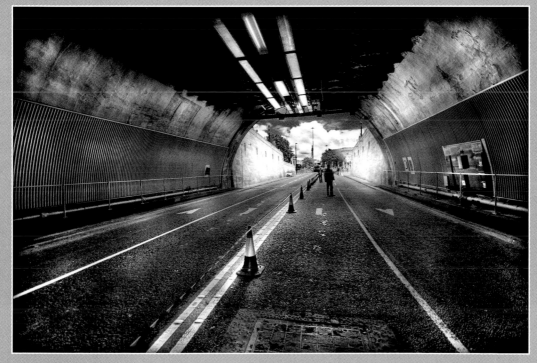

Remember to visit www.pwassignments.com after you complete this assignment and share your favorite photo! It's a community of enthusiastic photographers and a great place to view what other readers have created. You can also post comments, read encouraging suggestions, and get feedback.

BLACK AND WHITE

© Pete Carr

Volumes have and will be written about the beauty of black-and-white photography. When done well, black-and-white photos have the power to move us in completely different ways than color. The tones. The shades. The contrast. The way light plays across intimate or grandiose subjects. Black-and-white photos can be delicate or harsh, welcoming or foreboding, smooth or rough, real or fantastic. They have the unique ability to be timeless.

Black-and-white photos are not simply color photos without the color. They use light and shadow to tell their story rather than color. This information is taken from the three color channels that make up the original color photo and can be mixed in any proportion you desire when converting from color to black and white. This variability, and the control you exercise over it, results in handmade black-and-white photos that respond to your artistic vision. Understanding this is a big step toward moving into the world of black-and-white HDR photography. Learning how to see the differences between color and black and white — and combine black-and-white photography with the strengths of HDR — are the subjects of this chapter.

THINKING IN BLACK AND WHITE

It takes training to see in black and white because humans are very consciously aware of color — the color of the subjects, background, light, and reflections. A black-and-white photographer should be able to see a scene differently — long, deep shadows with rich contrast between the dark areas and highlights.

The beauty of black and white is a paradoxical combination of simplicity and complexity. With color information artfully removed, you are able to focus on tonal variations, the play of light and shadow, texture, and contrast. Your eyes respond to different stimuli than with a color photograph. They soak up tones and details, as in 7-1.

While tone mapping, Luminosity was set quite high to bring out the detail in the sky. Strength was also set close to its maximum to create the effect in the clouds, which includes some heavy vignetting.

You don't need to think in terms of black and white for every photo, obviously, but be open to the circumstances and recognize the possibilities for black and white.

WHAT TO LOOK FOR

Generally speaking, you should follow the same technical principles when shooting for black and white as you do for color HDR photography. Seek out high-contrast scenes. Try to shoot during the Golden Hour if you can. This is the best time to capture long shadows, which look even better in black and white.

Think of whether the tones will be sympathetic to black and white. Ask yourself if the photo will have the same impact without color — maybe it will have more impact in black and white, as in 7-2. This shot is of an old, abandoned car that leaps out in black and white. Converting it simplifies the photo and places the emphasis on details and contrast — not on what color the car is versus the truck or sky. In fact, the car is a rather bland off-white, a relatively uninteresting color.

7-1

ABOUT THIS PHOTO *Here is a black-and-white photo of a Superlambanana in Kensington, Liverpool. It was created from three raw images. After HDR conversion, it was converted to black and white. (ISO 100, f/8, 1/640 second, Sigma 10-20mm f/4-5.6 at 10mm) © Pete Carr*

Tone-mapping settings in Photomatix were pushed hard for figure 7-2. Strength, Luminosity, and Microcontrast were all maximized to enhance as many details as possible. The White Point was also maximized, which brightened the photo and increased contrast. The Saturation Shadows setting was reduced by one to keep the darker areas under control, even though the photo was eventually converted to black and white. Most significantly, Light Smoothing was dropped to Medium. This can result in a photo plagued with halos and an air of unreality, but with this photo it balanced the light between sky and ground better and created a powerfully pleasing effect.

ABOUT THIS PHOTO *This abandoned Pontiac Executive is a favorite subject. HDR from four raw exposures bracketed at -2/0/+2/+4 EV. (ISO 100, f/8, 1/60 second, Sigma 10-20mm f/4-5.6 at18mm) © Robert Correll*

THE FOCUS OF ATTENTION

A well-composed and processed black-and-white photo gets straight to the point without distraction. It does this through tone and contrast. The result is as if you were using depth of field to focus on someone or something specific in a photo. Notice the viaduct in 7-3. It cuts through the black-and-white landscape with clarity because it stands out against the lighter landscape. Light versus dark. Contrast. Detail. Your eyes are drawn to it first and you instantly know what the photo is about — a viaduct moving across a beautiful landscape.

For this shot, Strength was set fairly high to bring out the detail in the sky. Luminosity was used to balance the image so the sky isn't as blown out as it would normally be.

ABOUT THIS PHOTO
This is an HDR image of a viaduct. HDR created from one raw, converted to three 16-bit TIFFs. (ISO 100, f/8, 1/30 second, Canon 28-105mm f/3.5-4 at 28mm) © Pete Carr

7-3

OVERCAST DAYS

Another benefit of black and white is that it opens up more possibilities for you as a photographer than if you shoot only with color in mind. You can shoot on days when color would look dull. Overcast days are prone to desature colors so photos appear lifeless. Blue skies with white, fluffy clouds are replaced with a blanket of gray.

note
Dull days are an irritant to landscape photographers, but as mentioned before, they can be a pleasure for portrait or wedding photographers. The dynamic range is reduced to more manageable proportions, which means highlights are less likely to be blown and shadows are less likely to swallow details. Don't let this stop you from shooting HDR. While the effect may be lessened, it will still be possible to enhance details and contrast compared to traditional photographs.

These conditions don't have to ruin your day if you look for opportunities to shoot in black and white. The photo in 7-4 was taken on a cold, overcast day in Toronto. If shot only for color, the day might have been lost. While the gray sky threw a wet blanket over everything from the perspective of color, that problem disappears very naturally in black and white. Not only that, there are enough details in the clouds in black and white to make them interesting. HDR can pull more details out of a gray sky than you may notice on the scene. This photo presented similar tone-mapping challenges as shown in 7-3.

ABOUT THIS PHOTO *This photo of Toronto City Hall was taken on a cold, overcast day. HDR created from three bracketed photos at -2/0/+2 EV. (ISO 100, f/8, 1/200 second, Sigma 10-20mm f/4-5.6 at 10mm.) © Pete Carr*

7-4

Another benefit of shooting black-and-white photos on a cloudy day is that you can shoot at any time. There is no Golden Hour because there are no harsh shadows at noon — the sun is blocked. You can work all day at a given location. When you process the photos later add contrast without being afraid of blowing out highlights.

PEOPLE

Black-and-white processing presents people in a different and wonderful light. Emphasizing the Red channel of an RGB image during the conversion to black and white smoothes a per-

son's skin — the lack of detail (normally not what you want for HDR) removes lines and shows off the beauty of the face. This presents a glamorous portrait — smooth, clean, elegant, and beautiful, as you can see in figure 7-5.

> **note** You cannot directly manipulate channels in Photoshop Elements. You can, however, use the Convert to Black and White routine to specify how much of each channel contributes to the black-and-white conversion.

In this image, tone-mapping settings were quite restrained. Strength was set just above medium to enhance the detail in the eyes. Luminosity was also set to medium. Microcontrast was increased to reduce the overly tone-mapped look.

If you want to accentuate detail rather than smoothness, emphasize the Blue channel in your conversion, as seen in 7-6. The Blue channel brings out details in a person's face. Notice the

lines and roughness brought out by a combination of information in the Blue channel and using HDR. This man's face is rough-hewn and gritty — the opposite of glamour.

To get the detailed look in this image, Strength was increased to near-maximum. Luminosity was also turned up quite high too to balance the harsher light on one side of the man's face with the rest of the image.

7-5

ABOUT THIS PHOTO *HDR is used to enhance the detail in this model's eyes. The shallow depth of field was achieved by using the longest focal length of the lens and a wide-open aperture. HDR created from one raw converted to three 16-bit TIFFs. (ISO 320, f/2.8, 1/100 second, Canon 24-70mm f/2.8 at 70mm.) © Pete Carr*

You can, of course, push a good thing too far. Overemphasizing red removes all detail in a person's face. Likewise, overemphasizing blue adds so much detail the subject will look terrible. The latter situation is especially problematic in HDR. People aren't like mountains or old buildings. Be careful not to bring out so much detail your artistic license gets revoked.

> **tip** Know the rules, but experiment with breaking them. Whenever someone says "Don't do this..." try it anyway and see if there are situations where you can get away with it.

A good rule of thumb is to enhance the background but retain a level of normality in the person (as in 7-7). This applies both to HDR and black-and-white conversion. In figure 7-7, no selective editing was applied. The person wasn't dropped in from another photo or any other wizardry — this is all one HDR image. The Red channel was adjusted to remove a little detail in her face without losing too much detail in the background. HDR enhanced the snow dramatically.

While tone mapping, Luminosity was set quite high to help bring out more of the snow falling. Strength was turned up quite high too to enhance the scene and Micro-smoothing was added a little to reduce the overall HDR look.

> **tip** Always be mindful of when HDR has an adverse affect on people in your photos. Converting to black and white can help by taking color and saturation issues out of play.

7-7

ABOUT THIS PHOTO *HDR is used to enhance the detail in the background of this person in a fake snowstorm. HDR created from one raw exposure converted to three 16-bit TIFFs. (ISO 200, f/2.8, 1/500 second, Canon 24-70mm f/2.8 at 70mm) © Pete Carr*

HDR LANDSCAPES IN BLACK AND WHITE

If you are attempting to make a black-and-white landscape image using traditional photo-editing techniques, you may find yourself in the midst of a particular dilemma. If you increase contrast to enhance the presence of details you run the risk of losing information in shadow and blowing out highlights. This is because increasing contrast in an image editor pushes both ends of the light-to-dark spectrum away from each other. HDR allows you to bring details of your photos out intelligently using information gathered from the entire dynamic range of the source images to tone map onto a lower dynamic range file. It's brilliant and works exceedingly well for high-contrast black-and-white landscapes, as in 7-8, where large, foreboding clouds hover over rugged mountains, casting their shadows on the landscape. It's an impressive scene, made more appealing by the combination of HDR processing and black-and-white conversion.

To get the dramatic sky, Strength and Luminosity were both set quite high. This brought out a lot of detail in the sky without losing any in the ground.

Even if you are not using the best possible lens, details in the scene stand out because of HDR. Notice, however, that one area of the photo is left as silhouette. The man in the lower left provides scale for the photo, and his presence would not have worked as well if this photo was presented in color because his silhouette would not have been as stark. In black and white, the shadows and highlights contrast wonderfully.

> **note** There are a number of black-and-white HDR examples sprinkled throughout the book in other contexts. After reading this chapter, make a point to leaf through the book and examine them.

7-8

ABOUT THIS PHOTO *This HDR image of the mountain Ben Nevis in Scotland was created from one raw image converted to three 16-bit TIFFs. (ISO 100, f/11, 1/90 second, Canon 28-105mm f/3.5-4 at 28mm)* © Pete Carr

UNDERSTANDING COLOR CHANNELS

RGB images — even tone-mapped HDR files — are composed of three color channels: Red, Green, and Blue. Added together, they produce a full-color photo, such as the one in figure 7-9, which is a nice landscape with a railroad cutting across the scene in HDR. In this and the following images of the same scene, Strength was set high to bring out the detail in the clouds and landscape. Luminosity was set high to bring out the sky while retaining detail in the ground.

> **note** Black-and-white photographers will tell you that a good black-and-white photo is based on one of the three color channels, most often the Red channel. In fact, film photographers often put filters over their lenses to help in the production of Red-channel black and whites.

Taking 7-9 and splitting the color channels into separate images results in 7-10 through 7-12. These figures show the color channels of Red, Green, and Blue, respectively, which make up the photo in 7-9. The intensity of the channel's color is represented by gray values that range from black (no color) to white (full, intense color). Therefore, dark shades of gray reveal the absence of that channel's color as it contributes to the total image. Conversely, lighter shades of gray reveal bright colors for that channel. It works like a layer mask — black hides and white reveals.

Figures 7-10 through 7-12 illustrate the following color channels as they appear in black and white:

- **Red.** In figure 7-10, you see the Red channel. Notice the higher contrast on the side of the mountains. You can see more details there, but the berm the train tracks rest on has less detail. This is because the area beside the train tracks has more red, hence the shades of gray are lighter here. This is also why young, vibrant skin (for lighter-skinned people) appears smoother in the Red channel — the healthy pink skin has more red in it, just like the area surrounding the train tracks have in this image.

- **Green.** Figure 7-11 shows the Green channel, which is a close approximation to the lightness of the original color photo. This seems counterintuitive. You would expect to see much lighter shades of gray in this channel due to the amount of green in the color photo.

- **Blue.** Figure 7-12 shows the Blue channel. It is the least contrasted — the tree in the front right has all but disappeared. Notice that as a whole, this is almost an inverted version of the Red channel.

Figure 7-13 shows the completed conversion to black-and-white HDR. Can you tell what color channel was used more heavily than the others? If you guessed the Red channel, you'd be right.

ABOUT THESE PHOTOS *Figures 7-10, 7-11, and 7-12 are the individual RGB color channels taken from the photo in 7-9; respectively Red channel (7-10), Green channel (7-11), and Blue channel (7-12). 7-13 shows the final HDR image, as converted to black and white. (ISO 100, f/6.7, 1/125 second, Canon 28-105mm f/3.5 - 4.5 at 45mm) © Pete Carr*

7-13

This is why black-and-white photos are not simply color photos without the color, and why converting color HDR photos into black-and-white HDR images takes thoughtful attention. Each color channel has a different role to play in the color image and information from different color channels will impact the resulting black-and-white photo differently. What is light in the Red channel may be dark in the Green channel. Details preserved in the Blue channel may be lost in the Red channel. You should be thinking of how detail, contrast, tone, and luminosity are affected based on the blend of color channels that you use to, paradoxically, create black-and-white photos with.

note

Photoshop has a nifty tool, actually an adjustment layer called Selective Color. In addition to a range of other colors, you can adjust white, black, and neutral areas of the image. If you want to emphasize contrast, deepen the blacks (carefully) and neutrals.

CONVERTING HDR TO BLACK AND WHITE

When you decide to try your hand at black-and-white HDR photography, workflow and process questions naturally arise. There are many ways to get to a final, processed black-and-white HDR photo. This section shows you an effective way to manage the process and produce fantastic results.

> **note** Everyone has a different method for converting color photos to black and white. You are encouraged to experiment with different ideas. Some won't make that much of a difference and some will look pretty bad. Others may be very complex and time consuming. The solutions presented in this section are a professionally proven balance between productivity and quality.

HDR FIRST, THEN BLACK AND WHITE

Although you are probably excited to process your photos into black and white as soon as you can, process the color exposures into HDR using your standard HDR procedure before converting the final image to black and white. The primary reason is because creating one black-and-white image out of a single HDR image is easier than creating an HDR image out of several black-and-white photos. The following list explains the challenges when working from different situations, pre HDR conversion:

- **Bracketed raw exposures.** Converting the over and underexposed bracketed images to black and white is based on guesswork. You have no way of knowing how to decide what anything should look like because it is not properly exposed. If you use the center exposure as a baseline, you must decide on the best settings, convert the image, then apply the same settings to the other bracketed images. This multiplies your workload by the number of brackets you shoot.

- **Single raw exposure.** After converting the single raw exposure to three 16-bit TIFFs, you are in the situation as before with bracketed exposures and a multiplied workload.

- **Converting raw.** Depending on your raw editor, you might be able convert the raw images to black and white as you save them as TIFFs. You might even have a fair degree of control over this process. Assuming you apply identical black-and-white settings to all exposures, this might work well enough and not overly add to your workload; however, you may not get the ideal results when the images are processed as HDR.

In the end, whether or not you are willing to assume a greater workload or not, the flexibility of having a finished color HDR image to work from is tremendous. You may or may not choose to convert it to black and white, and if you do, you will be able to experiment with different conversions without having to go back to the beginning and start over.

> **tip** Try to keep your source images as unprocessed as possible as you convert raw files to TIFF and then process into HDR.

MAKING THE CONVERSION WITH PHOTOSHOP ELEMENTS

After you properly generate an HDR image that is tone mapped to your liking, it's time to convert it into black and white. Although you may be tempted to desaturate the photo in order to convert it to black and white — don't. Likewise, don't convert the image to grayscale. While it is true that both of these options remove color information from the file and convert it to black and white, you have no control over the process.

You have to take what it gives you, good or bad. Your goal is not simply to remove color; it is to be creatively involved in the process of black-and-white HDR photography.

To convert your image into black and white using Photoshop Elements, follow these steps:

1. **Open your tone-mapped photo in Photoshop Elements.** If it is 16-bit, you have to convert it to 8 bits per channel by choosing Image ⇨ Mode ⇨ 8 Bits/Channel.

2. **Choose Enhance ⇨ Convert to Black and White.** This opens the Convert to Black and White dialog box with preview windows, preset styles, and channel sliders (7-14). Most other applications have similar or greater capabilities than Photoshop Elements. You should look for a similar menu option or try mixing color channels.

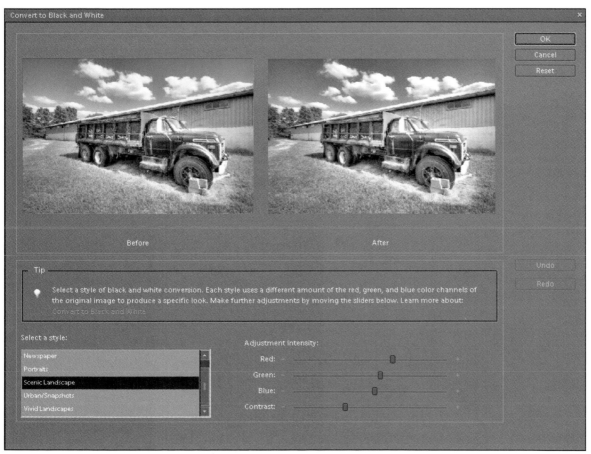

7-14

ABOUT THIS FIGURE *An old truck is converted to black and white in Photoshop Elements using a preset in the Convert to Black and White dialog box. The image has already been converted to HDR, tone mapped, saved as a TIFF, and converted to 8 bits per channel.* © Robert Correll

3. **Select a Style from the list at the left.** Investigate its effect by looking at the After window. Pay attention to tone and contrast. Select other presets to compare.

4. **Tweak the Adjustment Intensity sliders.** Many times you have to fine-tune the effect. Remember, the Red channel smoothes and the Blue channel emphasizes details. If you are shooting portraits, these channels can be used very effectively for people as well.

Continue working to improve your black-and-white HDR photos with additional post-processing. You can make a tremendous difference in how the final image looks during this stage, as seen in 7-15. The effect of HDR and black and white (with an emphasis on the Red channel) creates a totally unique photo. The final post-processing steps were completed in Lightroom and included increasing Fill Light and Black to bring out more detail and enhance contrast and an s-shaped curves adjustment to increase contrast.

> **x-ref** For more post-processing techniques, see Chapter 3.

The best way to learn is to experiment. Open your own graphics application, load a processed HDR file, and play with the settings found in the Convert to Black and White dialog box (or a suitable counterpart if you are using another application).

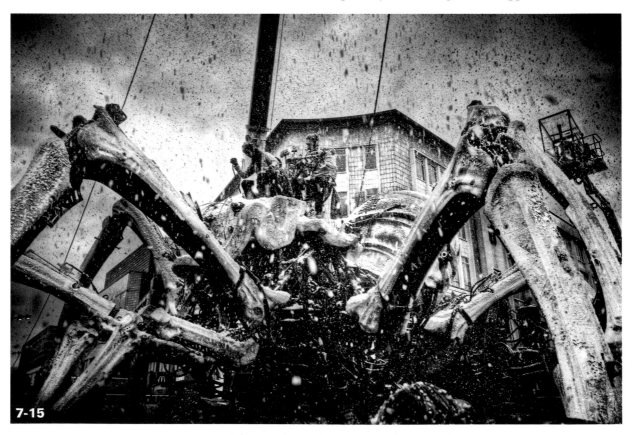

7-15

ABOUT THIS PHOTO *Shown here is La Princess as part of La Machine in Liverpool. HDR created from one raw exposure converted to three 16-bit TIFFs, and then converted to black and white. (ISO 1000, f/7.1, 1/200 second, Sigma 10-20mm f/4-5.6 at 18mm) © Pete Carr*

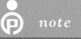

note When using Photoshop Elements, don't forget about the Infrared preset (or infrared filters if using another application) when deciding what creative route to take with black-and-white conversion. Infrared filters often create the appearance of visually unique black-and-white photos. This preset is located in the Convert to Black and White dialog box.

DODGING AND BURNING

Dodging and burning are time-tested techniques for increasing detail and contrast. The general principle involves selectively editing shadows and highlights. Use burn to darken areas of the image and dodge to lighten areas.

Both these techniques were used in 7-16, although you may not be able to tell where at first glance. The idea is to make dodging and burning blend in with the photo. You should undo anything that looks obvious or where there are tell-tale signs of your work (most often, brush paths of different tonality).

While tone mapping, Luminosity was set very high to bring out all the detail in the sky. Strength was also set high to give it a dramatic look. No Micro-smoothing was applied. The cathedral was too dark after the photo had been

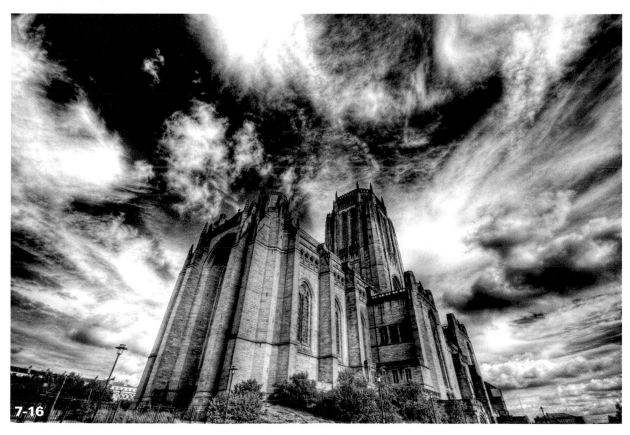

7-16

ABOUT THIS PHOTO *This HDR image of Liverpool's Anglican Cathedral uses both dodging and burning techniques to emphasize specific areas. HDR from three raw exposures bracketed at -2/0/+2 EV. (ISO 100, f/8, 1/125 second, Sigma 10-20mm f/4-5.6 at 10mm) © Pete Carr*

tone mapped and converted to black and white. Dodging corrected that and brought out more detail in the area. The sky was not dramatic enough — not enough contrast — so, areas of the sky were darkened with the Burn brush.

> **tip** Use a soft brush when dodging and burning. This helps blend the strokes into the photo.

You should approach dodge and burn with one overarching principle in mind: If you feel there are areas of the photo that can be improved by adding detail or contrast, do so. Figure 7-17 illustrates an HDR image that has been converted to black and white. It looks fine, but it can be improved. The ground is not clear enough and the propeller is lost in a region of similar tone. The aircraft could be brighter to make it stand

out from the ground, and the sky, while generally okay, is blown out in areas and needs more attention. It all comes down to details and contrast.

While tone mapping, Luminosity was set quite high to bring out the detail in the sky. Unfortunately, the photo was shot into the sun so it wasn't possible to retain all the detail. Strength was also fairly high to give the clouds a dramatic look.

The changes are seen in 7-18. The photo is far better — the additional contrast and enhanced details finish it off very nicely. The plane, propeller, and sky are all clear and distinct. Notice that the helicopters now stand out, whereas they disappeared into the sky and ground before.

It's important to note that these are selective changes. The entire sky did not need burned, for example — just a few areas. As you get more experience you'll see that you can easily overdo dodging and burning. Your photo can look overprocessed, devoid of detail, and potentially noisy.

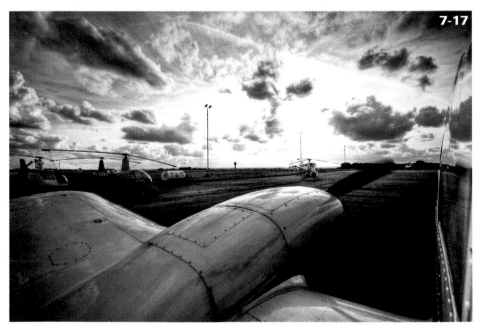

7-17

ABOUT THIS PHOTO *A light aircraft taking off at Liverpool airport shown before dodging and burning techniques were applied. HDR created from one raw exposure converted to three 16-bit TIFFs. (ISO 100, f/5.6, 1/1000 second, Sigma 10-20mm f/4-5.6 at 10mm) © Pete Carr*

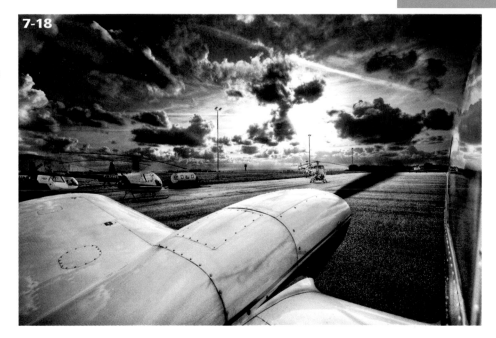

7-18

Examine your work with a critical eye and don't hesitate to click Undo and start over. Remember, HDR is about capturing detail in shadows and highlights.

Enhancing contrast through dodging and burning is great, but the more you push the envelope you risk turning your photo into what you were trying to avoid in the first place — a photo with blown-out highs and black lumps for shadows.

x-ref | Modify the strength or exposure of the brush in order to control the effect and experiment with setting the range from shadows to highlights. More tips on dodging and burning can be found in Chapter 1.

TONING

While black-and-white photos look fantastic, there's something to be said for toning your images. That something is a rich tonality that is not as stark as pure black and white. There are many ways to add a colorful tint to black-and-white HDR photos, and they all boil down to adding at least one other color to the photo. Often, but not always, black is kept in the image.

ENHANCING WITH COLOR

Many people love toned (also called tinted) images for the feelings they evoke. The photo can be of a romantic scene, loved ones, or something nostalgic, like the large ocean liner in 7-19. This photograph was processed into HDR, converted

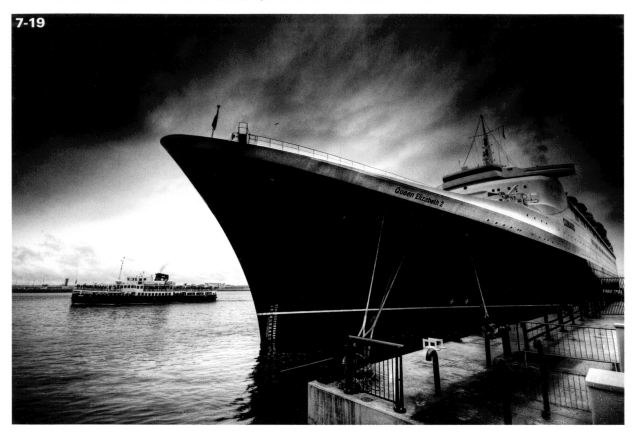

7-19

to black and white, and then toned. A combination of red and yellow is used across the shadows and highlights. The midtones are ignored to preserve a strong sense of black and white.

Tone-mapping settings in Photomatix were quite high to get the detail back in the sky. It was a very gray, dull day, so Luminosity and Strength were turned up to add drama to the sky.

In 7-20, reds and yellows are used for the shadows, and blue is used to tint the highlights. This combination works well for this scene. Toning, when combined with the subject, produces an otherworldly, yet somehow subtle science-fiction feeling.

To bring out the detail in the smoke, Strength was set quite high. This added to the gritty, dramatic effect. Luminosity was also set quite high to balance the light.

Neither of the previous two photos would look the same without the additional toning. Try not to overdo it, however. Subtle tones, selectively added to impart flavor and feeling, can elevate photos to another plane.

7-20

ABOUT THIS PHOTO *This HDR image of La Princess as part of La Machine. HDR created from one raw exposure converted to three 16-bit TIFFs. (ISO 200, f/5, 1/640 second, Canon 24-70mm f/2.8 at 24mm) © Pete Carr*

CREATING TONED IMAGES IN PHOTOSHOP ELEMENTS

Toning your black-and-white HDR photos in Photoshop Elements is a pretty easy process using a feature called Variations. To create a toned image, follow these steps:

1. **Open an HDR image that you've converted to black and white.**

2. **Choose Enhance ⇨ Adjust Color ⇨ Color Variations.** The Color Variations dialog box appears, as shown in figure 7-21. You get a nice-sized preview area, some controls to change how the effect is applied, and smaller thumbnails that correspond to different color variations.

3. **First, select an area of the image.** This is important because it limits changes to a range of tones: Midtones, Shadows, and Highlights. Ignore Saturation for this task.

> **note** As is often the case, there are more ways than one to accomplish a task in Photoshop Elements. Aside from Variations, you can create toned images by using tinted Solid Color Fill layers (set to Color blend mode and tweak opacity), the Colorize feature of the Hue/Saturation color adjustment or even Hue/Saturation adjustment layers.

183

Color Variations

OK
Cancel
Help

Before After

Undo
Redo
Reset Image

Tip
Select the brightness values you want to adjust (middle tones, dark areas, or light areas). Drag the Amount slider to set the intensity of the change. Click a thumbnail preview to make your image match it.

1. Select area of image to adjust.

○ Midtones
○ Shadows
◉ Highlights
○ Saturation

2. Adjust Color Intensity.

Amount:

3. Use buttons below to adjust your image.

Increase Red Increase Green Increase Blue Lighten

Decrease Red Decrease Green Decrease Blue Darken

ABOUT THIS FIGURE
This is the Color Variations dia-log box in Photoshop Elements.
© Robert Correll

7-21

4. **Click the color box that reflects the adjustment you want to make to your image.** You may increase or decrease the amount of Red, Green, or Blue in addition to lightening or darkening the photo. Each click increases or decreases the color by the intensity chosen on the small slider to the left.

5. **Mix and match the areas and color combinations.** Generally speaking, blue and green work well together, as do red and yellow. They work because black and white is built on contrast. Cross-processing, covered later in the book, is produced with yellow and green. Experiment and have fun with your own combinations. Make them truly your own.

6. **Click OK when you are happy with the result.**

In general, it's best to leave the midtones alone. Stick with adjusting the shadows and highlights. This preserves contrast across the photo. For a sepia look, increase yellows and reds a bit, as in 7-22, but not too much.

To bring out the detail in the building, Strength was set very high. Luminosity was also set quite high so the image was better balanced before the contrast was turned up in Photoshop.

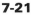 *tip* Beware of looking like everyone else all the time. Some tints are all the rage, which results in diminishing the effect of a style.

ABOUT THIS PHOTO
The HDR image of this military parade through Liverpool was created from one raw image. (ISO 100, f/2.8, 1/3200 second, Canon 24-70mm f/2.8 at 70mm)
© Pete Carr

7-22

Assignment

Tell a Story in Black-and-White HDR

This chapter has thrown a new wrinkle into the mix: black and white. Black-and-white HDR photography requires different thinking, a new way of processing HDR photos into black and white, and unique post-processing techniques to complete images.

Complete this chapter by going out and finding a story to tell in black-and-white HDR. Think about light, shadows, contrast, and tones. Look at how the light plays on the scene and use it to tell the story.

This example is of an event in Liverpool called La Machine where a 50-foot spider walked around the city of Liverpool for a few days. It was an incredible event. The sky was quite dull originally so Luminosity was increased in Photomatix. Strength was turned up quite high, which increased the noise, but this was acceptable because this image was meant to be converted to black and white. And, this image works in black and white because all distraction is removed. The story is of the spider and people's expressions. HDR was created from one raw exposure converted to three 16-bit TIFFs. Taken at ISO 1600, f/5.6, 1/125 second with a Canon 24-70mm f/2.8 lens at 24mm.

© Pete Carr

Remember to visit www.pwassignments.com after you complete this assignment and share your favorite photo! It's a community of enthusiastic photographers and a great place to view what other readers have created. You can also post comments, read encouraging suggestions, and get feedback.

PHOTOGRAPHING PEOPLE

WORKING WITH AND WITHOUT FLASH

BLENDING HDR WITH NORMAL EXPOSURES

© Pete Carr

Most people imagine sweeping landscapes, stunning sunsets, or impressive architecture when they think of HDR — that and the sometimes peculiar way HDR can be processed to create an unusual, often unrealistic appearance.

This chapter tries to break that stereotype by showing you that it is entirely possible — in fact, beneficial — to take photographs of people and use HDR to accentuate details, overcome lighting problems, and rescue otherwise drab photos.

This chapter relies heavily on the single-exposure HDR technique because it is virtually impossible to get good bracketed photos of people with no movement — especially children — outside of a studio. Thankfully, the dynamic range inherent in raw photos allows us to save brackets with different exposures and use HDR to get at the entire range of the photo during tone mapping. It is not as effective as true bracketing, but is a valuable part of HDR photography as a whole.

PHOTOGRAPHING PEOPLE

If you are a portrait photographer or take good casual shots of everyday life, you won't find it hard to begin experimenting with people and HDR, as with the casual self-portrait in 8-1. The

8-1

ABOUT THIS PHOTO *This self-portrait was made while shooting HDR in the backyard, shooting into the neighbor's reflective garage window. HDR creates an interesting effect without being overly artificial. HDR from a single raw exposure converted to four 16-bit TIFFs. (ISO 100, f/8, 1/20 second, Sony 18-70mm f/3.5-5.6 at 50mm) © Robert Correll*

original photo had a range of dark areas in the reflection while the highlights on the garage door were very light. The final result is a testament to how effective HDR can be at rescuing photos while at the same time keeping people recognizable. Although not a "studio grade" sitting, it remains an effective and interesting portrait.

The raw exposure was converted to four 16-bit TIFFs, exposed at -2/0/+2/+4 EV. Three exposures resulted in the reflection being too dark. So in Photomatix, the Strength was set to maximum to bring all the detail out. Luminosity was raised to balance the light between the white doors and the dark reflection. Light Smoothing was lowered to help this also. Some Microsmoothing was applied to reduce the tone-mapped effect.

HDR IN EVERYDAY PHOTOGRAPHY

Despite the fact that HDR thrives when you put your camera on a tripod and carefully bracket a scene, it is also fun to try on the casual photos you take of everyday life. The photo in 8-2 was taken at the local zoo as Sam watched the monkeys very intently. The unretouched JPEG file is shown so you can compare the difference between HDR and what the camera processed. It's a perfect close-up of his profile, taken quickly without a flash or tripod. The raw exposure was carefully processed into HDR and kept very realistic, as seen in 8-3. The benefit of using HDR here was to bring out detail in his hair, face, the concrete wall, and generally liven up the photo.

In Photomatix, Strength was maximized to bring out details throughout the photo. Light Smoothing was reduced to High, which had the

ABOUT THIS PHOTO
This is the original JPEG processed by camera. For dramatic comparison, see the HDR version in figure 8-3. (ISO 400, f/5.6, 1/80 second, Sony 18-70mm f/3.5-5.6 at 55mm) © Robert Correll

8-3

ABOUT THIS PHOTO *HDR enhances color, contrast, and details without sacrificing realism. HDR from a single raw exposure converted to three 16-bit TIFFs. (ISO 400, f/5.6, 1/80 second, Sony 18-70mm f/3.5-5.6 at 55mm) © Robert Correll*

effect of balancing the light between the background and foreground. Thankfully, it did not produce any unnatural halos. The White Point was raised to lighten the photo and add contrast.

Figure 8-4 is another spur-of-the-moment shot. It wasn't something planned out or metered — just shot at the right moment. The original photo was taken in raw so it was possible to go back later and see if HDR would work. Jake's zaniness makes the fact that the result, while a bit less realistic than a normal photo, does not feel out of place.

Within Photomatix, therefore, settings were pushed without being overly concerned that this would not look quite normal. Strength was maximized to bring out as many details as possible and Light Smoothing reduced to High. Saturation was increased to bring out the colors in his shirt, the pillow, and the grass. White Point was also raised to increase lightness and contrast. Afterwards, a slight curves adjustment was made in Photoshop to sharpen the contrast a bit.

8-4

ABOUT THIS PHOTO *Casual HDR shots of family and friends are fun and can work out very well. The HDR settings were pushed a bit in this image to get this result. HDR from a single raw exposure converted to three 16-bit TIFFs. (ISO 100, f/8, 1/20 second, Sigma 10-20mm f/4-5.6 at 18mm) © Robert Correll*

PORTRAITS

Although it is challenging, you can successfully use HDR in casual portrait photography. The next photo (8-5) was shot at home, not in a studio with professional lighting. It is a photo that you might take of your friends or family members. Grace was sitting at the table during the birthday party of one of her brothers. She looked up, resulting in a charming pose. The original photo, shown here as an unretouched JPEG for comparative purposes, was a little dark and had no detail in the wall. The final result in HDR (see 8-6) was processed from the raw exposure.

 tip Go back through your raw photo library and look for photos that might work with HDR. You can quickly try them out by dropping the raw photo into Photomatix. If it looks good, try processing the raw file into three exposures and proceed more deliberately. Always save the test — in the end, it might look the best.

8-5

ABOUT THIS PHOTO
This is a JPEG produced by the camera shown with no post-processing. (ISO 400, f/8, 1/80 second, Sony 18-70mm f/3.5-5.6 at 55mm) © Robert Correll

8-6

note You will find it virtually impossible to take bracketed photos of people for HDR, even with a fast camera and AEB. Don't be discouraged or give up. Take the best single exposure in raw that you can and create brackets from that in your raw editor.

While a little noisy, HDR rescues lost detail and makes the entire photo more vibrant and compelling. A relatively natural look was kept by not getting too carried away with the settings in Photomatix. Strength was set to maximum to bring the details out and a small amount of Micro-smoothing was applied to reduce noise and create a more natural-looking photo.

STUDIO PHOTOGRAPHY AND HDR? To be honest, there is very little need for HDR in the studio because you control the dynamic range of the scene through ambient lighting, backdrops, strobes, and other gear. HDR won't help you in the studio as much as a good lighting setup — unless you're going after an artistic statement. Feel free to experiment and create whatever photos you desire.

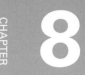

WORKING WITH AND WITHOUT FLASH

Lighting models can take time to learn and be tricky to execute. You can use some form of strobe or flash, natural light, or use both types if you can. Both have their pros and cons. Natural light is outside of your control, but is free and you don't have to carry it around. Flash allows you to fine-tune your setup and correct lighting deficiencies on location, but you are burdened with transporting and setting it up.

HDR eliminates the need for a flash in many situations, but as always, use your best judgment. Don't be so dogmatic about HDR that you refuse to recognize the obvious when necessary. If you need a flash to help illuminate your subjects — whether you are shooting HDR or not — use it. A flash is especially useful to balance lighting, even in HDR. For example, if you are shooting a

subject and their face is in partial shadow, that is the time to pull out the flash, whether you are shooting HDR or not. The flash evens the lighting on their face, resulting in a much better photo.

USING EXTERNAL FLASH

External flashes are often called *off-camera flash*. They mount in the hot shoe on top of the camera. The hot shoe is a mechanical and electrical connection between the camera and external flash. These off-camera flash units often have heads that can be tilted, and allow for diffusers or even filters to be attached.

Pete used an external flash, the Canon Speedlight 430EX, in 8-7. It was a dark, overcast day. Even though HDR brings out details later in the process, try to capture as much as you can while shooting. In this case, a flash was needed to balance the person in the Cylon costume with the

ABOUT THIS PHOTO
This is a normal flash exposure of a Battlestar Galactica Cylon at a SciFi event. (ISO 800, f/5.6, 1/8000 second, Canon 24-70mm f/2.8 at 43mm)
© Pete Carr

8-7

background clouds. The camera had to be set to a very fast shutter speed, 1/8000 second, to capture as much detail as possible in the clouds without blowing them out. At this speed, the costumed person would have been seriously underexposed. Therefore, flash was used to light the model.

The result of processing the single raw photo first into three brackets and then into HDR is shown in 8-8. To create the dramatic sky during tone mapping, Strength was set quite high. Luminosity was set high to balance the light between the Cylon and the sky. As you can see, HDR enhances the details in the clouds with dramatic effect, but also improves the model. This photo would not have been possible without using a flash. The bottom line is to make sure you get as much detail as you can while you're out shooting. Don't expect the computer to do it all for you. As you get more experience, you will know when you have the detail you need in-camera, which you can enhance with HDR later.

USING NATURAL LIGHT

As a diffuser softens light from a flash, shooting during an overcast day softens light from the sun. Soft, natural light can't be beat when photographing people, even for HDR. You won't have to deal with harsh, long shadows in the background and on people's faces. In 8-9, the natural beauty of the model is enhanced with soft shadows and smooth skin, while she and her blouse contrast with the gritty detail preserved in the brick background. It's the best of both worlds. Converting the image to black and white after HDR processing also helped accentuate these features of the photo.

Strength was set high here to bring out the detail in the bricks. Luminosity wasn't set too high because having lots of detail in the girl's face could look strange. Micro-smoothing was increased to add a level of normalcy to the image.

8-8

ABOUT THIS PHOTO
This flash exposure was processed as HDR to bring out details in the clouds and reflections. (ISO 800, f/5.6, 1/8000 second, Canon 24-70mm f/2.8 at 43mm) © Pete Carr

8-9

ABOUT THIS PHOTO *This was shot on an overcast day. Note the contrast between the model and the wall, in addition to the normal tones of her skin, clothes, and hair. (ISO 640, f/2.8, 1/100 second, Canon 24-70mm f/2.8 at 70mm) © Pete Carr*

There are times and situations when the sky is not overcast and you can't wait for the perfect lighting conditions. Perhaps you're on a professional shoot, shooting an amateur model, out with your family, or at some kind of event. For example, in 8-10, a captain stands on his ship in the bright sunlight. This photo is pushed up 2EV in order to show how bright it was that day. To expose the captain correctly, the background is completely blown out.

In this case, if you cannot use a flash to try to balance the lighting, expose the background and subject so you get the most detail in both areas. Make sure your camera's metering is set to Average — you don't want Spot or Center-weighted. Under similar circumstances, the subject will appear somewhat underexposed and the background will appear a bit overexposed. This is because you're trying to preserve detail across the entire photo.

Notice that the captain is clearly visible — there are no problems with his lighting, such as deep, dark eye sockets. It's as if a flash was used. This is from a single shot taken under less-than-ideal circumstances with no lighting gear.

In the end, HDR was able to bring out details in the background and in the captain, as seen in 8-11. Luminosity was set high to bring back detail in the sky and retain detail in the man's face. Strength was set between medium and high, but not so high as to create a strange looking image.

8-10

8-11

ABOUT THESE PHOTOS *Figure 8-10 shows a ship captain posing on a dock in Liverpool. Exposure is compensated to illustrate blowing out the background. Figure 8-11 shows the same image processed as HDR and converted to black and white. Details are enhanced throughout without deep shadows in his face. (ISO 200, f/4.5, 1/1600 second, Canon 24-70mm f/2.8 at 24mm)* © Pete Carr

BORDERS®

BORDERS
BOOKS MUSIC AND CAFE
811 S.E.160th Ave
Vancouver, WA 98683

SALE 09/01/2011 EMP: 00421
STORE: 0629 REG# 03/66 TRAN#: 1185

HDR PHOTOGRAPHY PHOTO WORKSHOP
9753794 QP 1 16.00
 39.99 60% PROMO

Subtotal 16.00
WASHINGTON 8.2% 1.31
1 Item Total 17.31
CASH 20.00
Cash Change Due 2.69

You Saved $23.99

09/01/2011 05:43PM

ALL SALES FINAL
NO RETURNS/EXCHANGES

BLENDING HDR WITH NORMAL EXPOSURES

There are times when you have no other choice than to blend a normal exposure with HDR if you want the final photo to look more realistic. This is more of a common problem with people than with other subjects. The two approaches shown here treat the subject and HDR differently.

By blending normal subjects over HDR backgrounds, the background is shot and processed as HDR while the subject is photographed separately and not processed as HDR. The subject is essentially pasted into the final HDR shot. The challenge here is to make the subjects look like they belong in the photo and not overdo the HDR.

BLENDING SUBJECTS OVER HDR BACKGROUNDS

There are times when you will achieve the best result by treating the background and people separately, and only at the end of the process composite them into the same shot.

Technically, the lighting challenges presented in 8-12 are very difficult. The road goes back some distance. Lighting the shops and floor all the way into the far background would be very hard. Raising the exposure to lighten the background would blow the highlights of the sky out, and an ND filter would not match the outline well. That's just the background. The intent for this shot was to have models in the foreground, but they would have to be lit so they are in balance with the rest of the scene as they walk toward the camera. It should come as no surprise that this high-contrast scene, which presents serious lighting challenges, is ideal for HDR.

If this were a simple location shot you could put up a tripod and shoot the scene with bracketed exposures and be done with it. Alternatively, if all you wanted was a nice shot of models and didn't care about the background, you could shoot them with a standard flash for fill light and not worry about the background. Quite often, the secret to accomplishing both tasks is to tackle them separately.

ABOUT THIS PHOTO
This model shoot was done on location in Liverpool. This is the background. (ISO 100, f/8, 1/60 second, Sigma 10-20mm f/4-5.6 at 11mm.) © Pete Carr

8-12

In this case, the best and easiest solution was to use a tripod to shoot the models traditionally, leave the camera set up to shoot the location as a standard exercise in HDR, and then merge the two together in software to form a composite image (see 8-13). Although this approach relies on some trickery, it is not completely fake. The models were on location in the exact spot they appear in the final photograph. They were photographed first as they walked toward the camera, holding their bags, looking at the stores. This was to get a good well-lit photo of the models.

note In some cases, you may be able to use the same shot for the models and the background in HDR (see Chapter 9). In this case, however, the dynamic range of the scene is too great for one raw photo to look right. The sky is too bright in relation to the dark stores and background. Because the camera is not moved, it is possible to do this in stages.

For the background, the models simply stood off to the side out of the scene, and five bracketed photos were taken 2EV apart. Don't be afraid to take more than three shots if the dynamic range of the scene calls for it.

Back at the computer, Pete processed the background as HDR. He converted the five raw files to 16-bit TIFFs and loaded them into Photomatix. After converting the files to HDR, Pete kept the tone-mapping settings low to keep the background reasonably realistic compared to the people. Not every scene has to have every drop of drama squeezed out of it.

Luminosity was set to maximum to balance out the bright sky and darker shops. Strength was set to just above medium so the image wasn't too dramatic. The idea was to keep it normal looking. Micro-smoothing was increased a bit too to reduce the noise. He then loaded the resulting

8-13

ABOUT THIS PHOTO
Here is the final image with the models in place. The background is an HDR with a normal exposure of the models creating the composite. (ISO 100, f/8, 1/60 second, Sigma 10-20mm f/4-5.6 at 11mm) © Pete Carr

tone-mapped image into Photoshop and merged it with the unprocessed shot of the models. Pete cut the models out of the unprocessed shot and placed them into the HDR image, which was then processed as a single photo.

> **note** There are many ways to composite photos. After copying and pasting the second image into the first, you can erase areas of the upper layer you don't want or use a mask to hide them. Later, you can merge them together (Layer ⇨ Merge) or select the entire canvas (Select ⇨ All), copy merged (Edit ⇨ Copy Merged), and paste the result as a new layer. The Copy Merged command is very useful if you have material on different layers (the different versions of the photo blended together with a blend mode change or by making the upper layer semitransparent) you want to copy. These menu options are for Photoshop Elements, but most image editors have similarly named comments.

BLENDING HDR WITH NORMAL PHOTO LAYERS

An important skill to master, especially when taking photographs of people, is blending the normal photo with the final HDR image. This takes place in your image editor after you create the tone-mapped HDR file. The goal is to bring a sense of normalcy back to the photo.

The photo in 8-14 is a good illustration of starting out with something that looks very drab and using HDR to rescue it, only to have to blend the raw photo back with the HDR to preserve some of the natural character of a person's face. This figure is shown so that you have a sense of what this photo looks like in JPEG straight out of the camera. You will also be able to compare the JPEG to a processed raw image of the same photo, the preliminary unblended HDR file, and a final blended image. In this way, you see all the levels of development: automatic JPEG (which is shown only to compare — it is not processed further), raw processing, HDR, and blended HDR.

8-14

ABOUT THIS PHOTO *This is a good clear photo of Ben, yet it is dull and lifeless. This is the untouched camera-processed JPEG, cropped for a tighter view. (ISO 100, f/8, 1/100 second, Sony 18-70mm f/3.5-5.6 at 60mm) © Robert Correll*

Figure 8-15 shows the raw exposure (not the JPEG) after a quick round of editing in Adobe Camera Raw. The photo has been dramatically improved when compared to JPEG. It is sharp and clear, but still lacks vibrancy. This photo looks good enough that there would be no real harm in stopping now and perhaps moving on to further image editing, but the point is to show you where HDR can take this photo beyond JPEG and processed raw.

After converting the single raw exposure into three 16-bit TIFFs, the challenge was to tone map the resulting HDR so that it would look realistic. Many settings in Photomatix were set fairly very low. Strength is close to its default. Light Smoothing is Very High. Luminosity and Microcontrast are both at zero. Saturation was set fairly high, however, to boost the color in the image. The White Point was dropped low to avoid blowing out areas of the boy's face, and the Black Point was raised to bring more contrast back into the photo. Finally, Micro-smoothing was raised quite high to take some of the tone-mapped look out of his face. The resulting photo is shown in 8-16. It is very good, but can still be improved.

8-15

ABOUT THIS PHOTO *The raw version of the photo from 8-14 processed through Adobe Camera Raw with moderate Vibrance, Saturation, and Sharpness enhancements. (ISO 100, f/8, 1/100 second, Sony 18-70mm f/3.5-5.6 at 60mm) © Robert Correll*

8-16

ABOUT THIS PHOTO
The result of tone mapping in Photomatix, which shows promise. HDR from a single raw exposure converted to three 16-bit TIFFs. (ISO 100, f/8, 1/100 second, Sony 18-70mm f/3.5-5.6 at 60mm) © Robert Correll

To continue to improve this photo, the solution is to blend the processed raw photo with the tone-mapped HDR to bring back the realism. The following sequence of steps takes you through this process, starting from the end of tone mapping until the end of the blending.

1. **Open your image editor.** You may use any you like, as long as it supports layers and, ideally, blend modes. Good examples are Adobe Photoshop Elements, Photoshop, and Corel Paint Shop Pro Photo. For this example, Photoshop Elements is used.

2. **Open the tone-mapped HDR file.** This is the final tone-mapped HDR file.

3. **Open the processed raw photo.** This photo will be partially transparent. Make sure this is the active image in the editor.

4. **Select the processed raw.** In Photoshop Elements, choose Select ⇨ All to select the entire photo.

5. **Copy the image.** Choose Edit ⇨ Copy to copy the photo.

6. **Switch to the HDR image and paste what you just copied.** With the tone-mapped HDR image active, choose Edit ⇨ Paste to paste the processed raw photo as a new layer on top of the tone-mapped HDR layer, as in 8-17. If one or both of the photos is 16-bit, Photoshop Elements requires you convert to 8-bits before continuing. If necessary, do so.

8-17

ABOUT THIS FIGURE *HDR and processed raw photo in one file, with HDR on the bottom layer.* © Robert Correll

7. **Rename the upper layer.** Double-click the name in the Layers palette and rename it to something obvious, like "raw," as in 8-18. Renaming the bottom layer requires that you convert it from "background" to a normal layer and is not done here.

8. **Change blend mode of the raw layer to Soft Light.** In the Layers palette, select the raw layer, and then click the Blend Modes control drop-down menu (it is set to Normal by default). Choose Soft Light from the list as shown in 8-19. You may want to experiment with other blend modes, including Normal, but Soft Light allows the HDR layer's vibrancy to show through better.

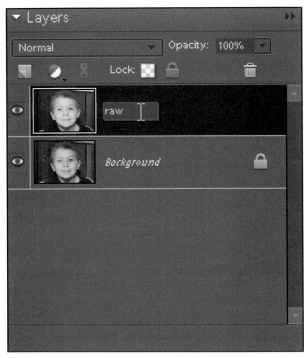

8-18

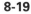

8-19

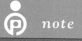

You can experiment with putting the HDR layer on top of the photo layer. Change the blend mode and opacity of the upper HDR layer in that case. In general, if you want to add realism, work with the HDR layer on bottom. If you want to add more of an HDR quality, put the photo on the bottom and blend the HDR from the top.

8-20

ABOUT THIS FIGURE *Using the Opacity control to blend.*
© *Robert Correll*

9. **Lower the Opacity of the raw layer to suit your taste.** Use the Opacity control, as shown in 8-20, to reduce the visibility of the photo layer. Located in the top right of the Layers palette, it shows the opacity of the selected layer as a percentage. You can either enter a percentage directly into the field, or click the drop-down arrow and adjust the slider that appears. Reducing the opacity further blends the two layers together (changing the blend mode started the process), giving you the best of both worlds. If necessary, use the Eraser tool to remove portions of the upper layer that don't require blending. They may look perfectly good as full-strength HDR.

10. **Save the result as a new image type.** If you are working in Photoshop or Photoshop Elements, save the result as a Photoshop Image (.psd). If you are working in Paint Shop Pro, choose Paint Shop Pro Image (.pspimage). Both of these image types preserve the layers you have just created and all blending. You can open this file and continue editing or change the settings if you want.

11. **Further process the file, if necessary.** In this case, a few freckles and a blemish on the wall were cloned out.

12. **Save the final file as a TIFF or JPEG in order to print or put the file on the Web.** This way you have preserved your original photos, your working file with the separate layers, and now have a final file for distribution.

The final result has transformed a drab photo into a vibrant keeper for the family (8-21). The secret was to process the raw photo and HDR separately, then blend them together. This process enabled HDR to restore hidden details and pizzazz that were missing from the original photo but not turn it into something overly artistic.

8-21

ABOUT THIS PHOTO The final image that is HDR blended with processed raw restores details and adds vibrancy to this photo while maintaining a high degree of realism. (ISO 100, f/8, 1/100 second, Sony 18-70mm f/3.5-5.6 at 60mm) © Robert Correll

Assignment

Create a Portrait in HDR

Photographing people for HDR is challenging. The dilemma is to use HDR to overcome many of the limitations inherent in traditional photography, yet keep people looking like people. For this assignment, find a person to photograph. If you're not used to photographing people, it may help to start with someone with whom are you are familiar. Compose the shot however you like. Pose your model in front of an interesting building, street, church, or focus tightly on him or her. Use any manner of lighting you want — from natural sunlight through a window to a flash or strobes.

This example is of a street performer in Liverpool. He is wearing a mask, so the Photomatix settings could be pushed farther than most HDR shots with people, creating a highly detailed image. Strength was set high to maximize details and Luminosity was set high to balance the light.

The HDR image was created from one raw exposure converted to three 16-bit TIFFs before converting the image to black and white. The black-and-white conversion results in a scene where the person almost looks chrome, adding to the unique nature of this photo, which was taken at ISO 250, f/5.6, 1/500 second with a Canon 24-70mm f/2.8 lens at 70mm.

© Pete Carr

Remember to visit www.pwassignments.com after you complete this assignment and share your favorite photo! It's a community of enthusiastic photographers and a great place to view what other readers have created. You can also post comments, read encouraging suggestions, and get feedback.

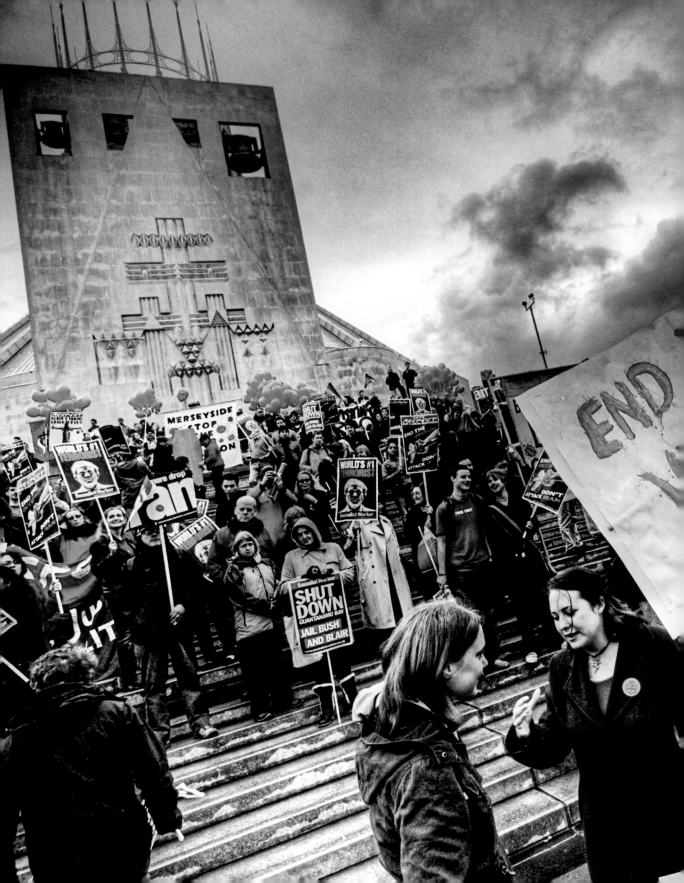

STREET PHOTOGRAPHY

© Pete Carr

Street photography is about being out there on the street, photographing people in fleeting moments of time. It requires a different set of skills than other disciplines. You will not be setting up a tripod and leisurely shooting brackets of an inanimate object or landscape. You must learn to be comfortable with strangers while you take their pictures. These are most likely not your friends, family, or models that you have contracted beforehand. You must learn to be inconspicuous and recede into the background as you carry around your gear, be ready to shoot at a moment's notice, and be patient.

Henri Cartier-Bresson, widely acknowledged as the creator of street photography, once said, "Photographers deal in things which are continually vanishing, and when they have vanished there is no contrivance on earth which can make them come back again." This is particularly true of capturing moments on the street — the everyday activities of real people going about their lives.

This chapter focuses on the mind-set and techniques necessary to capture these moments on the street for use in HDR photography. HDR complements street photography by allowing you to work under less than ideal lighting conditions, most often without a flash. You are able to keep highlights from being blown out and bring out details in processing that normal raw editors cannot. You won't be shooting brackets during street photography unless you have a camera with an exceptionally high shooting speed. Therefore, your work will mirror this chapter's examples: HDR created from a single raw photo.

STREET PHOTOGRAPHY

Street photography is the art of documenting life on the street. The focus is on people and what they're doing: crazy holiday shoppers, children being children (as in 9-1), protesters protesting, a couple out for a romantic stroll, or a somber moment.

This photo was tone mapped with a slightly surreal look for a magical effect. Strength was maximized for detail and Luminosity was maximized to achieve the glowing look. Reducing Luminosity to its default makes this photo look much more normal. Micro-smoothing was raised a bit to combat noise and smooth the texture of the lion.

caution Taking photos is not illegal in most places, so don't be afraid to stand on the streets of London or New York and document life around you. Be careful to preserve their editorial nature, however. If you change the context of the photo for advertising or other types of commercial use, you may need model releases or other forms of permission. In the end, you are responsible for checking local laws with regard to taking and publicly displaying or selling your photographs.

GETTING INTO THE ACTION

The focus of street photography is often action, as shown in 9-2. This photo captures a protest in Liverpool when U.S. Secretary of State Condoleezza Rice was visiting. The scene is stark, dramatic, and intimate. It could not have been captured from a distance with the same impact. In this case, a wide-angle lens captured the entire scene at close range. The bold colors of the American flag stand out, as does the police line.

9-1

ABOUT THIS PHOTO *A young girl drinks out of a fun fountain at a zoo. HDR from a single raw exposure converted to three 16-bit TIFFs. (ISO 100, f/5.6, 1/250 second, Sony 18-70mm f/3.5-5.6 at 26mm) © Robert Correll*

In Photomatix, Strength was increased and set high to enhance the gritty feel. Luminosity was set high to bring out the detail in the shadows, mainly the road and parts of the clouds.

Converting the photo to HDR brings out details not visible in the original. The police line was dark and faded into the background. It has been accentuated and contrasts with the texture of the road much more. The sky was enhanced and is much more powerful, matching the energy of the overall scene. Overall contrast was increased without losing details in the sky or other areas. A 430ex external flash was used to light the person with the flag — not the entire scene.

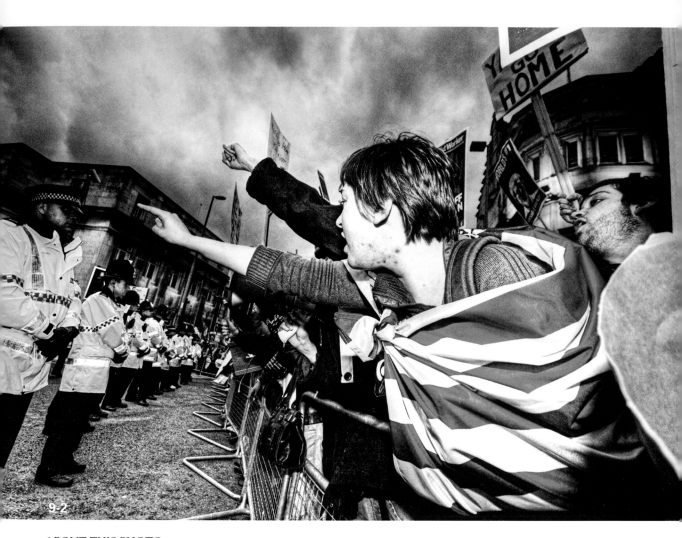

ABOUT THIS PHOTO *A crowd protests Condoleezza Rice's appearance in Liverpool. HDR from a single raw exposure converted to three 16-bit TIFFs. (ISO 800, f/8, 1/30 second, Sigma 10-20mm f/4-5.6 at 10mm) © Pete Carr*

SHOOTING UP CLOSE AND PERSONAL

Street photography also documents simpler, often personal moments in public. It is critical to be unobtrusive in order to photograph these scenes without changing them. To do that, you must be close to what is happening but remain part of the background.

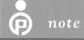 note

People in public don't have the same expectation of privacy as they do in their own homes, but they still may not want you to take their photo. Be mindful of this when going out into the streets and taking photos of people. Photographing children is an especially sensitive matter. You should ask permission from a parent or guardian prior to taking a child's photograph, regardless of the setting.

This kind of private moment was captured at the Hillsborough Memorial beside Shankly Gates at Anfield, Liverpool, and is shown in 9-3. The monument, with its eternal flame, is a reminder of the 96 people who tragically died during a match between Liverpool and Nottingham Forest at Hillsborough Football Ground. Before games, fans touch the memorial as a sign of respect.

It is hard to photograph such scenes because they are so intensely personal. The moments and people are real and powerful. When you come up to scenes like this, try and have a wide-angle lens ready and take your time. Stop, look, understand what is happening, and decide what you want to say about the scene. As you wait for the right photo you are also waiting for acceptance. This close, people know you are taking photos. Without saying a word, you want to establish a

comfort zone with the people you are photographing. If anyone has a problem with you, they will let you know right away. If no one says anything within a few minutes, that means they have most likely relaxed and accept your presence.

HDR helps in these situations because you aren't forced to rely on a flash. Capture one solid shot in raw and use the single-exposure techniques illustrated throughout this book to create HDR. In this case, Strength was set high to enhance details in the scene and Luminosity was set quite high to bring out details in the clouds while retaining detail in the woman's face. Additional Micro-smoothing helps control noise and the tone-mapping effect. The image was converted to black and white as a final step in the process to match the overall mood and subject.

ABOUT THIS PHOTO
A Liverpool Football Club fan pays respects to the 96 who died at Hillsborough. HDR from a single raw exposure converted to three 16-bit TIFFs. (ISO 640, f/4, 1/400 second, Sigma 10-20mm f/4-5.6 at 10mm) © Pete Carr

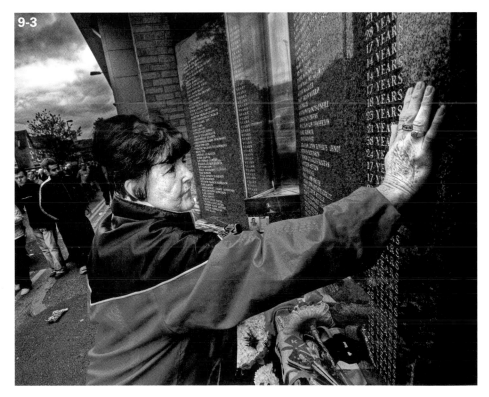

CAMERA SETTINGS

Street photography is a dynamic affair. As such, your camera settings must be ready to work in a fast-paced environment. Here are some general guidelines for shooting street photography for HDR:

- **White balance.** This is best left on auto, especially if you are shooting in raw, because with raw, you set the white balance later during raw conversion.

- **Shutter speed.** A good rule of thumb is to keep the bottom number of the shutter speed fraction at or above the focal length you are using. For example, at 70mm, use a shutter speed of 1/80 second or faster. If you are shooting fast action or in bright conditions, a higher shutter speed may be necessary, even if you boost the ISO.

- **Aperture (f-number).** In general, start out at f/8 and focus on infinity. You'll have a good depth of field, an aperture that lets in a fair amount of light, and be able to shoot without worrying about whether everyone is perfectly in focus or not. If you want to isolate the subject, shoot with a larger aperture (smaller f-number). This blurs the background.

- **ISO.** Keep the ISO as low as practical, but HDR street photography generally requires higher ISO settings than standard HDR photography. It's all about motion. A slightly higher ISO guarantees a faster shutter speed. It's less of an issue on a bright sunny day, but on an overcast day there is a chance for blurring because with less light, the shutter speed will be slower. Therefore, increase the ISO on overcast days, in alleys, and other darker settings to make sure that everyone is frozen with no blur.

- **Raw.** If possible, shoot in raw. Raw files preserve a greater dynamic range than JPEGs and allow you to make more effective white balance and exposure adjustments in software.

- **AEB.** AEB is nearly impossible to use in street photography. There simply isn't enough time to get off three exposures in the split second you have. Set up for the best overall exposure without blowing out highlights and rely on shooting in raw and processing single-exposure HDR.

- **Filters.** Depending on the horizon, filters can be useful in HDR street photography because they can protect against blowing out the sky.

> *tip* Check your camera's noise reduction options when shooting at high ISOs. If noise reduction is immediately applied (as is possible with the Sony Alpha 300 series, for example), your practical shooting speed may be dramatically slowed because of the processing delay. If that is the case, turn in-camera noise reduction off and apply it later in software.

The photo in 9-4 was shot from the hip with the aforementioned guidelines in mind. There was no need to look in the viewfinder because at f/8 and focus at infinity, the depth of field (and hence the depth of focus) was large enough to capture the subjects sharply. The ISO was raised to 1600 because clouds kept passing in front of the sun, darkening the scene. The high ISO necessitated a fast shutter speed to avoid completely overexposing the image, but even at 1/6400 second, some areas of the photo are blown out. As is sometimes the case, however, this photo works despite the blown out areas. Attempts to reduce their effect make the girl look much worse. The focal length was 18mm, just wide enough to capture the girl in front. 10mm would have been too wide.

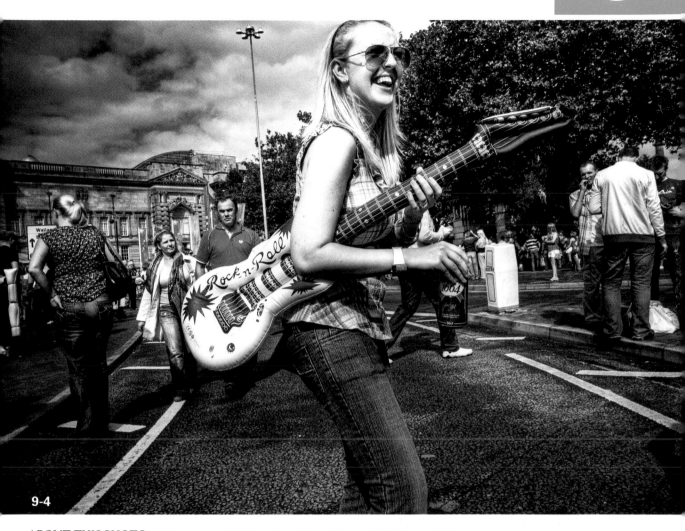

9-4

ABOUT THIS PHOTO *This is a scene at the Mathew Street Festival, Liverpool. HDR from a single raw exposure converted to three 16-bit TIFFs. (ISO 1600, f/8, 1/6400 second, Sigma 10-20mm f/4-5.6 at 18mm) © Pete Carr*

HDR has brought out details in the clouds and road by increasing the Strength setting in Photomatix to enhance the detail. Luminosity was set quite high to bring out details in the darker areas without blowing out the lighter. Finally, the photo was converted to black and white as homage to the discipline of street photography, which traditionally is shot or presented in black and white.

> **note** Technically, focusing your lens to a distance called the hyperfocal distance guarantees you the largest depth of field for the specific combination of the f/number and lens you are using. Street photography requires that you be ready at a moment's notice, however, so you may not have time to consult charts, iPhone applications, or other depth of field aids. For more information on hyperfocal distance, visit http://dofmaster.com/hyperfocal.html.

WIDE-ANGLE STREET PHOTOGRAPHY

There's nothing like getting into the action and shooting wide-angle street photography with a good wide- or ultra wide-angle lens. Look for something in the range of 10-24mm and bring your confidence. You will need to get close to your subjects — sometimes only a few feet away, as in figure 9-5, where a wide-angle lens at 10mm captured the action but required being virtually in the surf. A larger focal length, 50mm for example, would have limited the view and been too tight. Moving back to increase the view would have shrunk the kids and introduced other distracting elements into the photo.

HDR was used for this photo to bring out details in the sky and water, but not at the expense of contrast. In Photomatix, Luminosity was set high to retain detail in the water while bringing out detail in the clouds. Strength was set high to enhance the dramatic look of the clouds. Microsmoothing helped reduce noise.

Finally, the HDR image was converted to black and white. There was very little color to begin with, actually. The day was dull and gray and the seawater was murky and light brown. While HDR brought out details in the sky and water, the black-and-white conversion increases contrast so that certain elements, such as the child's face and the water splashing to the left, stand out more.

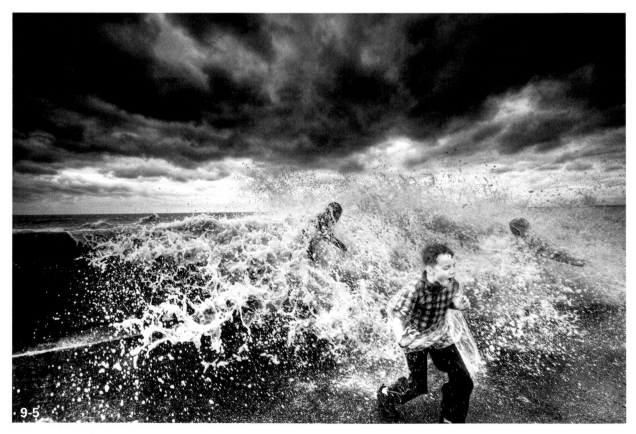

9-5

ABOUT THIS PHOTO *Kids run from a big wave during a stormy day. An ND filter was used to preserve highlights, and HDR enhances the detail and contrast. (ISO 640, f/8, 1/400 second, Sigma 10-20mm f/4-5.6 at 10mm) © Pete Carr*

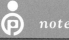 *note*

Different focal lengths emphasize different aspects of street photography. Wide-angle lenses (10-24mm) allow you to get close but capture a great deal. At the extreme end (between 50 and 70mm), midrange zoom lenses allow you to be farther away from the action and zoom in for details. The middle ground (between 24 and 50mm) forces you to get closer to capture the moment.

Another good example of wide-angle street photography can be seen in 9-6, prior to processing into HDR. In this case, the scene shows a snow storm on Princes Street in Edinburgh, Scotland, at night. It is not a bad photo, but the snow is not as apparent as it could be, nor are there any details in the large gothic building to the left of the wheel. Shooting at 10mm allows the crowd, traffic, Ferris wheel, and architecture to all be seen. At 50mm, the focus would have been on someone specific: a face in the crowd.

After processing this single raw exposure into HDR, the snow takes on a larger role in the sky and there are obvious details in the building, as you can see in figure 9-7. In Photomatix, Strength was lowered and Micro-smoothing was raised to keep the photo more realistic. Luminosity was raised to help bring the snow out from the background. Artistically, the colors, while still apparent, are desaturated.

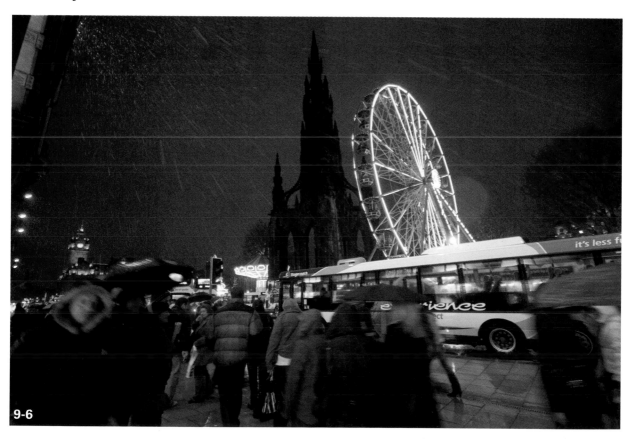

9-6

ABOUT THIS PHOTO *This scene of Princes Street in Edinburgh, Scotland is before processing into HDR. (ISO 1600, f/4, 1/15 second, Sigma 10-20mm f/4-5.6 at 10mm) © Pete Carr*

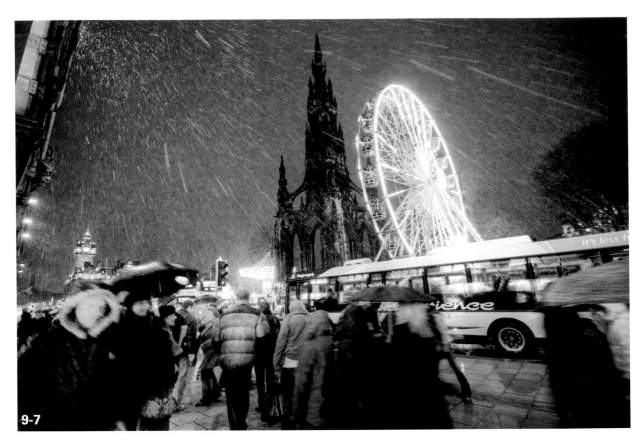

ABOUT THIS PHOTO *The same image of Princes Street in Edinburgh, Scotland from 9-6 after conversion to HDR from one raw exposure converted to three 16-bit TIFFs. (ISO 1600, f/4, 1/15 second. Sigma 10-20mm f/4-5.6 at 10mm) © Pete Carr*

MID-RANGE ZOOM PHOTOGRAPHY

Midrange zoom lenses are great for walking about. They range from around 17-55mm or 24-70mm. The great thing about these lenses is that you can be standing next to someone and shoot at 24mm and then quickly zoom to something farther away if you need to and shoot at 70mm.

A street scene of a driving rain storm is shown in 9-8 before processing. Notice the lack of details in the trees and buildings in the background.

HDR is used subtly in figure 9-9 to bring out detail and contrast — in a different way than for landscapes or buildings where you often want to maximize detail. HDR can cause people to look unnatural, so a light touch is most often best. In fact, it is often good to set Micro-smoothing to at least 15 and keep the Strength and Luminosity at lower levels than normal. In addition, HDR brings out details of the rain, emphasizing the terrible weather and the rain-soaked street. Saturation was enhanced in Photomatix, but could also have been increased in further post-processing.

ABOUT THESE PHOTOS *Figure 9-8 shows a torrential rain in Liverpool prior to HDR processing. Figure 9-9 shows the HDR image that was created from one raw exposure converted to three 16-bit TIFFs. (ISO 1600, f/2.8, 1/100 second, Canon 24-70mm f/2.8 at 70mm)* © Pete Carr

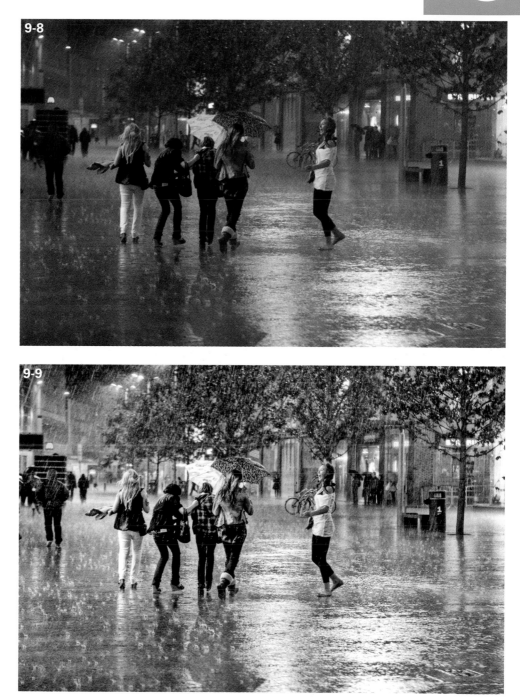

The photo in 9-10 shows the opposite end of the midrange zoom lens. This was taken standing next to a hot dog vendor. It was shot at 32mm, which is really the perfect focal length for this situation. It was not necessary to zoom in, and a wide-angle lens would have captured too much. The shot needed to be close and intimate in order to capture the people, the stand, steam, and sun. Notice the combination of a wide-open aperture, which limits depth of field but also increases the amount of light entering the camera, and the fast shutter speed which was necessary to shoot toward the sun, which is behind the stand top-center of the frame. Although promis-

ing, this unprocessed photo has very little detail in the buildings to the side and the main subjects are in shadow.

After processing a single raw photo into HDR (see 9-11), there are more details in the image, such as the rising steam. This helps balance the image. If the exposure had been increased in a raw editor alone, these areas would likely have been blown out and lost. Although there are spots on the edge of blowing out, HDR enhanced the darker regions without overly compromising the lighter ones.

In Photomatix, Luminosity was set quite high to keep the highlights from being too blown out. The sun backlighting the steam rising from the vendor's cart is very bright. This also brought out detail in the darker areas. Strength was increased to medium to enhance those details but not so much to create an overly processed image.

9-10

ABOUT THIS PHOTO
A 32mm focal length was used to shoot this scene of a hot dog vendor, shown here before HDR processing. (ISO 100, f/2.8, 1/1000 second, Canon 24-70mm f/2.8 at 32mm)
© Pete Carr

ABOUT THIS PHOTO *Figure 9-10 after processing to HDR, which really brought out the details. HDR from a single raw exposure converted to three 16-bit TIFFs. (ISO 100, f/2.8, 1/1000 second, Canon 24-70mm f/2.8 at 32mm) © Pete Carr*

9-11

USING A COMPACT DIGITAL CAMERA

Despite their power, dSLRs are not always the best camera for street photography. To be blunt, they can be large, clunky, and can draw too much attention to you. Henri Cartier-Bresson used a Leica because of its small size and quiet operation. It was unobtrusive and hardly noticeable.

Today, compact digital cameras, such as the Canon G9 or G10, are closing the gap between the dSLR and cameras with a much broader appeal. They can shoot in raw and have high ISO performance. They are small, light and quiet, do not have large lenses, can zoom in to moderate levels, and can fit in your pocket. They are good for HDR street photography with two real issues: They have limited

wide-angle capability, as you generally can't go under 24mm; and they have high ISO noise, which simply isn't on par with any dSLR on the market. You may struggle over ISO 400 or 800.

The photo in 9-12 was taken with a Canon G9. There is a little more noise to contend with at ISO 200 than a professional-level dSLR because of the camera's smaller sensor, but in situations where you would rather look like a tourist than a photographer — it's the ideal solution.

Although it was a nice, sunny day and the original photo was not bad to begin with, the sky held little interest. So, when converting it to HDR, increasing Luminosity and reducing Micro-smoothing helped raise contrast and drama in the sky more than what was possible in a raw editor.

9-12

ABOUT THIS PHOTO *This café on Falkner Street in Liverpool was shot with a compact digital camera. HDR from a single raw exposure converted to three 16-bit TIFFs. (ISO 200, f/5, 1/250 second, Canon G9 digital compact camera) © Pete Carr*

The sky now balances the street as they move toward one another in the far background. Notice too that the row of buildings to the right has exceptional detail into the distance. This is a primary result of HDR.

TECHNIQUES

You should now have a pretty good idea what street photography is and what you can do with it. Don't forget that the purpose is to photograph people on the street and develop the photos with HDR. The following techniques will deepen your

knowledge of street photography and further illustrate the capabilities of using HDR to bring out the best in your photos.

WORKING WITH NATURAL LIGHT

Natural light can be your best ally and worst enemy as a street photographer. This is not unlike the other realms of HDR. The difference here is that you must use the available light to photograph street life in action without time to bracket your shots.

Overcast days are great for street photography because there is no harsh light — no areas of shadow or bright spots to worry about. You lose contrast, but you can make up for some of that in HDR, especially if you convert the photo to black and white afterwards. The photo in 9-13 is a dark, stormy day at the beach. After tone mapping in HDR, the photo has plenty of detail and there are no over- or underexposed areas. In Photomatix, Strength was reduced and Micro-smoothing increased in order to keep the boy more realistic. Luminosity was increased to enhance contrast in the clouds and water.

Not every day is dramatically overcast, and shooting in color during a dull day can leave you with a plain white or gray sky. Tone mapping does not always work if there are no details to be brought out. In these circumstances, try to keep the sky out of the shot. Focus on the action in the street.

Shooting on sunny days eliminates the dullness of a gray sky but presents other problems. At midday, shadows are harsh and unforgiving. People's faces and eyes are often lost in shadow. HDR can help here, but if there is a shadow line running across someone's face it is still going to be there in HDR.

The third option is to wait for the Golden Hour. Find the best parts of the city — where you know light will cascade across the city and onto the streets — and learn them. Become familiar with

ABOUT THIS PHOTO *This photo shows stormy weather at New Brighton beach, Wirral, UK. HDR from a single raw exposure converted to three 16-bit TIFFs. (ISO 250, f/6.3, 1/800 second, Sigma 10-20mm f/4-5.6 at 20mm) © Pete Carr*

9-13

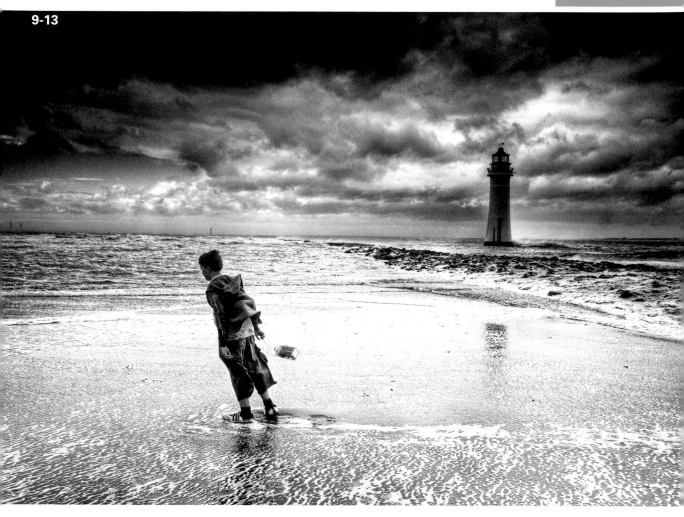

the layout. Know the side streets. Knowing how the light interacts with the scene better prepares you to take advantage of the right moment, as in 9-14.

Although it was spontaneous, this photo also took time to plan and patience to capture. Notice the light falling on the street — this particular spot was worth photographing with the church in the far background. It's nothing more than a strip of light on the street, which is a small amount to work with. The challenge was waiting for something to happen.

Most people were simply walking up the street with their backs to the camera. Nothing was happening, and honestly, people's backs do not always make for an interesting photo. This can be a problem with street photography. You find an amazing spot where the light and architecture combine and you wait and wait for something worth photographing to happen, something that adds feeling and emotion to the photo. It is the human connection you're after, one that allows the viewer to

relate to the scene. As this couple crossed the road, they happened to be in the perfect spot when the boy looked right into the camera. That was the moment, the human connection.

For this shot, HDR helped bring out details in the couple as well as the background without blowing out the sky. In Photomatix, Strength was lowered and Micro-smoothing raised to preserve realism.

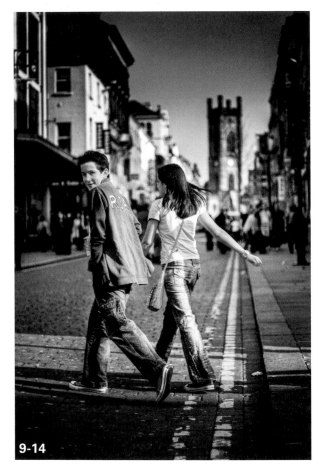

9-14

ABOUT THIS PHOTO *A couple crosses Bold Street, Liverpool. HDR from a single raw exposure converted to three 16-bit TIFFs. (ISO 100, f/2, 1/500 second, Canon 50mm f/1.8) © Pete Carr*

WORKING WHILE ON THE MOVE

While a good deal of street photography involves finding a scene and waiting for the right moment, you can also work on the move. Look for something that tells a story in an instant. For example, 9-15 shows a torrential downpour. The story is in the woman's expression. You can see it and immediately understand. The moment was there and gone in an instant. The low light conditions required an ISO of 1600 and HDR was used to bring out detail in the rain. Unfortunately, this also increased the noise. Micro-smoothing in

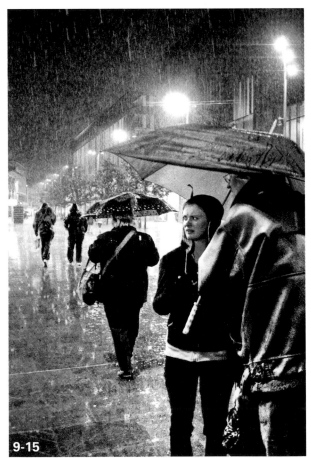

9-15

ABOUT THIS PHOTO *The expression on a woman's face tells the story in this photo of people out in the torrential rain in Liverpool. (ISO 1600, f/2.8, 1/100 second, Canon 24-70mm f/2.8 at 24mm) © Pete Carr*

Photomatix was set to +15 to help smooth some of the noise out, but the remainder was left in. This might be too distracting in a color photo, but in this case the noise looks like film grain, and is one reason the tone-mapped HDR image is converted to black and white.

Another example of walking around to catch a moment is shown in 9-16. It is a classic gritty urban shot with a lighthearted twist, a photo of a girl posing on her furry pink car. It is not completely natural because she is performing a bit for the camera (even so, it's a real moment), but the story of the people around her is refreshingly unselfconscious. Processing the photo into HDR, as in 9-17, creates a punchy, contrasted look without losing any detail. In Photomatix,

Luminosity was elevated to achieve this, yet Strength was lowered to keep the people fairly realistic.

Remember, when you look at HDR images, look everywhere, not just at the main subject. Notice the detail in the street, sidewalk, and stones of the buildings. They would not be as apparent in a standard photograph. HDR accentuates contrast and emphasizes detail. The more you push the settings, the more contrast and detail are added, often at the expense of realism. Notice too the people to the far right, the reflections off the window, and the fact that you can see through the window to the other side of the crossing street. All these details are exposed so you can see them. Not much is compromised.

ABOUT THIS PHOTO
A street scene of a girl posing on a car prior to HDR processing. (ISO 100, f/5.6, 1/125 second, Sigma 10-20mm f/4-5.6 at 11mm) © Pete Carr

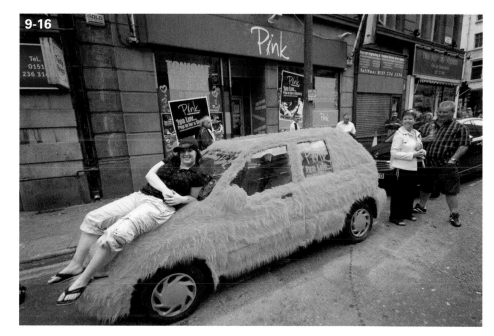

CAPTURING CANDID MOMENTS NATURALLY

Candid moments are ultimately what street photography is all about. As a photographer, you want to keep those moments as natural as possible. Although carrying around a dSLR makes it harder to remain inconspicuous, it is not impossible. Relax and stay calm. Act like you know what you are doing and you are supposed to be there. If you act nervous and look like you are doing something wrong, people will pick up on that and mistrust you.

The photo in 9-18 was shot with a fixed 50mm lens, perfect for casual dSLR street photography. Coupled with the heavy snow (it looks like rain, a misperception aided by the presence of the umbrella, but it is definitely snow), people were too busy to notice that a photographer was taking their picture. They often assume you are a tourist.

The problem with the photo is that the snow is almost invisible. HDR provides the way to get the message across that it really was snowing as well as enhance other details. Yes, you can increase the exposure in a raw editor to lighten

9-18

9-19

ABOUT THESE PHOTOS *Figure 9-18 shows a snowy street scene in Edinburgh. 9-19 after conversion to HDR. HDR from a single raw exposure converted to three 16-bit TIFFs. (ISO 1600, f/1.8 1/60 second, Canon 50mm f/1.8) © Pete Carr*

the image, but there are areas that are already quite bright. Brightening them would take focus away from the snow. With HDR it's possible to get a more balanced image with more detail in the falling snow and fewer blown out areas. In addition, HDR balances the light better and more detail has been retained in the shops, as you can see in 9-19. There is a string of lights across the road in the background that also looks better due to HDR. It is not as blown out and seems more natural.

While tone mapping in Photomatix, Luminosity was set quite high to help bring out more of the snow in the darker areas without causing those other brighter areas, such as the string of lights to become blown out. Strength was set to medium to enhance the detail a bit but not overly so. Also, in the color settings, the saturation of the shadows and highlights was reduced because the initial tone mapping looked too saturated.

WAITING FOR THE RIGHT MOMENT

Your goal in street photography is, in essence, to capture the right moment of a scene. You have to be there, recognize it, and act on it within a fraction of a second. You can't manufacture it and still call it street photography.

You may have to return to a location you've scouted out as being photogenic and full of action five, ten, or twenty times to finally capture that moment you really want. Be patient, keep working, and trust that you will find a moment as rewarding as the one shown in 9-20 where you see a photo of a door leading into an anonymous building. The door has a drawing of a girl writing graffiti on it. It's almost an optical illusion, as the girl is not real — she is part of the graffiti. Alone, it might be interesting, but not as powerfully poignant as what happened when an elderly man reached out to the girl to offer her a cookie.

The key tone-mapping setting in this image was Strength. It was set high enough to enhance the detail in the brickwork but not so high as to create a false look. Luminosity was increased a little because the end result was going to be a high-contrast black-and-white image. Therefore, it was good to get a balanced image right from the start and not risk blowing out highlights later if contrast had to be increased.

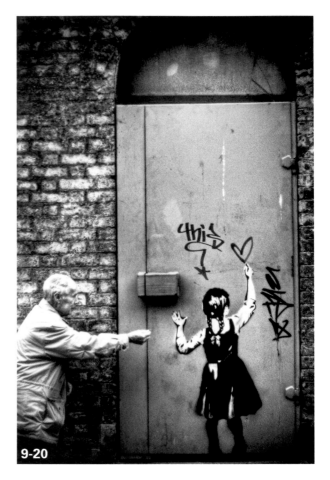

9-20

ABOUT THIS PHOTO *A man offers a graffiti girl a cookie. HDR from a single raw exposure converted to three 16-bit TIFFs (ISO320, f/1.8, 1/1250. Canon 50mm f/1.8 at 50mm) © Pete Carr*

As is sometimes the case, the main reason that this image is black and white is simply that it doesn't work as well in color. The door is gray, surrounded by pale yellow bricks, and the man is wearing a cream jacket. The girl is already in black and white. As a color photograph it felt dull and boring, but as a black-and-white photo it comes alive with contrast, creating a gritty urban scene.

Assignment

Capture a Candid Moment on the Street in HDR

Your assignment for this chapter is to go out and wait for the right moment. This is the essence of street photography. It could be a person laughing, a couple embracing in the rain, or a crowd of people taking to the street in protest. You may have to wait around for an hour or more in a good spot before something happens. Be patient.

After photographing this moment, convert the raw file into three bracketed exposures using your raw editor, convert it to HDR, tone map, and then do any additional post-processing needed, and post it to the Web site to share with other readers.

In this example, Pete took a photo of a Liverpool Football Club supporter paying her respects to the 96 who died at Hillsborough. The woman in the scene is leaving a football shirt for someone, perhaps someone she knew, as a token of her love and respect. You can see the heartache in her face. The original photo is shown on the left, with the HDR version on the right, which was created from one raw exposure converted to three 16-bit TIFFs. Taken at ISO 200, f/3.5, 1/800 second with a Canon 24-70 f/2.8 lens at 54mm.

© Pete Carr

Remember to visit www.pwassignments.com after you complete this assignment and share your favorite photo! It's a community of enthusiastic photographers and a great place to view what other readers have created. You can also post comments, read encouraging suggestions, and get feedback.

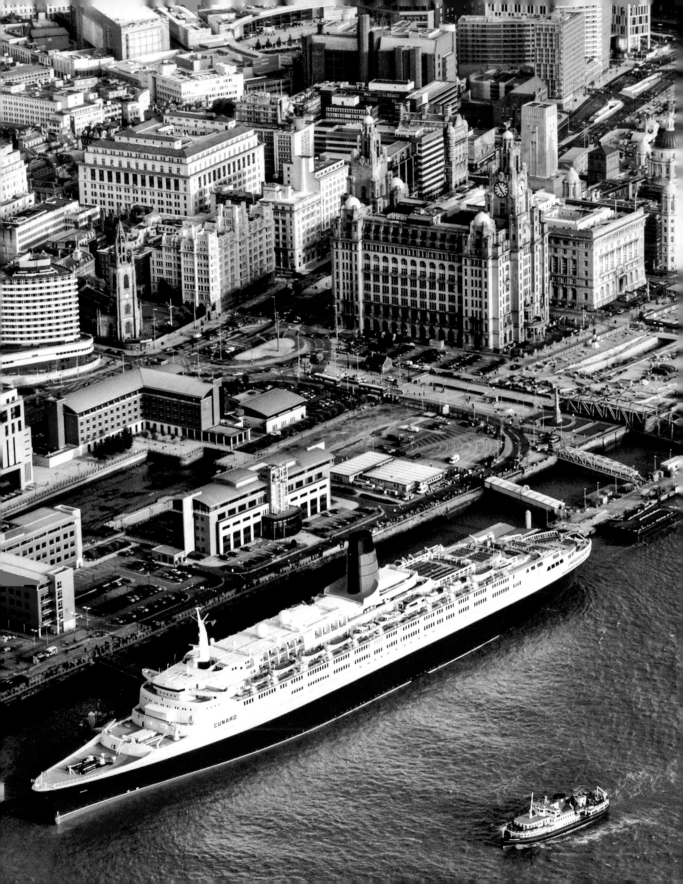

© Pete Carr

Although very popular, landscapes, architecture and buildings, interior spaces, and people aren't the only subjects that work with HDR. This chapter takes a quick look at some other creative possibilities within your reach. You learn how to take incredibly colorful photos past the Golden Hour into dusk and transform them into HDR, look at shooting different vehicles for HDR, and finish with a software effect called cross-processing.

In the end, you use your creativity to direct your efforts in HDR. Although not every scene or subject works as well as another, find the areas that suit your interests and talents and jump in. You don't always have to shoot sunsets, sweeping vistas, or impressive buildings — try cars, statues, ships, skylines at dusk, or even bugs, as in 10-1, which is presented fairly realistically. For this photo, a single raw exposure was converted into three 16-bit TIFFs and the result was tone mapped in Photomatix. Details and contrast of the grasshopper are enhanced by the HDR, although the settings were very conservative: Strength was just below its default and Micro-smoothing was increased.

10-1

ABOUT THIS PHOTO *A grasshopper is caught resting. HDR from a single raw exposure converted to three 16-bit TIFFs. (ISO 100, f/8, 1/160 second, Sony 18-70mm f/3.5-5.6 at 70mm) © Robert Correll*

HDR AT DUSK

Shooting at dusk opens a whole new world for HDR. Cities and landscapes look vastly different at night and the photographic challenge is upside down. During the day, you are mostly concerned with not blowing out highlights because of the sun and reflections of light. You don't have to worry about the sun at night, and exposures at dusk offer creative possibilities impossible to realize during the day, such as capturing scenic lighting. In other words, the bright, multicolored lights in the photo of Liverpool at dusk (see 10-2) are as much a central subject of the scene as the buildings, ships, sky, and water.

Turning to HDR, figure 10-2 was tone mapped very lightly in order to keep it realistic. Pushing the settings too hard would have destroyed such a lovely scene. Therefore, Strength was dropped to 70% and Micro-smoothing was set to +10 to smooth details. In addition, the Temperature, Highlights, and Shadows Saturation were reduced to -3 to keep from oversaturating the entire image. Keep a close eye on saturation in Photomatix, as it can sometimes produce a very saturated image in tone mapping. Afterward, contrast was increased in Photoshop using Curves and orange and blue were further desaturated with the Hue/Saturation tool.

10-2

ABOUT THIS PHOTO *This photo was shot at dusk in Liverpool. HDR created from one raw photo converted to three 16-bit TIFFs. (ISO 100, f/16, 1/250 second, Sigma 24-70mm f/2.8 at 24mm) © Pete Carr*

TAKING LONG EXPOSURES

Shooting long exposures is a fun technique that, among other things, turns moving cars into streaks of light. The process has less to do with getting the ideal exposure of the dark background than with creating the best light and movement effects in the photograph. Therefore, shutter speeds are a product of experience, trial, and error. This is because it is hard to visualize beforehand how these exposures will actually look. You may have a good idea in your mind, but you have to take the photo to find out. In other words, if you take a five-minute exposure you may not know beforehand how a particular light source in the scene will interact with your lens and affect the exposure. It might produce a nasty flare that distracts from the photo or it might not. Predicting this behavior when looking through the viewfinder as you set up the shot is very difficult.

Another variable aspect of long exposures is cloud movement. A three-minute exposure might produce fantastic clouds, but it also might result in something intruding on the scene. Therefore, things to note are flare from street lights and unwanted or wanted movement in objects like boats, clouds or trees. An interesting side effect of long exposure times is that moving objects that aren't lit disappear from the photo. In other words, people walking in front of the camera do not register. If they stand still, you see a blurry figure.

> **tip** See if your camera has a Bulb setting that allows you to keep the shutter open as long as you hold the Shutter Release button down. This may be the only way to capture exposures that are longer than the shutter speeds pre-programmed into your camera. For example, the Canon XSi/450D has a maximum shutter speed time of 30 seconds.

To take long exposures, set your aperture small — in the range of f/13 or f/22. This reduces the amount of light coming through the lens and helps you avoid overexposing long exposures. You will also find that a smaller aperture is more forgiving because less light comes into the camera per second or fraction of a second. You can go over or under an ideal exposure time and it will affect the photo less than with a large aperture. If your camera has the options, enter Manual shooting mode and set the shutter speed and aperture yourself, based on what part of the scene (lighter or darker areas) you meter.

You'll clearly need to use a tripod for longer exposures, or some other way to stabilize the camera for 30 seconds or more. Using a remote shutter release cable can be very helpful if you want a really crisp photo and are using the Bulb shutter setting. It will help keep you and your finger from being stuck in one position throughout the shot and keep you from moving the camera when you press, hold, and then release the button because you can lock the button open for the entire exposure.

> **note** Dusk, for the most part, lasts around 30 minutes. By the time you've done some exposure and lighting tests, you may have time for only one decent photo. If this is the case, produce the HDR from the single raw photo converted to three 16-bit TIFFs.

A very long exposure was taken of a bridge in Salford Quays, Manchester, England, in 10-3. The idea was to capture the motion of the clouds, which reflect the orange street lights, against the deep black sky. HDR rescued details that were lost on the pathway over the bridge and the lights to the left. This photo didn't require an overly dramatic look from HDR — the lights and the shape already provide that. Therefore, when tone mapped for HDR, Micro-smoothing was set to 15, which has a relatively dramatic effect on smoothing out the photo.

ABOUT THIS PHOTO
This is the Salford Quays Bridge in Manchester, England. HDR created from one raw converted to three 16-bit TIFFs. (ISO 100, f/29, 242 seconds, Sigma 10-20mm f/4-5.6 at 16mm) © Pete Carr

10-3

WORKING AT DUSK

It is best to work at dusk rather than the deepest part of the night. Dusk is the transition period from day to night after the sun sets. It starts around 10 to 15 minutes after sunset and only lasts approximately 30 minutes, so you have to work fast. Wait for the fading light to dip toward the horizon and line up with the foreground. The background should sit nicely behind the subject you are photographing — a car, ship, skyline, or landscape. The sweet spot of the 30-minute window is very small — about five minutes when the conditions are perfect. If you miss it, you may have to try again on another night.

If you hit it, it's amazing, as you can see in 10-4. This long-exposure photo was taken from Toronto Island and processed into HDR from one raw image. HDR brings out the dark details in the sky without blowing out all the lights in the city or their reflections in the water. Luminosity was set high to balance the bright city lights against the deep blue sky. Strength was set just above medium to enhance the detail a little but not too much. If noise is an issue, you may perform noise reduction as you convert the raw image or images to TIFFs, enable noise reduction as you generate HDR, and continue to conduct image-wide or targeted noise reduction in final post-processing.

10-4

ABOUT THIS PHOTO *This photo was shot at dusk in Toronto. HDR created from one raw photo, converted to three 16-bit TIFFs. (ISO 100, f/16, 30 seconds, Sigma 24-70mm f/2.8 at 24mm) © Pete Carr*

Keep in mind that shooting when the sky is completely dark causes HDR applications to attempt to bring out detail that isn't there to begin with. This causes colored dots to appear in your image. The software is pushing the photo, bracketed or not, beyond its limits in order to lighten it. Although you can burn in the colored dots in Photoshop, it is a laborious and time-consuming process.

COMPENSATING FOR STREET LIGHTING

Street lighting at night can be very colorful — sometimes too colorful. If you are working with a wide-angle lens, you may experience lens flares. If that happens, zoom in to try and reduce or eliminate the flares by keeping the lights out of the photo as much as possible. Moving to a different angle can also reduce them. If neither of these techniques works, hold out your hand or use another barrier to block the light that is causing the flare — providing what you use to block the light doesn't end up in the photo.

The other issue with street lighting is colorcast. Street lamps often give off a very orange or yellow glow, which stands out and often detracts from the photo. There is a danger of putting a very strong yellow or orange tinted set of images into Photomatix because the tone-mapping process may emphasize the tint even further. If tinting looks like it will be an issue or you make a first pass at tone mapping the image and it looks horrible due to the street lights, return to your raw editor and correct the white balance. This process works best with a single raw photo converted to three TIFFs because you only have to make the white balance adjustment once. If you are using bracketed raw photos, make a note of the color temperature and adjust each image separately.

If, after tone mapping, you need to adjust the white balance in your image-editing program, you may want to concentrate on the problem areas only; with Photoshop Elements, you can do the following:

1. **Open the image you want to adjust in Photoshop Elements.**

2. **Set the foreground color to blue.** Click the foreground color box to open the Select foreground color dialog box, and then pick a shade of blue (pure blue's RGB value is 0,0,255) to be the foreground color.

3. **Click the Create adjustment layer icon in the Layers palette (see 10-5), and choose Gradient from the drop-down menu.** This creates the gradient adjustment layer automatically and opens the Gradient Fill dialog box.

10-5

ABOUT THIS FIGURE *You can create a gradient layer from the Layers palette in order to transition from solid blue to transparent.* © Pete Carr

4. **Change the Angle to suit the flow of color in your photo.** Run the gradient so that it transitions from blue over the colored light you are trying to minimize to transparent over areas you want left alone. In other words, the gradient transition should mirror the direction of the color cast, much like an ND grad filter should mirror the horizon. For this photo, an angle of 90 degrees runs the gradient from blue at the bottom of the photo to transparent at the top, as in 10-6.

5. **Blend the layer by lowering its opacity.** The Opacity control is located on the Layers palette. Click the current opacity number to enter a new number or click the control and slide it down. The blue cools the yellow tones at the bottom of the image but does not affect the upper part because the gradient moves to transparency.

The result of creating a new layer and adding a gradient to that layer is shown in 10-7 — a fantastic purple sky that is not overpowered by

10-6

ABOUT THIS FIGURE *The Gradient Fill dialog box in Photoshop Elements. © Pete Carr*

yellow street lights. In this case, three bracketed photos were shot in order to capture more dynamic range than is possible with one photo. This allowed detail to be brought out in the dark sky even though the street lights are very bright. Luminosity was set quite high here because of all the various light sources. It reduced the brightness of those lights without compromising detail elsewhere. Strength was set to high in order to enhance the detail in the scene.

note Other methods of altering color hues in Photoshop Elements include reducing a color's saturation in the respective color channel by choosing Enhance ⇨ Adjust Color ⇨ Adjust Hue/Saturation or choosing Enhance ⇨ Adjust Color to open the Color Variations dialog box.

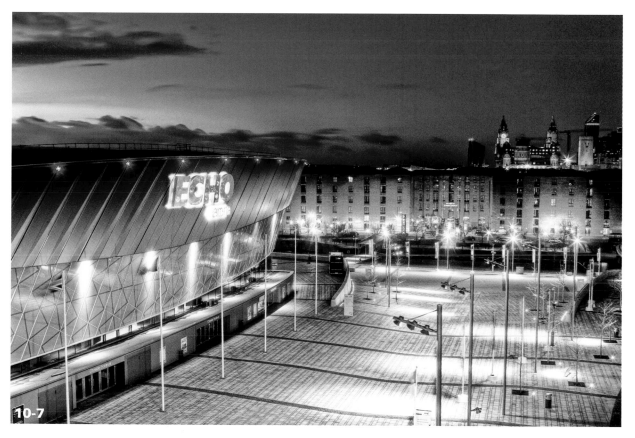

10-7

ABOUT THIS PHOTO *This shot of Liverpool's ACC Arena with Albert Dock and the city in the distance is the result of creating a gradient layer from the Layers palette that transitioned from solid blue to transparent after HDR conversion from three bracketed raw exposures at -2/0/+2 EV. (ISO 100, f/11, 6 seconds, Canon 24-70mm f/2.8 at 24mm.) © Pete Carr*

VEHICLES

HDR is not a monolithic discipline where everyone has to take the same photos. Gathered here are more scenes and subjects that show the techniques and benefits of shooting and processing HDR photography, this time with various kinds of vehicles. They are very popular subjects. Studying and shooting them will expand your creative horizons.

SHIPS

Ships are stunning subjects to photograph. They are majestic, stately, and larger than life. The water, sky, clouds, and skyline present fantastic scenery in which to capture the ship. Ships require a wide-angle lens if you plan on getting close. For large naval vessels and cruise ships, 10-16mm captures the ship and its surroundings perfectly, as in 10-8.

The idea for this image was to be as dramatic as possible. The photo was taken in the afternoon and the sun is just out of frame to the upper right. Normally, it would have been a bad idea to shoot in this direction, but thankfully, the clouds blocked the sun.

In Photomatix, Strength and Luminosity were both set high, but not at their maximum. This gave a strong HDR flavor. Going any higher

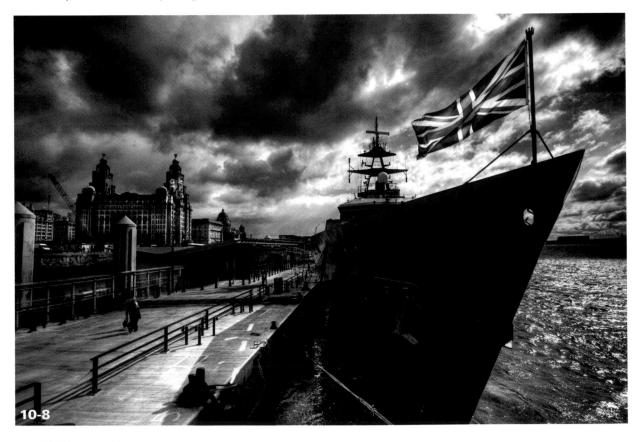

10-8

ABOUT THIS PHOTO *The* HMS Mersey *is docked in Liverpool. HDR from a single raw photo converted to three 16-bit TIFFs. (ISO 100, f/7.1, 1/2500 second, Sigma 10-20mm f/4-5.6 at 10mm) © Pete Carr*

240

would have introduced more unwanted noise. As it was, Micro-smoothing was increased anyway to limit noise and color banding. Noise was more of a problem with this photo because it was the only exposure. There are times when life trumps art, and this day a tripod wasn't available. The black-and-white conversion was rather heavy-handed in order to create a World War II look, and lots of contrast gives it a punchy feel.

If you can get the right angle, capture ships during sunset or sunrise, as in 10-9. This is a classic high-contrast HDR scene, shot as three bracketed exposures. Despite the good setup, the ship did not look right once converted to HDR — it wasn't white, as it should have been. In HDR, white can sometimes turn gray or pick up the tones of surrounding objects. In this case, the ship picked up an odd color cast. Luminosity was set high for this photo to bring out detail in the ship and balance it against the bright sunset sky. Strength was increased to enhance the detail in the ship. Micro-smoothing was increased a little to make sure the image didn't look too processed.

To selectively remove a color cast from a white or gray-white area, use the following steps in Photoshop Elements to desaturate an area:

1. **Open the tone-mapped HDR image.** If necessary, convert the bit depth from 16 bits to 8 bits per channel by choosing Image ⇨ Mode ⇨ 8 Bits/Channel.

2. **Select the Sponge tool.** Located at the bottom of the Toolbar, the Sponge tool is organized with the Dodge and Burn Tools. If the Sponge tool is hidden underneath either of these, click and hold the visible tool, and then select the Sponge tool from the flyout menu.

3. **Choose a softer brush from the Options bar.** You can tell a soft brush from a hard brush from the Options bar because the softer brushes have fuzzier edges. Choose one that has a soft edge. This enables a soft, smooth transition at the edge of the sponge between what you are adjusting with the tool and leaving alone, effectively blending your work better with the original.

ABOUT THIS PHOTO
HDR image of the cruise ship Balmoral, *which is docked in Liverpool. HDR from three raw exposures bracketed at -2/0/+2 EV. (ISO 100, f/8, 1/8 second, Sigma 10-20mm f/4-5.6 at 10mm) © Pete Carr*

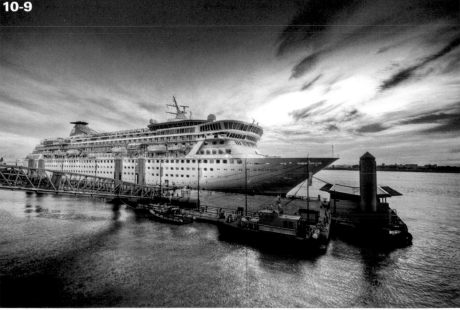

10-9

4. **Adjust the size of the brush.** Use the brush size control in the Options bar to size the brush so it doesn't go outside the area you want to desaturate.

5. **Set the mode to Desaturate, if necessary.** This causes the sponge to desaturate, as opposed to saturate. Desaturate lowers a color's intensity and moves it toward grayscale.

6. **Sponge areas you want to desaturate.** Use the Sponge as you would a paintbrush to lower the saturation to specific areas.

The other color-related problem that needed attention is the Red channel. Because of the color of the sunset, the reds are too intense and the photo is oversaturated. To fix this, follow these steps in Photoshop Elements:

1. **Open the tone-mapped HDR image.** If necessary, convert the bit depth from 16 bits to 8 bits per channel by choosing Image ⇨ Mode ⇨ 8 Bits/Channel.

2. **Choose Enhance ⇨ Adjust Color ⇨ Adjust Hue/Saturation.** The Hue/Saturation dialog box appears.

3. **Select a color channel from the Edit drop-down menu, such as Red.**

4. **Decrease the saturation.** Either enter a negative number or move the slider to the left to lower the saturation, as shown in 10-10.

5. **Click OK to finish.**

 tip If you are photographing a scene that involves water, try using a longer exposure — one good side effect of long exposures is that they smooth water out.

To illustrate the dramatic difference between a shot at sunset and a shot a bit later at dusk, the same ship was photographed again (see 10-11). The trick was to wait for the brightness of the background to match the foreground. In this case, HDR helped bring out details in the clouds, sky, and ship. Within Photomatix, Strength was set high enough to enhance details but not so high as to make the photo look unrealistic. Micro-smoothing was increased to about a quarter to help preserve realism and keep the image from looking too processed. In addition, Luminosity was increased to help balance the light from the sky, sea, and ship. Unbalanced lighting is a common problem when shooting at dusk, especially with a wide-angle lens. As before, there are color problems with the white ship that are corrected by using the Sponge tool to desaturate the white of the ship. The contrast is increased and no areas are overexposed.

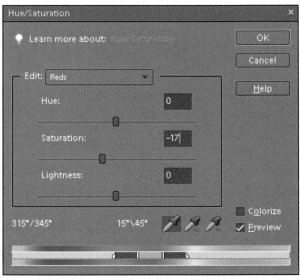

10-10

ABOUT THIS FIGURE *Lowering saturation in the Red channel only.* © Robert Correll

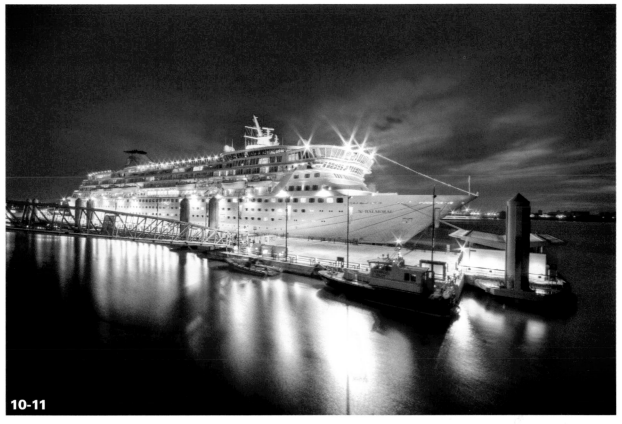

10-11

ABOUT THIS PHOTO. *Here is the cruise ship* Balmoral *docked in Liverpool taken this time at dusk. HDR created from single raw exposure converted to three 16-bit* TIFFs. *(ISO 100, f/20, 30 seconds, Sigma 10-20mm f/4-5.6 at 10mm) © Pete Carr*

INSIDE AN AIRCRAFT

Taking photos out the window of a plane while in flight is a well-established tradition of tourists and other travelers. The view is amazing — you don't get to see cities, clouds, mountains, oceans, and other scenery from above very often. You cannot set up lights, and flash photography may not be permitted. This presents a problem if you want to show the outside and inside of the plane at the same time. It's the dynamic range issue, and can be a real problem if you are flying over white clouds. They are exceptionally bright compared to the dimly lit interior of the plane.

To overcome this problem, take three bracketed photographs. If you are unable to auto bracket, it will be very tricky to succeed at this because you must adjust the settings without moving the camera. Even with auto bracketing, you will need a camera with fast shooting speed because you will most likely be working without a tripod and have to support the camera by hand. The shorter the time that is required, the better.

Bracketing in this situation allows you to capture as much of the dynamic range of the scene, and therefore detail, as possible. In this instance, it is probably not possible to work with single-exposure

HDR. After generating the HDR, tone mapping the image should produce a balanced photo with details across the dynamic range of the scene.

The photo in 10-12 was taken on a flight to Toronto with a dSLR that was handheld, using AEB. If you have a fast enough camera and can stabilize the camera with your hands or resting on something, you don't always need a tripod or monopod. This photo was processed in HDR to achieve a realistic look. Most importantly, Strength was set to just above halfway and Micro-smoothing increased slightly in order to reduce the effect of tone mapping and smooth details. Luminosity was set to high to help smooth the light between the inside of the plane and the outside.

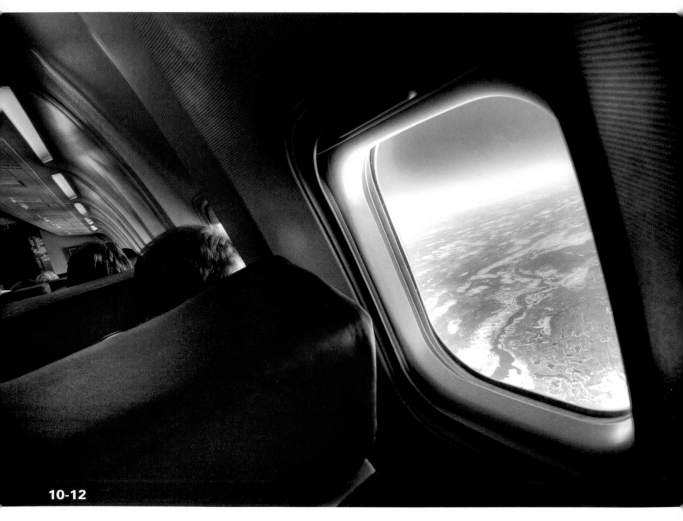

10-12

ABOUT THIS PHOTO *This HDR image was shot on a flight to Toronto. HDR from three raw exposures bracketed at -2/0/+2 EV. (ISO 1600, f/4, 1/15 second, Sigma 10-20mm f/4-5.6 at 10mm) © Pete Carr*

CARS

People love taking photos of cars, especially their own freshly washed and waxed vehicles. Next time you get the itch, take your car out to a scenic location and treat it to an HDR photo shoot. With HDR, you don't have to be in advertising with a huge travel budget that takes you to the south of France or Austria with amazing mountain ranges, wonderful skies, and perfectly lit cars. You shouldn't turn that down if it comes your way, but with HDR it's possible to achieve startling results with a more realistic budget.

First, find the right landscape. You want something that complements the car — maybe a deep valley with mountains on both sides illuminated except in the morning or a rugged scene with woods and a lake. You can also go the opposite route and shoot on a completely flat surface at sunset. Be creative.

note

Remember the Rule of Thirds when composing shots with cars. Overly crazy angles don't work well here, even if the landscape is dramatic. It upsets the eye and people wonder why the horizon is off. If your audience has to tilt its head too far, then something is off.

The photo in 10-13 is of a Honda S2000 at sunset after a quick drive. It was completely unplanned, and the strobes, reflectors, lamps, and other professional lighting equipment required for a traditional advertising shot wouldn't have fit in the car anyway. With HDR, it was possible to shoot directly toward the bright sunset without sacrificing details of the car using only a dSLR and a tripod. The trick was to hide the sun behind the car. That prevented the sun from being a large blob of blown-out highs that are too bright for HDR to rescue in this instance.

ABOUT THIS PHOTO
The shot of this Honda S2000 was taken at sunset and processed into HDR from three bracketed photos of -2/0/+2 EV. (ISO 800, f/22, 1/40 second, Sigma 10-20mm f/4-5.6 at 20mm) © Pete Carr

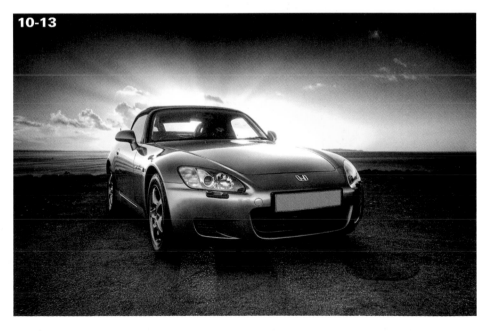
10-13

The HDR result was achieved with three bracketed photos. Within Photomatix, three photos are often critical when shooting toward the sun, as the dynamic range of the scene increases dramatically, outpacing what can be captured by a single exposure, even in raw. Strength was set lower than maximum to keep the amount of noise present in the image as low as possible. HDR processing can accentuate noise, so reducing the strength not only reduces the effect but additional noise as well. The camera that took this photo has a poor noise performance at higher ISOs. Micro-smoothing was increased to reduce the overall tone-mapping effect and Luminosity was slightly increased to reduce the brightness of the sun.

tip
If the sun is in your line of sight and is too bright, hide it.

Cars also look fantastic in urban settings. Gritty areas like warehouses, back alleys, and walls with graffiti work well as backdrops (as in 10-14). Look for opposites — contrast between the car and the background. Graffiti is particularly nice to work in front of because the bold color reacts well to enhanced contrast.

x-ref
For more information on blending layers to combine HDR and normalcy, see Chapter 8.

The very gritty location contrasts with the smooth lines of the car. The graffiti adds personality and color, while the concrete and walls are teeming with detail. HDR enhances the detail and adds contrast that would have been lost in a normal shot. The image is colorful, saturated, and bold, which allows for a more exaggerated angle captured with a wide-angle lens.

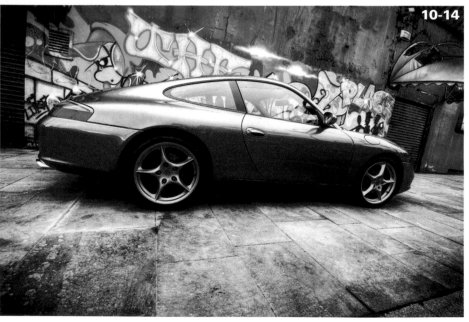

10-14

ABOUT THIS PHOTO
The smooth lines of this Porsche 911 contrast with the gritty location. HDR created from three bracketed photos at -2/0/+2 EV. (ISO 100, f/8, 1/640 second, Sigma 10-20mm f/4-5.6 at 10mm) © Pete Carr

In Photomatix, Strength was maximized, Luminosity was raised to just over medium, and Micro-smoothing set to 0 to bring out and retain detail and grittiness. This shot doesn't need to look well balanced and normal. It cries out for a high-contrast, urban look. The problem with this is the car. It should look the opposite: well polished and organic. To preserve the car's smooth look, the original raw photo was placed over the tone-mapped HDR image in Photoshop and the layers blended together.

> note Be careful of distorting the look of a car if you use a wide-angle lens.

A completely different take on the same scene is shown in 10-15. This is a shot straight from the side with no odd angles or distortion. The smooth style of the Porsche still sits in stark contrast with the chaotic background. The graffiti has just the right amount of smoothness and complements the sleek lines of the car. The black and white emphasizes contrast, and the HDR was processed with less grit to reduce the impact of the surface details. This prevents different styles from stepping on one another. This wasn't a strong high-contrast scene, so the Luminosity setting in Photomatix didn't need to be set very high, just over medium. Strength was set high to emphasize the detail in the graffiti and pavement.

10-15

ABOUT THIS PHOTO *This shot of the Porsche 911 is straight from the side with no odd angles or distortion. HDR created from three bracketed photos at -2/0/+2 EV. (ISO 100, f/8, 1/640 second, Sigma 10-20mm f/4-5.6 at 10mm) © Pete Carr*

OLDER VEHICLES

Old, worn-out vehicles have a tremendous amount of character that is wonderfully accentuated in HDR. They can be rusting, dented, banged up, falling apart — it doesn't matter. Rust in particular seems to show up beautifully in HDR, as shown in 10-16. The truck bed, step, wheel well, and front end are all streaked and spotted, having been aged with time and use. This was taken close-up in order to capture the small texture and surface variations. It was rendered in HDR using six bracketed exposures taken 2EV apart. This wide range of photos,

heavily skewed towards underexposure, was necessary to account for the very bright glare coming off the windscreen and the dark shadows underneath the truck.

As you can tell, it is rendered dramatically. Strength was lowered to make it appear reasonably realistic, although Luminosity and Microcontrast both were maximized to enhance details and contrast. The final image was post-processed in Photoshop. Dust spots were removed and small Levels and Curves adjustments balanced the colors and contrast a little bit better.

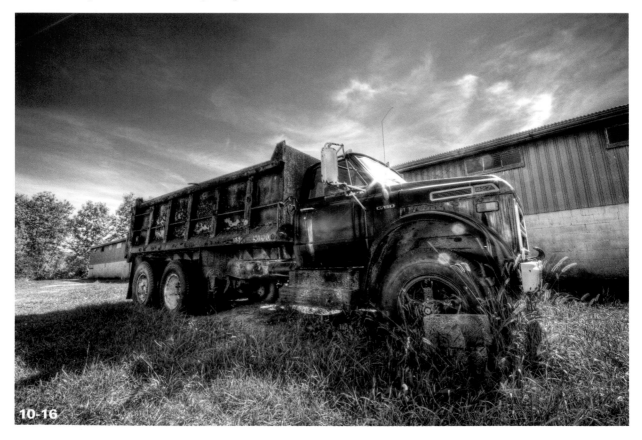

10-16

ABOUT THIS PHOTO *A shot of a beautifully rusting, abandoned dump truck. HDR from six raw exposures bracketed at -10/-8/-6/-4/-2/0 EV. (ISO 100, f/16, 1/250 second, Sigma 10-20mm f/4-5.6 at 11mm) © Robert Correll*

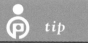 *tip*

Return to your favorite scenes and keep photographing them. You will learn a great deal by analyzing how your photos change and what contributes to how well they look. Choose different tone-mapping settings and closely track how they make the image different. Note what works and what doesn't.

A close-up of a chrome fender on an old Cushman Eagle scooter is shown in 10-17. The chrome stands out beautifully and it is apparent that the fender is damaged. HDR accentuates the contrast and brings out details of the tire and chrome. Light Smoothing looked best when reduced from Very High to High, but Strength had to be lowered to minimize the appearance of halos around the fender and tire. Other combinations of Light Smoothing and Strength couldn't produce the same clear and piercing look in the chrome. Luminosity was minimized to smooth the lighting even as Microcontrast was maximized to darken areas of the photo.

ABOUT THIS PHOTO
The fender of this Cushman Eagle scooter was shot in the parking lot of an air show. Always be on the lookout for creative subjects. HDR from a single raw exposure converted to three 16-bit TIFFs. (ISO 100, f/5.6, 1/400 second, Sony 18-70mm f/3.5-5.6 at 40mm) © Robert Correll

CROSS-PROCESSING

Cross-processing is an old film technique where film is processed in a chemical solution designed for a different type of film. The result was a photo that looked a bit unreal because the colors were off and contrast was greater than normal. In software, cross-processing adds the same green and yellow tints to photos, along with increasing the contrast. It doesn't work on everything, but is worth trying. However, when trying this, be careful not to increase contrast so much that you blow out highlights.

The reasons to cross-process are primarily artistic, but sometimes practical. In the first instance, you may simply love the cross-processed style and like the way photos appear. From a practical perspective, cross-processing can help you rescue some photos. For example, a tone-mapped photo that does not work in color or black and white may look stunning after cross-processing. It's hard to

10-17

predict these situations beforehand, which is why a healthy sense of experimentation and openness to go in different directions, often where the photo leads you, is important.

APPLYING THE TECHNIQUE

As with converting color HDR photos to black and white, apply cross-processing after you have generated the HDR file and tone mapped it in Photomatix or another HDR application. Cross-processing takes place in your image editor, ideally after you have performed any other final adjustments, including noise and contrast.

Unfortunately, cross-processing is not well supported in Photoshop Elements. The main problem is that Elements does not support manipulating separate color channels with Curves. It is possible, however, to create the general feel of cross-processing in Elements following this approach:

1. **Open Photoshop Elements and load the tone-mapped HDR image.** Cross-processing takes place after you have generated the HDR from your bracketed photos and tone mapped the resulting image, which is shown in 10-18. Here settings emphasized details and ambience. Strength was maximized to

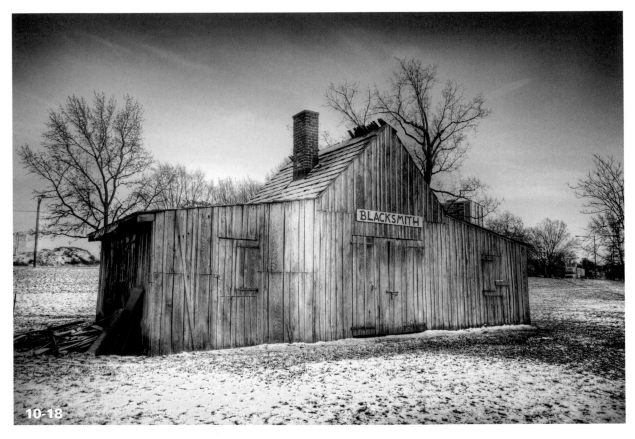

10-18

ABOUT THIS PHOTO *Standard HDR created from three bracketed photos at -2/0/+2 EV with additional post-processing in Photoshop Elements. (ISO 100, f/8, 1/30 second, Sigma 10-20mm f/4-5.6 at 20mm) © Robert Correll*

accentuate detail in the building and grass. Luminosity was increased slightly to balance the light of the sky with the rest of the image. Microcontrast was reduced to remove some of the halo effect. This image has had a few dust spots removed and the snow and parts of the building were dodged to bring out highlights. Parts of the building and sky have been burned to emphasize drama and contrast of existing details.

2. **Choose Enhance ➪ Adjust Color ➪ Adjust Color Curves.** The Adjust Color Curves dialog box appears.

3. **Select Increase Contrast preset, as shown in 10-19.** This alters the contrast curve to something approaching a true cross-processing adjustment.

4. **Click OK to apply the changes.**

5. **Choose Enhance ➪ Adjust Color ➪ Color Variations.** The Color Variations dialog box appears.

6. **Select Shadows and increase green.** This adds a subtle green tint to the shadows.

7. **Select Highlights, and then increase a combination of red and green.** Because you can't directly add yellow in the Color Variations dialog of Photoshop Elements, you must add red and green, which combine to give the highlights a yellow tint.

8. **Finalize your adjustments.** You may need to increase contrast again or perform a final levels adjustment. The final image is seen in 10-20.

10-19

ABOUT THIS FIGURE
Increase the contrast in preparation for color tinting.
© Robert Correll

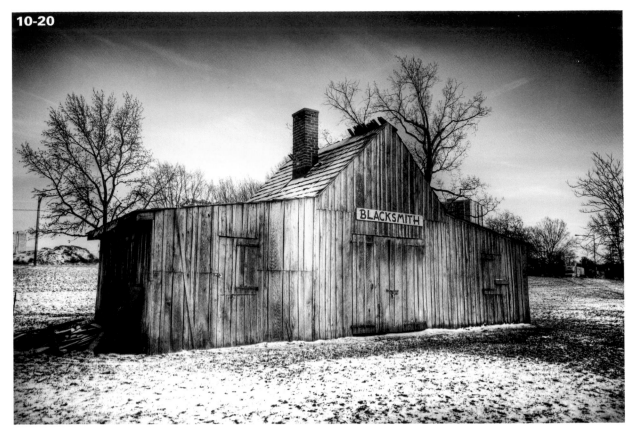

10-20

If you compare figures 10-18 with 10-20, both are good examples of HDR. The more traditional HDR file in 10-18 has good color, detail, and drama while the cross-processed file adds its characteristic otherworldliness to it.

CROSS-PROCESSING EXAMPLES

In general, cross-processing works best in urban areas because landscapes with green grass can appear unnaturally green after processing. For urban shots and street photography, as in 10-21, cross-processing can look very nice. HDR brings out the small details and textures in this photo — notice the details throughout and the contrasting shadows and colors of the building facades. The strength setting in Photomatix was reduced in order to balance the additional detail with

realism, and Luminosity was increased to balance the light across the image. Micro-smoothing was elevated to reduce the overall tone-mapping effect and reduce local contrast, which sometimes appears too gritty and stereotypically HDR. Cross-processing accentuates the handbag, boots, and several sidewalk squares.

The photo in 10-22 shows a Norwegian couple celebrating a Norwegian national holiday and is also nicely cross-processed. The two are standing in front of a nice piece of graffiti that lends itself to high-contrast processing. An HDR image was created from a single raw image because three shots are not normally possible with people. After tone mapping, the image was converted to black and white, then cross-processed.

ABOUT THIS PHOTO
A girl runs past a bakery. HDR created from a single raw exposure converted to three 16-bit TIFFs. (ISO 100, f/8, 1/640 second, Sigma 10-20mm f/4-5.6 at 10mm) © Pete Carr

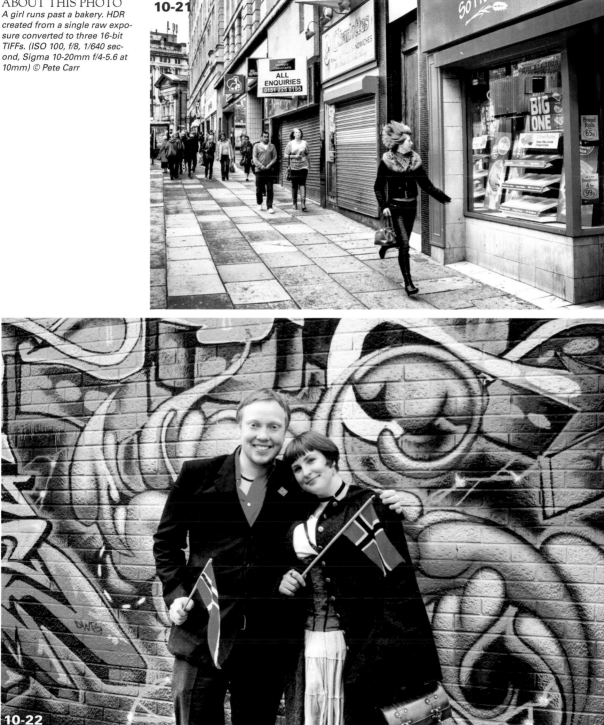

10-21

10-22

ABOUT THIS PHOTO *A couple celebrates a Norwegian holiday. HDR from a single raw exposure converted to three 16-bit TIFFs. (ISO 400, f/6.3, 1/80 second, Canon 24-70mm f/2.8 at 24mm) © Pete Carr*

Afterwards, Pete started over because cross-processing the black-and-white photo looked too green. The black-and-white version looked fine and the color version looked fine. It was the combination of black and white converted to color that, for this photo, looked off. Starting from the color version of the tone-mapped HDR file once again, the photo was cross-processed, and works very well. The green tint is apparent in the dark clothes but does not overpower the entire image. When scenes are not overwhelmingly high-contrast, such as this one, Luminosity doesn't need to be set very high. Depending on the image and the need to balance the light, just over medium is a good place to set it. Strength was set high to emphasize details in the graffiti and the texture of the wall.

It may surprise you to learn that cross-processing can work wonders on sunsets, normally rich in yellows, reds, and oranges. A classic sunset that has been cross-processed is shown in 10-23. It has

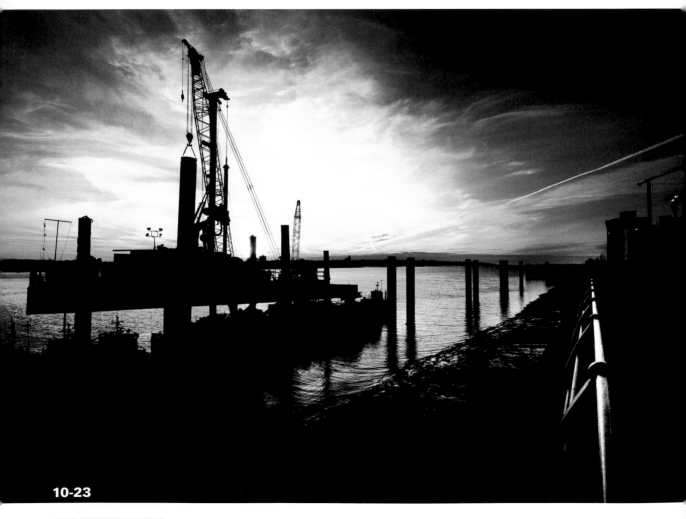

10-23

ABOUT THIS PHOTO *This shot of construction of the Liverpool cruise terminal has been cross-processed. The HDR image was created from three bracketed raw images converted to 16-bit TIFFs. (ISO 100, f/6.3, 1/640 second, Sigma 10-20mm f/4-5.6 at 10mm) © Pete Carr*

a surreal look due to the silhouettes and colors. The clouds are now bursting with yellows and greens.

HDR brings out the details in the clouds and water, leaving the rest purposefully in darkness. It is sometimes not necessary to bring out all the detail. The idea for this photo was to make the sky and clouds look spectacular, much like something out of science-fiction. In Photomatix, Strength was maximized to accentuate the process and Luminosity was likewise maximized.

ABOUT THIS PHOTO
Superlambananas pose outside St. Georges Hall. HDR from three raw exposures bracketed at -2/0/+2 EV. (ISO 250, f/6.3, 1/800 second, Sigma 10-20mm f/4-5.6 at 20mm) © Pete Carr

This enhanced contrast was at the expense of some overexposure, which was then brought somewhat under control by setting Microsmoothing to +10.

Figure 10-24 is another photo of Superlambananas, now cross-processed. The colors are very different now, which changes the feel of the image. The reds and blues remain prominent, but in a different way. The building and ground pick up the green and yellow tint while the sky is less affected.

10-24

Assignment

Amaze Us with Your Creativity

Your final assignment is to amaze us with your creativity. Go crazy! Find a car, ship, plane, landscape, incredible-looking abstract building, or a unique person to photograph. Review this and the other chapters for ideas of places and things that might be interesting for you to photograph.

If possible, shoot three bracketed raw photos. Otherwise, shoot one good raw exposure. Generate the HDR and then tone map the result. Continue to post-process in Photoshop Elements or the tool of your choice.

The final example is a simple study of how HDR can be beautiful and practical. The sunset visible through the window reminds us that at the end of a hard day of work there is a lot of beauty out there. The clouds are gorgeous and the sky is a nice blue. Details within and without the office are well balanced — neither is lost or compromised. No flash was used; no lighting at all other than natural light. It really shows what you can do with a camera, three photos, a bit of creativity, and HDR (here generated from three raw exposures bracketed at -2/0/+2 EV). Taken at ISO 320, f/4, 1/125 second with a Sigma 10-20mm f/4-5.6 at 20mm.

© Pete Carr

Remember to visit www.pwassignments.com after you complete this assignment and share your favorite photo! It's a community of enthusiastic photographers and a great place to view what other readers have created. You can also post comments, read encouraging suggestions, and get feedback.

HDR Software

Photo-Editing Software

HDR Photographers

Forums

©Robert Correll

The Web allows us to sit comfortably within the confines of our own homes — or in the yard, on a train, in the car, at school, on our phones, in the coffee shop, or at work — and actively participate in the HDR community. Use this moderate list of resources as a starting point as you continue your journey into HDR. Check out other programs, people, technical HDR details, alternate HDR workflows and strategies, and most importantly, photos.

HDR SOFTWARE

These dedicated HDR applications allow you to create HDR files from multiple bracketed or single exposures, and then tone map the results. These are both critical steps in the process of HDR photography.

PHOTOMATIX

www.hdrsoft.com

Photomatix is our software tool of choice for HDR photography. There are alternatives, but Photomatix remains the leading dedicated HDR application. It does the job and provides great results. Windows/Macintosh.

Enter this code to get 15% off the purchase price of Photomatix software: *Vanilladays*.

ARTIZEN HDR

www.supportingcomputers.net

Artizen HDR has a complete set of powerful tools that enable you to create HDR and edit the results. Windows only.

DYNAMIC PHOTO HDR

www.mediachance.com/hdri

Dynamic Photo HDR is easy to use and contains a number of useful features. Windows/Macintosh.

EASY HDR

www.easyhdr.com

easyHDR comes in Basic (which is free) and Pro. easyHDR is a fairly nice package with options to blend or tone map photos. Windows only.

FDR TOOLS

www.fdrtools.com

FDR Tools is one of the leading competitors to Photomatix. The interface is a bit more complicated and less intuitive than Photomatix, but the results can be good. Windows/Macintosh.

QTPFSGUI

qtpfsgui.sourceforge.net

Qtpfsgui is an open source graphical user interface application for HDR imaging. It is free for Linux, Windows, and Mac OS X.

PHOTO-EDITING SOFTWARE

Additional image processing is an important part of HDR photography. These applications are well-rounded image and photo editors that have a plethora of features with which to reduce noise, eliminate dust, dodge, burn, mask, colorize, and convert your HDR photos to black and white.

ADOBE PHOTOSHOP ELEMENTS

www.adobe.com/products/photoshopelwin

www.adobe.com/products/photoshopelmac

Photoshop Elements is the leading consumer photo-editing application. It has many of the same features as Photoshop but at a fraction of the price. Elements has a much gentler learning curve and has a very good interface. Most Photoshop plug-ins are fully compatible with Elements.

ADOBE PHOTOSHOP

www.adobe.com/products/photoshop/photoshop

Adobe Photoshop is the leading professional photo and graphic artist software package worldwide. Photoshop is complex and can take a long time to master, but your efforts will be rewarded.

ADOBE LIGHTROOM

www.adobe.com/products/photoshoplightroom

Adobe Lightroom is Photoshop for photographers. It is streamlined to fit a photographer's day-to-day needs and workflow. Photo edits are nondestructive, which means that you can undo all changes and revert to the original photo much like having a negative. Organize, preview, and edit hundreds of digital photos quickly and easily.

COREL PAINT SHOP PRO PHOTO

www.corel.com

Paint Shop Pro Photo is one of the leading Windows-only alternatives to Photoshop. It is cheaper than Photoshop but compares favorably in many respects, being very powerful and versatile in its own right. Like Photoshop, you can use it for HDR and photo editing.

GIMP

www.gimp.org

The GIMP (GNU Image Manipulation Program) is a free image-editing application that has versions available for Linux, Mac OS, and Windows computers. It has a fairly versatile array of photo editing and image creation tools and an enthusiastic following.

APPLE APERTURE

www.apple.com/aperture

Aperture is Apple's foray into the professional photography post-processing market. It contains a full array of photo editing and management features. Aperture is not available for Windows.

HDR PHOTOGRAPHERS

There are many fantastic photographers around the world who also create great HDR images. Take a look at their work and learn from what you see.

PETE CARR

www.petecarr.net

Pete has a daily photoblog that features life in Liverpool, UK. His powerful HDR images range from landscapes and cityscapes to street photography.

DANIEL CHEONG

flickr.com/photos/danielcheong

Daniel Cheong is a photographer in Dubai. He specializes in HDR and digital blending, resulting in amazing cityscapes of Dubai and Kuala Lumpur to landscapes.

CHRIS COLEMAN

flickr.com/photos/iceman9294

Chris Coleman has produced some very unique HDR, ranging from balloon flights to cityscapes.

ROBERT CORRELL

www.robertcorrell.com

Robert's HDR images include casual shots of everyday life in Indiana, family activities, unique small-scale subjects, street and event photography, landscapes, and cityscapes.

DAVID HERREMAN

flickr.com/photos/hdr400d

David Herreman is an amazing photographer with a collection of HDR images ranging from urban decay to landscapes.

JOHN MUELLER

flickr.com/photos/johnmueller

John Mueller is a photographer from California whose HDR includes fantastic landscape and auto shots. His photos are often natural looking.

DAVID J. NIGHTINGALE

www.chromasia.com

David J. Nightingale is one of the best HDR photographers. His award-winning photoblog often features images of Blackpool (UK), as well as HDR images of other locations.

RUBEN SEABRA

flickr.com/photos/atrium09

Ruben has a stunning collection of old buildings and landscapes on his Flickr stream, with the occasional portrait.

PETER VAN ALLEN

flickr.com/photos/petervanallen

Peter Van Allan is a graphic designer from Portland in Dorest, UK. He has HDR landscapes with stunning seascapes.

FORUMS

The world of HDR photography is growing. Find a community and participate. Share yourself and your talents.

PHOTOWORKSHOP.COM

photoworkshop.com

Photoworkshop.com is an interactive community of enthusiastic photographers. It is a great place to share your photos and view what other readers have created.

TALK PHOTOGRAPHY

www.talkphotography.co.uk

Talk Photography is one of the UK's largest photography forums. Its members range from digital compact users to professional photographers with years of experience.

FLICKR HDR GROUP

flickr.com/groups/hdr

The Flickr HDR group is a goldmine of information. There are many discussions on what HDR is and isn't, the art of HDR, and many other HDR topics.

FLICKR PHOTOMATIX GROUP

flickr.com/groups/Photomatix

This is similar to the Flickr HDR group but centered on Photomatix. This group has experts who are able to answer any question you may have on producing HDR images with Photomatix.

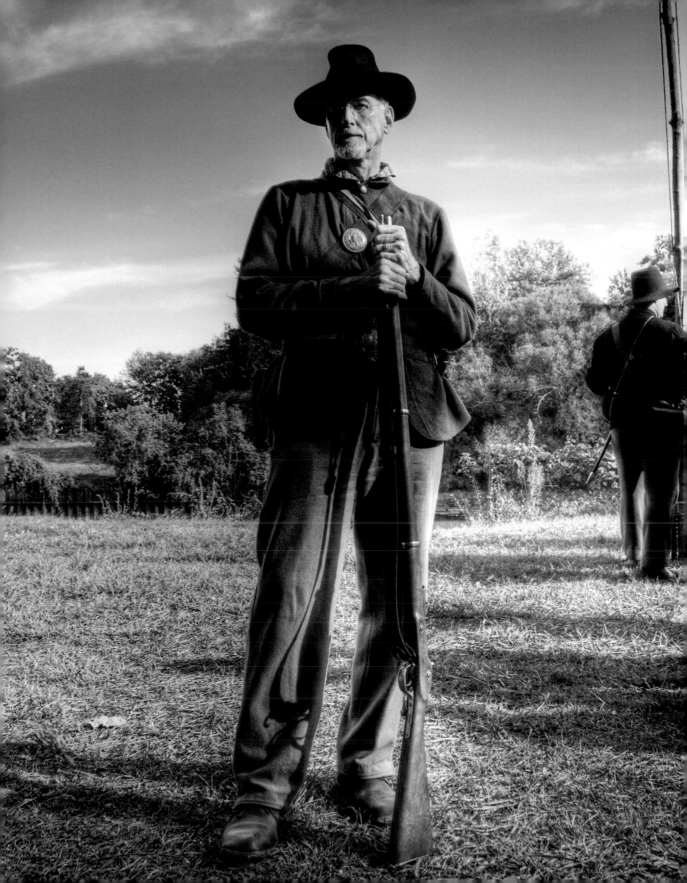

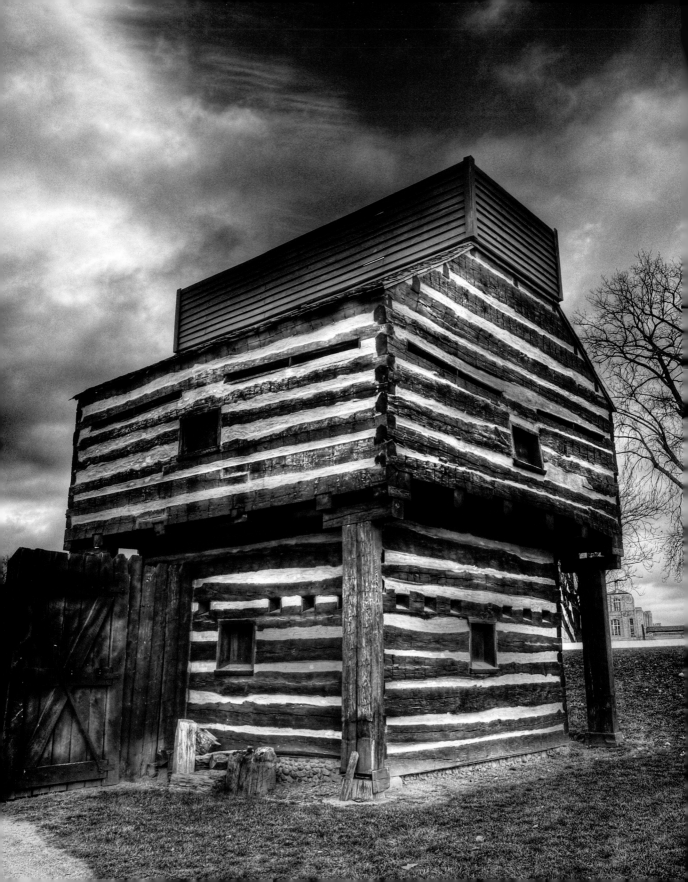

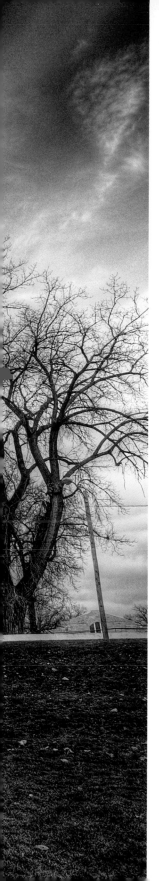

GLOSSARY

AEB Auto Exposure Bracketing is a camera feature that automatically adjusts the exposure for a series of photos, resulting in a set of at least three photos. Cameras differ in how much exposure compensation they offer per bracket. Some are +/-2EV per bracket (-2/0/+2EV) while others are less.

aperture Aperture describes the size of the opening in the lens that focuses light past the open shutter and onto the sensor inside the camera. A larger opening lets more light in and a smaller opening permits less light in. Aperture is expressed as an f-number, the number of which works opposite the aperture size. In other words, a small f-number such as f/2.8 is a larger aperture than a large f-number such as f/8.

Aperture Priority This mode locks the aperture to your chosen setting but allows the camera to modify shutter speed to get the best exposure.

bokeh The blurred area, most often perceived as behind the focal plane, that is not in the depth of field for a given lens and aperture and therefore not in focus. Not all lenses produce equally aesthetic bokeh. Some produce double images while others are very pleasing. See also *aperture* and *depth of field*.

bit depth A measure of how many binary digits (bits, which can be 0 or 1) are used to record or store data in a digital system or file. More bits allow larger numbers. For example, one 8-bit channel of an RGB image can store 256 values for color intensity while a 16-bit-per-channel TIFF image can store 65,536 values per channel.

blown highs This happens when details are lost in white skies or highlights. The photo as a whole does not have to be overexposed.

bracketing Bracketing is the process by which you shoot at least three different photos, two of which are bracketed around the central exposure, which is most often shot at 0EV. A good distance between the brackets is 2EV, resulting in three exposures shot at -2/0/+2EV. You can create brackets from a single raw photo by adjusting exposure in a raw editor (-2/0/+2EV) and saving the processed files with different names. Bracketing can be done manually or with AEB.

burning A technique used to darken areas of a photo during image processing. Most photo-editing applications have a Burn tool or brush.

circular polarizer These filters reduce glare caused by reflected sunlight.

color temperature The temperature of the light source as measured in Kelvin. As the temperature increases, the color of the light transitions from red through white to blue. Confusingly, our perception of the light is described the opposite way: a blue tint is "cool" and a yellow/red tint is "hot." Color temperature is used to help find the white balance of a photo.

compact digital cameras Small, light, digital cameras meant for the casual photographer. They normally have a decent built-in zoom lens and live view LCD screen on the back to compose and review photos. You often have less control over modes and options, but this is not universal. These cameras are generally viewed as being at the opposite end of the camera spectrum as dSLRs.

contrast ratio The ratio of the luminance of the brightest color (white) to that of the darkest color (black) that the system is capable of producing or viewing. Paper, monitors, cameras, LCDs, and your eyes have limited contrast ratios.

depth of field The depth of the plane perceived as in focus. Large apertures create smaller depths of field, resulting in a great deal of blurring (called bokeh) in front of and behind the focal point. Smaller apertures result in much larger depths of field, with little or no perceivable blurring throughout the depth of the photo.

digital noise Electrons detected by a digital camera's sensor that are from sources other than the light from the scene you are intending to measure. They appear as pixels of random color in a photo. Greater sensor size and efficiency combat noise. Common sources of digital noise are heat from sustained camera operation and background electron activity. High ISOs do not generate digital noise; they simply amplify the noise that is already there.

digital single lens reflex (dSLR) A dSLR camera is the digital equivalent of the traditional 35mm SLR camera, which has a mirror within the body of the camera that reflects the view from the lens into the viewfinder. dSLRs range from entry-level for the hobbyist to very expensive models for the consummate professional. A key feature of dSLRs is their ability to change lenses, making them a very versatile system.

dodging A technique used to lighten areas of a photo during image processing. Most photo-editing applications have a Dodge tool or brush.

dynamic range The ratio between the smallest and largest possible values of a changeable quantity. In photography, it is the difference between the brightest and darkest values the camera can record. Dynamic range can be expressed as EV, stops, or as a contrast ratio.

EV Also called Exposure Value. EV illustrates the relationship between exposure, shutter speed, and f-number. EV is a working figure that allows the effects of altering shutter speed and aperture on exposure to be quickly and easily compared.

EXIF Exchangeable Image File Format data, or EXIF data for short, was created to be able to store non-image data such as time of exposure, shutter speed, ISO, and f-number in the same file as a digital photograph. See also *JPEG*, *metadata*, and *TIFF*.

exposure How much light reaches the camera's sensor during a single photograph. Factors that affect non-flash exposure are aperture (how large an opening into the camera), shutter speed (how long the light is allowed to enter), and ISO (the sensor's sensitivity).

filters Filters are usually mounted in front of a camera's lens to control exposure by filtering out light. Exactly how they do this depends on the type of filter. Some filter all wavelengths and others are very selective.

f-numbers Also known as f-stops or stops. F-numbers describe the ratio between a lens's focal length and aperture diameter. For a given focal length, larger f-numbers have smaller apertures, letting less light into the camera, also deepening the depth of field. Smaller f-numbers have larger aperture diameters that let in more light, resulting in a shallower depth of field.

fps Frames per second. The rate at which a camera can take and store photos.

Golden Hour The hour after sunrise or the hour before sunset, where the sun's light is less harsh and strikes scenery at a more forgiving angle than directly overhead. This the best time to be out photographing landscapes and other outdoor subjects.

HDR photography High dynamic range photography is a photographic discipline and software process that captures high-contrast scenes using exposure bracketing techniques and processes them in order to keep details from being lost in shadow or blown out in highlights.

HDR files 32-bit high dynamic range files generated from multiple camera exposures. To be of practical use, they must be tone mapped onto a lower bit range, such as 16 or 8 bits per channel.

high contrast Used to describe a scene with a great deal of difference between highlight and shadow luminosity. It does not automatically mean a bright scene, as an indoor scene with very deep shadows and limited light can also be high contrast.

ISO An abbreviation for International Organization for Standardization, ISO was originally used to describe film speed, but in the digital world it is used to describe sensor gain. Higher settings turn up the sensitivity of the sensor, often at the cost of noise.

JPEG An acronym for Joint Photographic Experts Group, this is a very common and compatible photo file format. It is widely used on the Internet, is capable of millions of colors, stores metadata as EXIF information, and has a variable, but lossy, compression scheme. It is limited to 8 bits/channel. Best used as a final format for presentation on the Web. See also *lossy compression*, *metadata*, and *EXIF*.

light meter A device used to measure the intensity of light in order to guide photographic exposure settings. Incident meters measure light falling on a subject while spot meters measure reflected light. Digital cameras have built-in light meters, but you can also buy external, handheld light meters.

lossy compression Compression algorithms that do not preserve the original data as they reduce the size of an image. For example, you could compress the red color value of an image that has 100 pixels by averaging groups of two pixels together instead of saving each one. Each time through the process, data is irretrievably lost. See also *JPEG*.

low contrast A scene with very little difference between highlight and shadow luminosity. It does not automatically mean a dark scene, as even a bright but cloudy day can be low contrast. See also *luminosity*.

luminosity Without getting too technical, luminosity is how bright something is. A scene with high luminance is brighter than one with low luminance and raising the luminance in post-processing brightens the photo. See also *low contrast*.

Manual mode The camera mode where you make all exposure decisions based on the information at hand and adjust the camera settings (aperture, shutter speed, ISO) yourself.

metadata Non-image data that is stored in an image file that describes it. Individual entries can range from shutter speed for camera files to bit depth. See also *EXIF*, *JPEG*, and *TIFF*.

metering A process where a camera or light meter measures the amount of incident or reflected (also called spot) light in a scene, which assists in determining what camera settings should be used to take the proper exposure. Cameras often have several metering modes. The most common are Average, Center-weighted, and Spot.

ND filter Neutral Density filters reduce the amount of light coming into the lens, regardless of wavelength, which preserves the inherent colors of a scene while reducing exposure.

ND Grad filters Neutral Density filters with a graduated effect. Most often used to darken skies to keep them from being blown out while exposing other elements of a scene more brightly.

panorama A panorama uses several individual exposures stitched together to create a very wide-angle finished photo.

post-processing Technically, post-processing refers to anything that occurs after you take a digital photo. When a camera stores a JPEG, it is post-processing the raw data. When you convert the raw data to a 16-bit TIFF, you are also

post-processing. HDR is a form of post-processing, which is generally called HDR processing in this book. Further post-processing steps take place after tone mapping when you produce the final image. Noise reduction, black-and-white conversion, dodging, burning, layer blending, and toning are examples of the types of activities undertaken in this last stage of post-processing.

raw Raw is a term used to generally describe proprietary camera file formats that store data direct from the camera sensor. The main advantages are that the sensor bit depth (generally 12 to 14 bits) is not truncated to 8 bits/channel and that the photos are stored in an unprocessed state. They are not directly editable and require a raw editor to process into JPEG, TIFF, or other formats for post-processing.

saturation The purity of a color, ranging from gray to pure color. High saturation can make photos look unnatural and increase noise. Grayscale images are completely desaturated.

shutter speed Shutter speed is measured in minutes, seconds, or fractions of a second, and describes how fast the camera shutter opens and closes. Longer times (slower speeds) let more light into the camera. Shorter times (faster speeds) let less light in.

Rule of Thirds A technique used to compose photographs by dividing a scene into a 3 × 3 square grid like a Tic-Tac-Toe board. The focal points of the image are ideally placed either along the lines or where the lines intersect for the most pleasing effect.

tinting Also called toning. Tinting is a general name for applying color to a black-and-white photo. It can be duotoning (two colors), tritoning (three), or quadtoning (four). Sepia toning is another example of tinting.

single-exposure HDR HDR created from one camera raw file that is turned into three brackets (-2/0/+2EV) using raw image-editing software. These brackets are used to generate HDR, which is then tone mapped. Although this method does not capture the same dynamic range as multiple bracketed exposures, it is sometimes the only way to create HDR because of fps limitations of cameras and the movement of the subject.

TIFF An acronym for Tagged Image File Format, it is a high-quality photo file format that can use lossless compression (but is not required to). TIFFs are not well supported in Web browsers, but are powerful interim working files that can be viewed and printed in high quality. TIFFs can be 8 or 16 bits/channel.

tone mapping The process of condensing the dynamic range of a 32-bit HDR file onto a lower dynamic range, 16-bit file that you can view, edit, and print from standard image-editing programs. Tone-mapping settings within HDR applications guide how the 32-bit data is condensed. These settings can be changed, resulting in many possible different 16-bit interpretations of the same 32-bit source HDR file.

workflow A term used to describe work or processing order. An HDR workflow should promote creative flexibility and timeliness without unnecessarily compromising data integrity.

continued

continued

continued

continued

Develop your talent.

Go behind the lens with Wiley's Photo Workshop series, and learn how to shoot great photos from the start!
Each full-color book provides clear instructions, sample photos, and end-of-chapter assignments
that you can upload to pwassignments.com for input from others.

978-0-470-11433-9

978-0-470-11876-4

978-0-470-11436-0

978-0-470-14785-6

978-0-470-11435-3

978-0-470-11955-6

978-0-470-11434-6

978-0-470-41299-2

978-0-470-11432-2

978-0-470-40521-5

Available wherever books are sold.

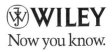

WILEY
Now you know.